How to Open & Operate a
Financially Successful

PHOTOGRAPHY
BUSINESS:

With Companion CD-ROM

By Bryan Ro

with Joni Strandque

HOW TO OPEN & OPERATE A FINANCIALLY SUCCESSFUL PHOTOGRAPHY BUSINESS: WITH COMPANION CD-ROM

Copyright © 2011 Atlantic Publishing Group, Inc.
1405 SW 6th Avenue • Ocala, Florida 34471 • Phone 800-814-1132 • Fax 352-622-1875
Web site: www.atlantic-pub.com • E-mail: sales@atlantic-pub.com
SAN Number: 268-1250

Library of Congress Cataloging-in-Publication Data

Rose, Bryan, 1976-
 How to open & operate a financially successful photography business : with companion CD-ROM / by Bryan Rose.
 p. cm.
 Includes bibliographical references and index.
 ISBN-13: 978-1-60138-018-0 (alk. paper)
 ISBN-10: 1-60138-018-6 (alk. paper)
 1. Photography--Business methods. I. Title.
 TR581.R62 2010
 770.68--dc22
 2010001083

PROJECT MANAGER: Nicole Orr • PEER REVIEWER: Marilee Griffin
INTERIOR DESIGN: Samantha Martin • FRONT COVER DESIGN: Meg Buchner
BACK COVER DESIGN: Jackie Miller • millerjackiej@gmail.com

Printed on Recycled Paper

We recently lost our beloved pet "Bear," who was not only our best and dearest friend but also the "Vice President of Sunshine" here at Atlantic Publishing. He did not receive a salary but worked tirelessly 24 hours a day to please his parents. Bear was a rescue dog that turned around and showered myself, my wife, Sherri, his grandparents Jean, Bob, and Nancy, and every person and animal he met (maybe not rabbits) with friendship and love. He made a lot of people smile every day.

We wanted you to know that a portion of the profits of this book will be donated to The Humane Society of the United States. *–Douglas & Sherri Brown*

The human-animal bond is as old as human history. We cherish our animal companions for their unconditional affection and acceptance. We feel a thrill when we glimpse wild creatures in their natural habitat or in our own backyard.

Unfortunately, the human-animal bond has at times been weakened. Humans have exploited some animal species to the point of extinction.

The Humane Society of the United States makes a difference in the lives of animals here at home and worldwide. The HSUS is dedicated to creating a world where our relationship with animals is guided by compassion. We seek a truly humane society in which animals are respected for their intrinsic value, and where the human-animal bond is strong.

Want to help animals? We have plenty of suggestions. Adopt a pet from a local shelter, join The Humane Society and be a part of our work to help companion animals and wildlife. You will be funding our educational, legislative, investigative and outreach projects in the U.S. and across the globe.

Or perhaps you'd like to make a memorial donation in honor of a pet, friend or relative? You can through our Kindred Spirits program. And if you'd like to contribute in a more structured way, our Planned Giving Office has suggestions about estate planning, annuities, and even gifts of stock that avoid capital gains taxes.

Maybe you have land that you would like to preserve as a lasting habitat for wildlife. Our Wildlife Land Trust can help you. Perhaps the land you want to share is a backyard— that's enough. Our Urban Wildlife Sanctuary Program will show you how to create a habitat for your wild neighbors.

So you see, it's easy to help animals. And The HSUS is here to help.

THE HUMANE SOCIETY
OF THE UNITED STATES.

2100 L Street NW • Washington, DC 20037 • 202-452-1100
www.hsus.org

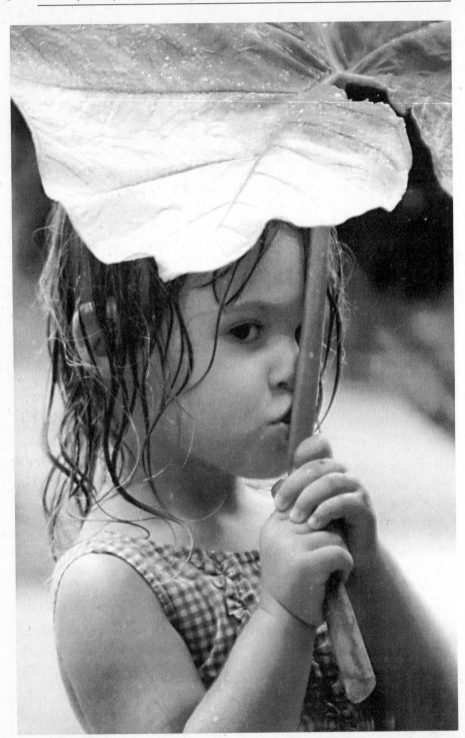

Photo provided by Trista Blouin

Dedication

To Brian Watling – for your love, friendship, and support.

To Laura Rose – for always being my inspiration and for
all the loving support you have given me.

Photo provided by Sivan Grosman

Table of Contents

Chapter 4: Determining Start-Up Equipment and Costs 59

Chapter 9: Methods to Include in Your Marketing Plan 149

Chapter 10: Setting Your Rates 167

Chapter 11: Running Your Business 179

Chapter 14: Photography and the Law 247

Chapter 15: Your Photography Business 267

Glossary of Terms 273

Bibliography 281

Author Biographies 283

Index 285

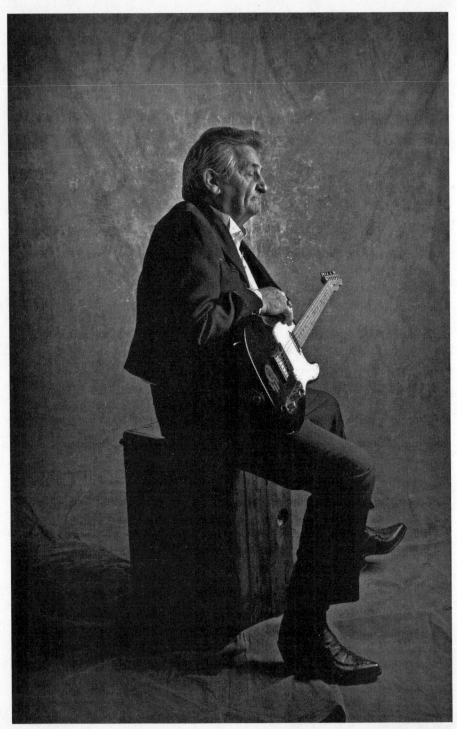

Photo provided by Darin Back

Preface

As photographers, we do so much more than take pictures. We are storytellers who use images to document everything from the mundane to the magnificent.

In lieu of telling stories with constructed sentences of subjects, verbs, and nouns, we tell them with light, composition, and subject. Texture and color serve as our adverbs and adjectives. All components are interwoven to make a statement, convey an attitude, or communicate a message that, ideally, will draw the observer to action or understanding. With the click of a button, we capture moments in time. We document joys, sorrows, and rites of passage. Our images have the capacity to make people think and feel. We activate the minds of others.

According to the United States Bureau of Labor Statistics, photographers held about 122,000 jobs in 2006. More than half were self-employed, which is higher than the average for most other occupations. They also estimate an expected growth rate for the profession at 10 percent through the year 2016. One reason for the growth is technology, which requires

more images to populate the increase in Internet-based advertising and editorial choices.

Despite this growth, the competition to make a living will be high in the field as more people seek self-sufficiency and self-reliance, holding interest in the perks of life as a photographer. Start-up costs, particularly in the realm of digital photography, are low.

The median annual earnings of salaried photographers in May 2006 were $26,170, with the middle 50 percent earning anywhere between $18,680 and $38,730. Only the highest 10 percent in the field grossed more than $56,000 during that year, according to the Department of Labor.

Although you probably will not become a multimillionaire as a result of being a photographer, you will enjoy a quality of life that is not enjoyed in many other professions. Whether you desire to see the world or capture the innocence of a newborn's face, the rewards are many.

I hope this book will help you establish a firm business foundation, no matter what your dream.

Introduction

I started in photography by accident. Taking a job as a sports editor at a small-town newspaper, I was also responsible for taking my own photos. The training method at the newspaper basically consisted of taking a camera and being wished good luck — I really learned on the fly.

As many of you know, once you start in photography, it pulls you in, regardless of how much of a learning curve you had when you got started. I was hooked after my first assignment, and over the years my love of photography grew. As my career wore on, I found myself leaving the newspaper, but I could not leave photography behind. At first, I continued to hone my skills as a recreational photographer. I soon turned that recreational drive I had developed into a freelance business, taking product shots for small companies.

This book will teach you what you need to know to create that business, and that life, as a professional photographer. You will learn how to enjoy the freedom and artistic creativity of the field, in addition to running a successful business.

I have made many mistakes in my career, and hope that I have included every lesson I have learned from those errors in this book.

In the early chapters, I will guide you through making the decision to become a professional and setting up your business. Unlike, say, accountants, photographers tend to open their own businesses with little business training. Thus, I will help you develop your business and marketing plans and understand what it will take to make your business succeed.

Money is, of course, the most important part of running a business because you are not going to remain in business if you do not both make money and manage it. I will help you with pricing and fee structures, as well as with managing your money.

You will need to know how to run your business within the law, maintain your copyright protection, and manage contracts with suppliers and customers, so I will devote time to discussing those topics. As a photographer, you may know how to function in the field, but you may be new to the business world. Learning to balance these aspects is important to establishing a viable business.

Marketing, sales, and public relations take up a large portion of the book, as no one is going to hire you if they do not know you exist. Marketing is the life's blood of your business. I will walk you through the process of marketing, promoting, and selling your services.

I will show you how to build your business so that it will prosper in the long run and continue to bring you a steady income and a fulfilling life.

Finally, I will go over what is on the CD-ROM, and how to use those forms and contracts to build your business from scratch. With that in hand, you will be able to start your photography business and, ideally, find yourself thriving in this wonderful field.

Chapter 1

The Life of a Photographer

Taking a moment and capturing it forever — that sums up the life of a photographer. Whether you shoot weddings, football games, senior portraits, mountains, or a house fire, you are documenting the lives of those you catch with your lens.

For good or bad, photographers are the chroniclers of our history, recording who we are and where we have been. From the battlefields of the Civil War to the lights and glamour of Hollywood, photographers are on the scene.

Although the photographer plays a major role in our society, not everyone who picks up a camera and points it can truly call himself or herself a photographer. A photographer is an artist, an empathetic eye, and an unflinching newsman. A photographer is an activist, a comedian, and a teacher.

You may have picked up this book because you too feel the need to document the lives around you, to preserve time for those who follow, and to bring justice or entertainment into the world.

However, the life of a photographer is not one of free-wheeling, always in the field on the hunt; rather, it is one of hard work and dedication.

CASE STUDY: A DAY IN THE LIFE

Emilie Sommer, emilie inc. photography
PO Box 2703
South Portland ME 04116
www.emilieinc.com
http://blog.emilieinc.net
photo@emilieinc.com | 207-272-2285

I own and operate emilie inc. photography, a boutique wedding and photography studio specializing in photojournalism. I have a 1,300-square-foot space in Portland, Maine to meet with clients, edit and tone images, host workshops and social networking events, and photograph indoor studio portraits during the winter.

I work from the studio on a daily basis during the week, unless I am on location for a portrait, and spend every weekend from June to October photographing weddings around New England. I spend the off-season months traveling to photograph destination weddings, attend conventions, and teach at various photography workshops.

This is my fifth year in business, but before starting my own company, I was a photographer and photo editor at *USA Today* and *The Washington Post*.

I had to work with photographers covering the DC sniper attacks of 2002, the wars in Afghanistan and Iraq, the Republican National Convention, and the Miss America Pageant.

I was working a 4 p.m. to midnight shift at *The Washington Post* as the night photo editor when I photographed my cousin's wedding as a gift and really enjoyed it. I had an "aha!" moment where I realized I could spend a lifetime doing what I love and create my own career path, rather than just follow one. I photographed a handful of weddings at cost or as an assistant to an already-established photographer to build my portfolio. Once I felt comfortable with the flow and responsibility, I started building my own clientele, but learning the history and craft [of the business was] vital to success. You cannot just pick up a camera and expect to be an expert.

A Day in the Life

No one would imagine the day-to-day life of an artist to be one of monotony and number crunching, and that is also true with photographers. Each day is a new day to reinvent your craft, feel the freedom of your business, and face the new challenges that crop up.

No customer is the same, no wedding matches the one before, and no matter how many times you visit the Serengeti, something new will catch your eye. Every day for a photographer is different.

But that is likely why you chose this career path. Photographers tend to march to the beat of their own drums. You likely chose this book and this career to live a life of freedom — to live a life that offers new challenges every day.

Of course, that challenge can mean different things to different people, even though the underlying principle is the same. The challenges of a studio photographer are much different than those of a photographer working in a third-world country. Each challenge is unique.

The People You Meet

As a photographer, you are going to work with a wide variety of people, depending on which photography career path you choose. A journalist will work with a different set of people than a wedding photographer will work with, but at their core, clients' desires are mostly the same. They all want the respect of the photographer. They want to know that you are there merely to document, not judge, embellish, or ridicule. Mastering how to deal with different personalities and learning to work with all kinds of people is one of the joys, and challenges, of photography.

Models

Studio photographers who work with magazines and catalogs need beautiful people. But, despite stereotypes, models are usually easier to work with than conventional wisdom might dictate They are professionals who have honed their skills and worked very hard to get where they are.

Most models are professionals, having worked on several jobs and in several different capacities. They want to be treated like professionals and given credit for their experience. They expect to come to work, be able to do their jobs, and be paid for their time and treated with respect — just like any working individual.

As with any other professional, problems arise when there is a lack of communication and respect. Keep those lines open and interact with your model. If you do, your shoot in that far off tropical location will go just as smoothly as you had hoped.

Art directors

Working on your own means you get to choose what photography jobs you want to do and what jobs you will pass on. But, it does not mean that you always get to call the shots once you get there. When you shoot for commercial clients, particularly advertising agencies, you will often work with art directors who make sure the photography works with the entire product, whether it be an advertisement, magazine article, or catalog. The key to making this relationship work is to understand that, while the art director is your client, he or she is also the employer and the boss for the whole project you are photographing.

Art directors have to take charge of every aspect of making the project come together, and they may seem a little too controlling or bossy. Art directors are usually intelligent, creative people who have a certain job —

creating a great image. If you go out of your way to make their job easier, either by taking great photos or listening to art direction, you can build a lasting relationship that could result in repeat business.

Editors

Editors work at newspapers, magazines, and on Web sites. If photojournalism, a type of photography that captures the news as it happens and requires photographers to work more independently, is your chosen path, there is little chance you will not run into one of them.

Like art directors, editors have a certain job to do for their publication, which has its own style, guidelines, and norms. By listening to the editor early on, you are more likely to capture the correct picture at the right time.

As an outside source, you are probably being hired to shoot for a specific article, and that article has a certain feel. It is the editor's job to make sure you portray that feel to the reader. As with the art director, if you go out of your way to make life easier for the editor and work hard to capture the essence of the job you were hired to shoot, it could lead to another call the next time the publication needs a photojournalist.

Wedding planners

Wedding photographers may never get away from the nervous bride, the distrusting mother of the groom, or the camera-hogging aunt as part of the perils of their line of work, but if you ever work with a wedding planner, you will be thankful the profession is around.

The wedding planner is the steady hand hired to make sure everything goes smoothly on the couple's big day. But, that means everything, and it is not solely his or her job just to make sure the photographer is happy.

Because wedding planners will plan many weddings in a year, probably once a week, building a strong relationship with a wedding planner can help grow your business and secure regular work. As the wedding planner gets used to your presence at the wedding, and gets used to the way you work, he or she may be more likely to recommend you to future clients.

Helping the wedding planner make sure that things happen when they are supposed to is the best way to continue working with that planner, as hiring the photographer is often included in the planner's duties.

As a wedding photographer, your job is to make sure that the photography does not encumber or burden anyone in the wedding party. Create beautiful images while being as unobtrusive as possible, and you can expect to be hearing from that planner for future weddings.

Gallery owners

Any photographer is an artist at heart, and if you are one of the lucky few whose "art" is good enough to be put on display, you will run into gallery owners. These people love art, obviously, but they are also business owners, just like you. If you focus on providing the best product to their customers, you will do well working with galleries. To provide quality work that a gallery owner could sell to clients, it is a good idea to get to know what type of photographs that gallery specializes in and who the clientele are.

Keep in mind the gallery owner is your customer, not your agent or salesperson. Their focus is on their own customers — those people who come in and purchase the artwork or donate money to keep the gallery open as a viable business. Keep that end in mind, and you will be able to sell and display your work for years to come.

The public

In photography, there is no way to avoid working with other people. Whether you shoot weddings or are out in nature trying to capture breathtaking shots of majestic mountains, you will run into somebody, a wedding guest or a fellow hiker or tourist. From star athletes to high-school students getting their senior pictures taken, photographers deal with people, usually in their everyday environments.

Learning to talk with people in a disarming manner and respecting the wishes of people who do not want to be photographed can make your life easier and keep you out of confrontations.

Where You Work

Photography is a job that can be done virtually anywhere. With modern technology and conveniences, and depending on what kind of photography you do, you could run your business from your car. For many, that is not an attractive option, but photography does give you the freedom to choose where you will be based.

Working from home

Many successful photographers work from home, even studio photographers. If you can create a studio in your home where your customers can enter without going through your living room, and have room to design an office, computer equipment, and all the other accoutrements of a photography business, you can run your business from home.

Working from home is obviously the cheapest and perhaps easiest way to set up a photography business. And, if you can work without a visitor-friendly studio, this is a particularly good way to begin operating. Care

needs to be taken, though, to separate your work life from your home life, so you know when you are at work and when you are truly at home.

Renting or purchasing space

For some people, the distractions or space limitations of working from home make that choice a poor option. For those photographers, purchasing a studio or an office is the way to go. It gets you outside the house and into a more professional state of mind, making it easy to balance work life and home life.

This is option, however, is more expensive. If you rent space, you also may not have complete say on the setup of your studio or office. But, for photographers who regularly see clients or may have to set up different sets for shots, having a studio away from home could be the best option.

Companies and newsrooms

Freelance photographers who deal with long-term projects may find themselves coming into an already established work environment at a catalog company, magazine, or newspaper. Those photographers may be given a desk or work area, and even a computer or other devices needed to complete the tasks they were hired to do.

It is important for these photographers to remember that they are only there temporarily. While some newsrooms do hire full-time staff photographers and supplement their photography department with freelance, or work-for-hire, photographers, it is becoming more common for companies to only use freelancers. As a freelancer, keeping things professional is important, as someone else may be using this equipment and work area after you leave. Also, these photographers need to realize they are going into an environment that has established customs and norms on how to operate and interact with fellow employees during the workday. Knowing

those norms and expectations can help the photographer get invited back for repeat work.

CASE STUDY: FOR LOVE, NOT MONEY

Rick J. Davis, Owner, Photographer
Sivad Studio
www.sivadstudio.com

My wife, Monica, and I opened Sivad studio in 1992 from the simple need of our growing family and my love of photography. It is a love I still have to this day, 16 years later.

Before becoming a professional photographer, I was a team leader at a silicon manufacturing plant. Monica was also in a high-stress management position. The hours we spent working for someone else meant that our first son spent upwards of 12 hours a day in day care. We acquired the funds to start the business through a settlement due to a motorcycle accident I was in during July of 1990. The cash I received allowed me to purchase my first medium format camera and flash equipment. I spent almost two years becoming educated in the photography field by attending college seminars and helping other photographers. Assisting other people allowed me to learn as much as I could about this field before we started our business.

Although I photograph children, weddings, and families, about 75 percent of my sessions are with high school seniors. I like to specialize in high school seniors because of the diversity of the sessions. Most of our marketing is done through direct mailers and public relations, handled by my wife.

At Sivad, we have two-and-a-half acres on which to take photos with many great settings and backgrounds, such as a gazebo, a soda machine, a garden swing, a field, and a pond. Our indoor studio features backdrops and props, including items such as candles, pillars, children's toys, and an indoor swing. I also enjoy shooting off-set in locations like Moulten Falls or the beach.

Because there are a lot of new photographers coming into the market every year, my suggestion to someone new to the business is to get into photography because you really love it. I have seen a lot of photographers come and go. Most of them were in it for the money, not the love. Some even start out with passion, but lose it once the strain of business takes hold. Once the passion goes, the business follows.

Getting Started

The life of a photographer can be an exciting one, but in order to have that life as your own business, you need to dig into the nitty gritty of every day business ownership.

Marketing plans, business plans, and accounting are just a few of the things you will encounter on the road to starting your business. But, in the end, running a photography business can be a very rewarding experience.

Why Start a Photography Business?

You have dreamt about it — you have fantasized about the freedom, and may have even doodled a mock-up of your business cards. But, what you do not know is how to make all of it a reality. You have picked up this book because your dream is to own a photography business — to feel the joy of the freedom and artistic expression that your own business could bring. The journey to starting your own business starts here.

Why a Photography Business?

This is actually three questions, not just one. First, why choose photography? Why a business? Finally, why a photography business? Only you can answer these questions.

Everyone has different reasons for getting into the photography field, but making sure you have the right reasons will be key to making your business successful.

Money, not working for someone else, and the ability to work less are all good goals to have, but they are not good reasons on their own to start a new business.

Better goals would be:

- I have a passion for capturing moments in people's lives.

- I have a gift for photography.

- I see a need for photographers in a certain field or area.

There are many good reasons to start a photography business. Just make sure your reasons are more like the ones in the list and not like the ones in the preceding paragraph.

You can determine whether your reasons for starting a new business are right by considering some of the following questions.

Why Now?

Asking this question is not to imply that you should wait to start your business, or that you should have started your photography business 10 years ago and have missed your opportunity. Rather, this question is to get you to take a long look at why you want to open your own photography business, and why you think you are ready for it.

Answers could include: "I have the money to start this business now, and it has been a lifelong dream," or, "I have been taking pictures at my child's soccer games and other parents have been asking me for copies."

Regardless of your answer to this question, looking at the factors that made you choose to start your business can teach you about what you want out of your business and about what kind of business you want to have. That brings you to the next question.

What Kind of Photography Business?

Many books about starting a photography business assume you are going to start a portrait studio. But, you may not be a studio photographer, and you may have no intention of becoming a studio photographer. What if you photograph animals in the wild or in zoos? What if you do fine-art prints, sell the occasional greeting card, submit work to galleries, and sell images to publications? It is important to be aware of your interests and intentions so that you can decide in which area to specialize.

Journalistic and publication photography, which may include almost anything: news photos, sports, school functions, and even tragic events. *(Photo Courtesy of Diana De Rosa)*

Commercial photography, meaning photographers shoot for advertisements, magazine articles, or catalog companies. *(Photo Courtesy of Joy Augeson, Augeson Photography)*

Wedding photography, or taking family or senior portraits. *(Photo Courtesy of Argentina Leyva, Argentina Leyva Photography)*

Stock photography, meaning that images are sold through an agency, can feature any type of subject, and be taken anywhere. *(Photo Courtesy of PhotoSpin.com)*

At this point, you do not have to know exactly what type of photography you want to specialize in, but you should have a general idea. This will help you answer the following questions, which can point your business in the right direction.

Do You Have the Skills?

If you are reading this book, chances are you are a good photographer and have been told as much. So, when you ask yourself whether or not you have the skills to be a good photographer, it is about more than if you can physically take a picture or not.

The skills required for the different types of photography are quite different. To be a good portrait photographer, you need to know how to use the proper lighting to give your client the best look possible. The same skills are needed for a commercial photographer, and even come in to play in some aspects of wedding photography.

If you want to be a journalistic photographer, you may have to think quickly on your feet and be able to adjust to fluid situations to best capture the moment. Shooting sports, a house fire, or even a city council meeting means being able to watch the action while being able to respond to what is happening.

Taking stock photos and being the type of photographer that works with art galleries and sells unique photos for multiple uses requires an eye for the unusual. You have to be able to see things differently from the way ordinary people see them. Take photos from different angles and different points of view. Publications and companies will not purchase stock photos if they *look* like stock photos, or general photos used for any project and are generally lacking in creativity and do not have any character. These photographers sell their work because it has a point of view that most people cannot see.

To help you determine what skills and attributes you bring to your photography business, ask yourself these three questions:

1. Do I like to be in the middle of the action because I can think quickly on my feet?

2. Am I the type of person who likes to make sure things are just right and in their places?

3. Can I look at something and see objects in ways that others do not?

By answering these simple questions, you can start pointing yourself toward the type of business you want to operate. If you answered "yes" to question one, then photojournalism may be the path you choose. For question two, working as a portrait or studio photographer could be a good career path. Also for question two, those who answered "yes" may be good at taking stock photos. Question three is directed more at those photographers who work for galleries and create artistic photographs.

```
CASE STUDY: : ROCKING OUT
WITH PICTURES
Sarah Sladek
Limelight Generations
www.limelightgenerations.com
ssladek@limelightgenerations.com
(763) 773-5463
17289 77th Avenue North
Maple Grove, MN 55311
```

Sarah Sladek wanted to capture the emotion and value of the day. She was hosting a national conference, called RockStars@Work, which was held at the Minneapolis Convention Center, and she knew that having quality images of the event would be crucial for marketing to prospective attendees and sponsors. Turning to a professional photographer (Wendy Blomseth, InBeaute Photography) was a no-brainer.

During the conference, Blomseth was able to capture the emotion and feel of the day, taking pictures of keynote speakers, award recipients, and event attendees with a mix of posed and candid shots. The results were nothing short of amazing, Sladek said. Blomseth was even able to work around the dry location of the conference room to make the photos look intimate in spite of the room's high ceilings, which could have made the images appear vast and empty. By zooming in and taking pictures from angles, Blomseth was able to focus on the people, not the space.

"I really like working with Wendy because she was knowledgeable about event photography and knew how to tell the event story through photography," Sladek said. "[She] really added to the 'rock star' theme."

What is Your Background?

When you start looking at the type of photography business that may suit you best, looking at your background is a good idea. Personal experiences, hobbies, and likes and dislikes can help you pick the best type of photography for you. The more you know about the subjects you are photographing, the better the photographer you will be.

It is important to understand your subject area when you are a photographer so you get the best shots possible. For example, if you wanted to be a sports photojournalist, it is important to understand the game you are covering to know when the most dramatic moments might be and where the action might take place next. That is something an avid sports fan would know.

Another example would be a wedding photographer who knows weddings and different cultural customs. This photographer is ready to catch unexpected moments that arise with the different ceremonies, such as the breaking of the glass at a Jewish wedding.

However, not having a background in a particular subject area does not disqualify you from that type of photography. You may have been an accountant all your life and now want to photograph birds in the wild. But, just because you sat at a desk crunching numbers all day instead of being a bird expert does not mean you cannot excel as a bird photographer. What you should do is research birds and bird watching so you can be better prepared when you are out in the field.

CASE STUDY: SERVING YOUR CLIENTELE

Kathy Hagood
Kathy Hagood Photography
www.hagoodnews.com
khagood@juno.com

For the past five years, I have been a freelance photographer, shooting weddings, events, and on-location portraits for customers and providing photography for publications, including magazines, newspapers, and Web sites. I am also a freelance writer, but I make most of my income through photography. My interest in photography began in college, where I took a number of photography and art courses and was the photo editor of the student newspaper. My style is primarily photojournalistic, but I

l pictures. My target market is the customer who wants
phy, but wants to save money by handling his or her
own prints, which is why I include a CD of the pictures with my price.

Before turning pro, I was a reporter and photographer at various news-
papers, and then in public affairs at Kennedy Space Center. After about
five years at Kennedy Space Center, I came to the realization that I was
entrepreneurial and needed to run my own business. When I first went
out on my own, I thought I was going to have a public relations and
copywriting business, but my local newspaper asked me to do writing
and photography for them. I found myself doing more and more pho-
tography, and people started asking me to take their portraits and shoot
events, which I enjoyed.

It dawned on me that I needed to go after more photography business,
so I printed some business cards, created a Web site, and began pitch-
ing my photography abilities everywhere I went. I joined photography
associations, networked at the Chamber of Commerce, and showed my
portfolio to editors. Most of my success has come from networking, my
Web site, and having my work in local publications.

My photography and writing have appeared in the *Chicago Sun-Times,
AAA Going Places, Latitudes, Florida Travel & Lifestyles, The Orlando
Sentinel, Florida Today, SpaceCoast Living* magazine, *About.com*, and
other publications.

Defining Need for Your Photography

By now, you should have a general idea of the type of photography busi-
ness you want, whether it is one where you work in a studio, are out in the
field, or even a combination of both. The next step in properly defining
your photography business is to determine how much demand there is in
your community for your type of photography. Or, if your community will
allow you to do the kind of photography you want to do.

This is the first area you will deal with that is not completely in y... con-trol. Understanding where you live and what opportunities are available to you are key to running a successful business. Someone who lives in Colorado, for example, and wants to photograph mountains should be able to find plenty of good locations to shoot.

Selling your work is another matter. With the Internet, those selling pictures for stock or artistic purposes can work from anywhere, given their desired subject is in abundance. For portrait or studio workers, who tend to have a customer base limited to their immediate area, it is important to know who the competition is and what other outside factors, like the number of customers available and demand for your product, are involved.

If your town has 10,000 people and there are already five portrait studios, opening another studio may not be a smart move. Furthermore, if you want to open a children's portrait studio in a retirement community in Florida, do not expect much business because couples in a retirement community would not have young children.

Researching the need of your photography business can also help in determining the type of business you will have.

Who Will Your Clients Be?

At this point, you probably do not have a client list, and that is okay. Right now, the important thing is to nail down some specifics about the demographics of your customers:

- If you are shooting portraits, will you be taking photos of young children and families, executive portraits, or senior portraits?

- If you are shooting commercial work, will your customers primarily be businesses coming directly to you, or will you work through ad agencies?

- If you are doing stock photography, do you have contracts yet with any agencies? Have you contacted any agencies to see whether or not they can use work like yours?

This will help you begin to start thinking about your client base and the demand for your product. Answering these questions can also help you look at your area and how you will sell your product. These answers will be important when you start putting your business plan together.

Starting Your Business Plan

Now that you have begun to determine the type of photography business that is right for you, begin to put together your business plan. If you are still not certain what type of business you want to start, do not panic.

Writing a business plan is a good way to pinpoint the type of business you will operate. Each of the different aspects of photography has its upsides and drawbacks. It is a good idea to look at the different types of photography, focusing on the lifestyle and the pay each will bring when developing your business plan.

Wedding and studio photographers have the most consistent pay possibilities, but live the most sedentary lifestyles. Wedding photographers do not travel around much and usually work in their own area. Studio photographers, of course, are basically tied to their studios. But, they are certain to get paid for their work, and they tend to receive some of the money up front. They also have higher start-up costs and require more equipment

than the more free-roaming photographers. Still, these two are the most stable of the photography professions.

The more independent, yet less stable, types of photography are those that involve shooting for galleries and to sell stock photos. You take your photos hoping that you can sell them to the gallery — or at least get a showing — where others can purchase your art. So, when you take the shot, you do not know whether it will ever pay off. The same is true with stock photos. You take a photo hoping someone, somewhere has a need for it.

Somewhere in between these two extremes is photojournalism. Many photojournalists work as freelancers, meaning they are not permanently employed by one company and can work for various places. These types of photographers can travel around or stay in their own area, but do not have the assurance of steady work or pay. News events rarely take place in a certain amount of time where photojournalists can plan what they will make from week to week. But, the assurance of some income for the shots they take is more stability than those shooting for galleries or stock photos get.

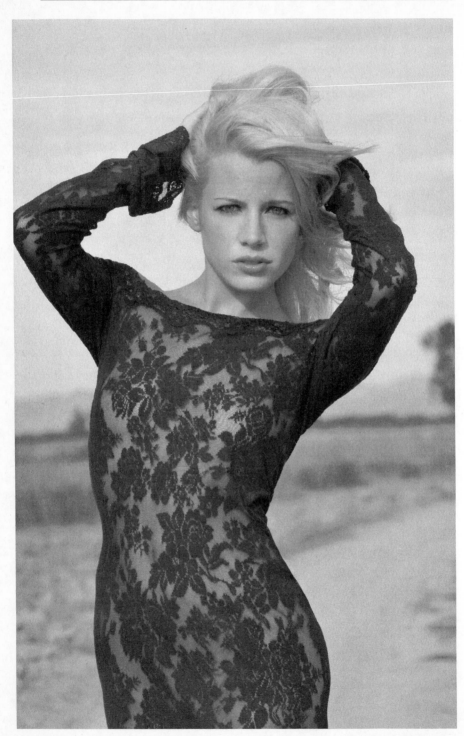

Photo provided by Bill Lemon

A business plan may be the most important document you ever create in terms of running your business, but do not let that scare you. A business plan is quite easy to put together. It will be the document you need to garner a loan, if you need one, and run your business. It will be your guide as you navigate the challenge of owning your own business. Without a business plan, any company or shop would be lost and have no direction.

The CD-ROM includes a sample business plan that shows you exactly what to include to help create a plan you can take to the bank to support a funding request. Creating your business plan will involve taking some of the answers to the questions in the previous chapters and putting them down in a well-thought-out document.

Deciding What Your Business Will Do

There are plenty of options in photography. You can be a comtographer working on assignments for advertising agencie
portraits in your own studio or on location. You can shoot ~
them to publications.

Now is the time to look over your answers from earlier in this book, take a long look at your vision of what you hope your business will be and do, and make some concrete decisions.

The first of those concrete decisions, and the first thing your business plan will need to address, is what, exactly, your business will do. If you are going to stick with the plan of a "general photographer" for now, you still need to know what you intend to primarily do, so you can plan not only your operations, but also your marketing. This can be a mission statement or just a direction of what kind of business you will run. Be specific. If you want to run a business that caters to senior portraits, that is what you should mention in your business plan.

Of course, the business plan is not set in stone. Say you decide you want to be a photojournalist because you love being in the middle of the action, have a knack for covering sports, and have experience in sports. But, after completing your business plan, you realize the work in that field is limited, and it may not make sense to pursue that field in your current situation. You can simply go back and review your options.

If it is the excitement you crave, maybe it is time to look at being a travel photographer, or a photojournalist who works the police and fire beat. The important thing is to make sure your business plan is as specific as possible so you can go back later and make changes in the area where it makes the most sense to do so.

Choosing Your Location

When starting any business, where that business is located can mean the difference between success and failure. That is also true in the world of photography, and, depending on the type of photography business you want to run, the location of your business may change. The bottom line is

that you need to have a space where you can comfortably work and be able to sell your product to clients.

To figure out what type of workspace is right for you, consider the following questions:

- Where will you work? If you are going to work out of your home, do you have a dedicated space you can use for business purposes? If not, where will you take photographs, do your processing (digital or film), and take care of business tasks?

- Where will you meet your clients to perform their work?

- Where will clients contact you?

- Will you have a business phone line, or will you use your home or cell phone?

- How will you separate your working environment from your home environment? This can be for those who are working out of their homes or for any freelance photographer, since the odd hours will probably require some work to be done at home.

- Will you be planning to take a tax deduction on your workspace, and do you know what that will require?

There are several questions to answer, but being specific is key in creating your business plan. This is your road map, and if you are going on vacation and have a map with only half the streets on it, you are not going to get very far.

After choosing what you are going to do, determining your location is the next most important part of your business plan. It can help you decide how much start-up capital you will need and what kind of items in your house

could possibly become a tax write off. Also, specifically writing down what you will do for your location can help you start thinking about ways to separate your personal life from your business life, which is crucial when running a business.

CASE STUDY: : ESTABLISH-ING YOURSELF IN THE BUSINESS WORLD

Rob Domaschuk
Rob Domaschuk Photography
Member, Professional Photographers of America (PPA)
Member, National Association of Photoshop Professionals (NAPP)
www.domaschuk.com
rob@robdomaschuk.com
630-631-3282

I've been running Rob Domaschuk Photography for more than three years. I am a fine-art photographer that adds the human form within the natural world as the primary element of the image. My work is commission-based, and I mainly shoot intimate portraits. In addition to my portraiture and commissioned work, I also operate Weddings by Rob. Because my main body of work includes artistic nudity, I've found that potential wedding photography clients can be turned off by that. To counter this, I started Weddings by Rob as an off-shoot of my main work. It has a completely different identity and unique content on its Web site, **www.weddingsbyrob.com**.

The intimate images I shoot are artistic in nature, designed to highlight and explore form, keeping in line with my approach of discovering the human form within the context of patterns, colors, and lines drawn by the man-made world.

I differentiate myself from my competitors by concentrating less on the body in front of my lens and more on helping each individual client understand the beauty within. As my tagline for this portion of my business goes, beauty is more than a dress size.

> I incorporate a professional makeup artist in each portraiture shoot and spend the first little while getting to know the person in front of my lens. Spending 10 to 15 minutes at the beginning of the session makes the remaining time much more productive and, most importantly, fun for the client.
>
> Each and every person I photograph is a unique individual with his or her own concerns, worries, angst, joys, and gifts. By learning these, I can provide my client with a finished product that reflects who they really are.

Describing Your Clientele

Like Rob in the previous case study, identifying who your clientele will be is important. By describing his clientele, he was able to avoid a mistake when he started his wedding photography business. By looking at the type of people he would be trying to attract to that business, he knew he needed to separate his two businesses with a name change. By accurately seeing who would be using his product, Rob was able to be successful in both stages of his photography business. That is why forming a complete clientele description is key to the success of the business.

At this point in preparing your business plan, you need to create a solid description of your clientele. Who is going to come to you for portraits? To whom are you going to sell your prints? For whom will you do commercial assignments?

You need a clear picture of who these people are, what they want, and where you will find them. This is the point where you may be going back to rewrite some of the parts of the business plan. If you have no clientele that match the descriptions already listed in your business plan, your business will not go far.

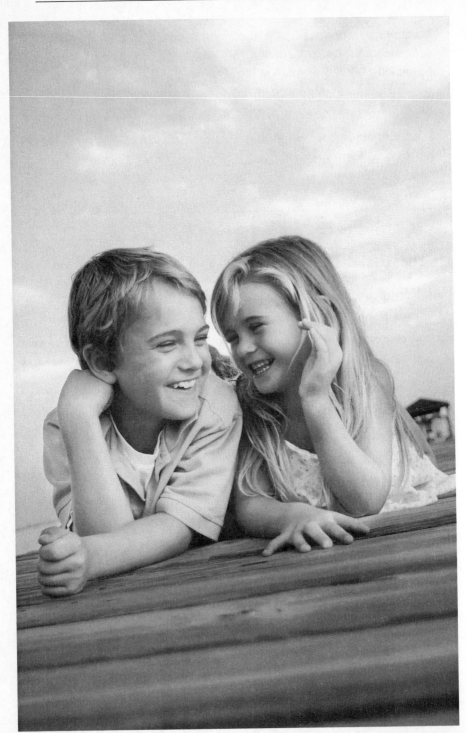

Photo provided by Trista Blouin

Furthermore, if your clientele fit into certain demographics, it can change the way you view the location of your business. For example, if you are doing executive portraits, you will have the type of client who will want to visit a professional-looking studio instead of having to find your house in some residential neighborhood. The same could be said if you plan on taking portraits of children — only in this case, it may be you who does not want screaming children running around your living room.

Creating a demographic profile of your clients is easy with the help of statistics you can garner from the Web. Demographic profiles of different areas are listed on many government Web sites and can give you keen insight as to the type of customer you could attract.

If you have not done market research and developed a demographic profile of your clients, this is the time to do so. You may want to talk to photographers in other geographic areas who do work similar to what you intend to do. Most of them will be happy to offer tips and suggestions if you call and ask to talk to them about their business. Insight from these photographers can be invaluable in discovering who and where your clients are. Understanding these two factors is crucial to your marketing.

Marketing

If you have been able to complete the above steps without having to change anything, the next two steps will be easy for you — they will not cause you to seriously rethink anything on which you have already decided.

No matter what type of photography you choose to do, where your business is located, or who your clients are, you are going to have to market to them. Marketing is the key to any successful business. *A complete marketing plan will be discussed in Chapter 7.*

However, you should have some idea now of what you are going to do. Based on your chosen field and your clientele, you need to decide how you are going to market yourself:

- Are you going to place an ad in the newspaper and the Yellow Pages, use direct mail, or set up a Web site?

- If you are a commercial photographer, are you going to call ad agencies and corporations, or send a brochure?

- If you shoot for publications, do you have any contacts at publications to whom you have already sent work?

Even word of mouth is a form of marketing. The point is, you have to get your name out there. For the first few years, you have to be a bit of a walking billboard. Make sure you mention your business and hand out business cards at every party or social gathering you attend. Even have them handy as you go through the drive-thru to give to the cashier. Do whatever it takes to get your name out there.

Cash Flow

If you have determined who your clients are, you probably have a good idea of where your income is going to come from. Where that income goes and how well it pays for your bills and operating costs is the focus of this section.

You need to look at your costs and what you expect to bring in each month and fill out a projected cash flow statement, so you can see how your expenses are going to relate to what you expect to make.

It is easy to get caught up in how much you will eventually be making, but many businesses have been killed by inadequate cash flow. It does not

matter how much money you will make next month if you cannot pay the rent this month.

The forms you need

The enclosed CD-ROM contains forms to help you determine some of the finer details of what it will take to start your business. These include:

- **Projected Cash Flow Statement**: This statement serves as a projection of cash coming in and going out, month by month, for the first year of business.

- **Fixed Costs Estimate**: This estimate looks at the fixed expenses on a month-by-month basis — for instance, rent, telephone, insurance, and fixed loan payments.

- **Variable Costs Estimate**: This estimate looks at the fluctuating costs of doing business — such as automobile fuel, office supplies, utilities, or equipment maintenance and repair — on a month-to-month basis.

- **Income Projection**: This projection addresses how much you expect to make in income per week, month, and year.

- **Pricing Structure Worksheet**: This worksheet helps you calculate how much it costs per day for you to be in business, and helps determine what you need to build into your fees, beyond fixed expenses, in order to make a profit.

CASE STUDY: LEARNING HOW TO HANDLE YOUR BUSINESS

Jan Stittleburg
JS PhotoFX Lilburn, GA
770-931-8170 www.jsphotofx.com
jan@jsphotofx.com

I have been behind the camera for more than 20 years, shooting everything from lace and jewelry to heavy metal welding fixtures. I went to school for mechanical design and spent eight years at the drafting board. JS PhotoFX was formed five years ago. Before this business, I spent about seven years learning prepress, computer graphics, and digital photography with a number of printing companies.

My main niche is residential architectural photography. My clients are remodelers and kitchen and interior designers who need photos for their Web sites, advertising, portfolio, contest entries, and for possible inclusion in magazine articles. I also do landscape photography for a landscaping company, as well as some product photography.

I shoot digital, which allows me to keep my costs in range of my clients' budgets. Using a mixture of strobe and tungsten light (which often uses brighter bulbs) can cause me problems in balancing the colors, but I find it gives a warmer and friendlier look to rooms.

I learned the basics about photography from commercial photographers Henry Peach and John Stoppel in Massachusetts. Ansel Adams, Robert Mapplethorpe, and Yousuf Karsh all influenced my style, as well.

Patience, determination, and focus are the three most important qualities a person in this business can have. Pride and financial mismanagement are the biggest career killers. There are a ton of great photographers out there, so no one can be called the best of the best, especially because photography is so subjective. Being able to manage business finances is equally important — especially keeping track of when taxes are due and how much you owe. Even if you are a fantastic photographer, if you cannot handle your money wisely, you will not be in business for long.

Photo provided by Sivan Grosman

What Form of Business?

Determining the structure of your business is another key decision you will need to make when putting together your business plan. The structure you choose will be determined by several factors, including how likely it is that you could be sued and what type of financing you will need to get your business off the ground.

To decide which type of photography business you will run (defined by your style of photography), consider these three points:

1. Your business structure impacts your ability to get business credit and obtain financial assistance; sole proprietorships, limited liability companies, and partnerships are less likely to qualify than corporations.

2. Your business structure determines how your business proceeds are taxed, and this can be crucial as your business grows, especially if you expand your business to more than one location with multiple employees.

3. Your business structure determines your level of liability, and may be important if your business grows.

Sole proprietorship

As a sole proprietor, you are the only owner of the business. You can choose to operate under your own name, or file a fictitious name under which to operate, doing business as (DBA) your chosen business' name.

You do not have to do any of the sometimes significant paperwork and record keeping that is required by corporations — aside from the necessary

bookkeeping to keep your business running smoothly and profitably. However, you also do not have the tax and legal protections of a corporation.

If you are planning to operate as a sole proprietor and plan to do business under another name, you will need to register a fictitious name (DBA) with your county clerk. This form tends to be quite simple, and DBAs are fairly inexpensive. The advantage of the sole proprietorship or operating as a DBA is the ease of running the business. There is much less work in terms of paperwork and regulations. The disadvantage is lack of personal protection if someone comes after the assets of your company or if you default on loans. For example, if you cannot pay back your business loan, the bank cannot come after your privately owned home.

Partnership

A partnership is essentially the same as a sole proprietorship, except that the "proprietors" are two or more people who have signed partnership papers to outline their individual and joint responsibilities to the company. A partnership is not incorporated, or formed into a legal business, and is owned jointly by the partners in shares outlined in the partnership agreement.

Of course, you should be cautious about forming a business partnership, even with a close friend, because partnerships can dissolve and there can be nasty disagreements. However, if you wish to form a partnership, give serious thought to whether you should form a simple partnership where you just agree to work together, or incorporate together, where your company is legally binding and responsibility for that company falls on both parties.

You do not need a business partnership in order to operate a business with your spouse; you are a sole proprietorship as a couple and do not have to sign further partnership agreements. Because you are married, you both own the business. If this is a major concern, however, you may want to call

your lawyer to confirm that the arrangement will work the way you want it to for both spouses.

Limited liability company

Limited liability companies (LLCs) have become more popular in recent years because of their ease of use and the protection of personal property from creditors they give business owners.

LLCs require less paperwork than corporations, but more than sole proprietorships or partnerships. LLC rules also differ from location to location in terms of taxes and how the business is viewed by the taxing entity.

If your photography business includes people coming to your studio, or if you need a business loan, a LLC may be a good option for you.

Most new businesses will form under a LLC due to the simplicity of the business style and the protection it provides individuals.

Corporations

One of the main reasons you may wish to incorporate is so that you appear larger and more stable when you seek business credit from suppliers and pursue financing. Sole proprietorships and partnerships may have a more difficult time securing financing than a corporation.

Another important consideration, and the most important in some cases, is that your personal assets are safe from the corporation's creditors, unless you have signed a personal guarantee. Sole proprietors and general partners in a partnership are personally liable for all debts and obligations of the business, including loans (a financial contract used for lending money), accounts payable (an accounting entry that shows an obligation to pay off short-term debt), defective products (products that need to be recalled or

that do not serve their function properly), and leases (contracts offering the right to use property). *See Chapter 11 for more information about these business obligations.*

You may find that forming an S corporation or limited liability company is easier than you expect and a good idea to protect you from financial liability while making your company look larger and more impressive.

Which Business Structure is Right for You?

You will have to spend some time considering your options and learning as much as possible about each of the previous options. Primarily, you should make your decision based on what you will be doing in your business and what you feel you need.

Do not rush to incorporate if you feel you would be better off as a sole proprietor, but by the same token, do not immediately decide to remain unincorporated without first investigating the benefits. Use the following business entity chart to help you decide which legal structure will best suit your needs.

If you are unsure about the right path for your business, bring your business plan to an accountant and have them explain the benefits of each business structure as it pertains to your specific needs. Accountant consulting fees can run more than $100, but in the long run, it may save you from making a poor business choice and opening yourself up for litigation, or being sued, down the line.

Legal Entity	Costs involved	Number of Owners
Sole Proprietorship	Local fees assessed for registering business; generally between $25 and $100	One
Partnership	Local fees assessed for registering business; generally between $25 and $100	Two or more
LLC	Filing fees for articles of incorporation; generally between $100 and $800, depending on the state	One or more
Corporation	Varies with each state, can range from $100 to $500	One or more; must designate directors and officers

Paperwork	Tax implications	Liability issues
Local licenses and registrations; assumed name registration	Owner is responsible for all personal and business taxes	Owner is personally liable for all financial and legal transactions
Partnership agreement	Business income passes through to partners and is taxed at the individual level only	Partners are personally liable for all financial and legal transactions, including those of the other partners
Articles of organization; operating agreement	Business income passes through to owners and is taxed at the individual level only	Owners are protected from liability; company carries all liability regarding financial and legal transactions
Articles of incorporation to be filed with state; quarterly and annual report requirements; annual meeting reports	Corporation is taxed as a legal entity; income earned from business is taxed at individual level	Owners are protected from liability; company carries all liability regarding financial and legal transactions

Putting It All Together

After investigating your options and figuring out exactly what your needs are, you should have your business plan ready to go. It may have taken a few tries, and you may have had to go back and rethink your business or business structure, but all that is done now and it is time to get on to actually starting your business.

No time can be more exhilarating and stressful simultaneously, but once you have finished your business plan, you can start setting up your business. Of course, there will be many things you will need to consider to make this step focus less about butterflies in your stomach and more about butterflies in your viewfinder.

Photo provided by Jason Henry

Chapter 4

Determining Start-Up Equipment and Costs

Now that you have your road map to take your business where you want it to go, you can start to run your business. Of course, how you start can have much to do with where you end up. You need to build the foundations of your business. Just like a house cannot stand without a solid foundation, neither can your business.

When starting a photography business, most of your initial expense will come from your equipment, granted you are not buying studio space. As in any profession, having the right equipment can make a big difference in your product or service, in this case, the photography. It may be worth spending more money up front to have newer technology that is more user-friendly. It could allow you to do more with your photos and make your business look more professional.

Start-Up Cost Estimate Worksheet

The start-up cost estimate worksheet on the CD-ROM will help you keep track of all your start-up costs. You may have additional costs that are not listed, depending on the exact requirements of your business. There is room on the worksheet to add these costs. Once you have filled out the worksheet

and determined your costs, you can use an online start-up cost calculator (**www.bplans.com/business_calculators/startup_costs_calculator.cfm**).

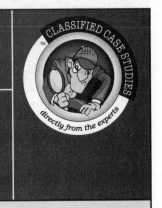

CASE STUDY: STARTING A BUSINESS AND AVOIDING DEBT

Nathan and Karen Bridges, owners and photographers
Beyond the Well Photography
309-287-5592
beyondthewell@gmail.com
www.beyondthewell.com/weddings

We are a husband-wife photography team specializing in wedding photojournalism. Our strengths and weaknesses seem to complement each other perfectly.

I (Karen) handle the administrative duties, such as marketing, answering e-mails, phone calls, keeping organized, and booking appointments. Nate color-corrects the photos for consistency and designs the Web site.

Occasionally, we do on-location side projects for actors, musicians, and families, but our main specialization is weddings. We travel throughout the Midwest and worldwide, if requested. We have five photography packages ranging from $1,799 to $3,899, based on time and additional add-on products, such as albums and engagement photos.

We formed our business in January 2006, and have been successful since the beginning. That first year, we did about 25 weddings together, and in our third year, we had 35 weddings — probably the maximum workload we will take on. When it comes to balancing work with life, we choose not to photograph more than one or two weddings in January or February.

Before we became pro, we were college students. Officially, I have known no other career than that of a professional photographer and owning my own business. This is true for Nate, as well. We used amateur DSLR cameras to begin with. After several paid weddings, we were able to upgrade to professional bodies.

It is important for new photographers to realize that they do not need to put themselves in debt to start up. Consider renting lenses and cameras in a pinch if you cannot afford the price tag right away. We occasionally rent cameras just to try them out — this helps us decide if it is worth paying out a few thousand dollars for a particular lens before actually making the commitment.

Equipment Costs

You may already have some of your own equipment. If so, now would be a good time to review what you have. Is your camera out of date? Is it capable of giving customers the level of quality they will need? Do you have the right accessories — tripods, computers, extra lenses — to properly do your job?

Again, spending a little more money here may pay off in the end. That does not mean you have to spend a fortune and go crazy buying all the newest equipment. Shop around to see if you can buy good used equipment, and estimate spending a little more than you would expect for equipment.

Talk with competitors or link up with others who run similar businesses on the Internet to see if there are any items they use that most people might not think of. Photographers can be very resourceful, and it is unusual for one not to have a few tricks of the trade.

Digital or Film?

This is one of the more contested questions in photography. On one side, you have the traditionalists who swear by their film cameras, and on the other side are those who enjoy the cost savings and user-friendliness of digital. The choice is completely yours, but there are advantages and disadvantages either way.

Film offers high quality because you can choose the type of film you use based on your specific project needs. Plus, if you already have film equipment, you may not want to upgrade to digital. On the other hand, film is much more expensive to shoot and process and requires either a good deal of expertise and equipment or an outside lab to develop and print your film.

Digital, however, has good quality and can produce amazing prints. It is also much cheaper to use. Once you learn to use a digital darkroom, which is a high-tech printer and software that can produce high quality photos, you can do much of the processing and printing yourself. In a sense, a digital darkroom allows for the same artistic features as a traditional darkroom, just on your computer. A digital darkroom can also include a film scanner, so if you are shooting film, you can also make your own photos. Digital equipment is more expensive, and you can pay quite a bit for good equipment, but most photographers think of digital as the true photographic future.

If cost is an issue, but you are leaning toward digital, you might consider buying fewer lenses and other accessories and investing in a good digital camera, such as Nikon™, Canon®, or Sony®. You will appreciate being able to upgrade the system you have later, and you will most likely be glad you went digital when you started your business.

Many people think they might not be comfortable shooting digital after shooting film for years. This is certainly an issue. Photographers who shoot film for many years can be a little intimidated by digital at first. However, it is much easier to reproduce exactly what you saw by using the color and tone adjustments in Adobe® Photoshop® than it is with film.

On the other hand, digital cameras can give new photographers a false sense of security. In some situations, like if the camera malfunctions or gets the wrong exposure than what was expected, you may have to revert back

to using basic techniques, such as manual exposure or bracket shooting. That can be harder to do on some digital cameras, due to their internal settings on how they capture images. You may want to consider shooting with a 35mm film camera in manual mode until you get an understanding of the basics of aperture and shutter speed and how they relate to each other, because it is easier to do on a film camera. But, those instances are few and far between and from a cost perspective, digital far outweighs film.

In the end, before launching your business, you will have to decide for yourself whether to go digital or stick with film. If you think you will probably switch to digital at some point, you should go ahead and run parallel platforms, or use both film and digital, or make the switch while you are setting up your business. It will be much harder to overhaul your systems once your business gets rolling.

CASE STUDY: ADAPTING TO CHANGING TIMES

Mindy Schwartz, Owner, Project Manager for Full Circle Admin Services
www.fullcircle-adminservices.blogspot.com
mssphotography@aol.com
615-330-1305

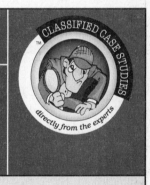

I'm originally from the New York and Connecticut area, and currently live in Nashville. I have a company that unites different freelancers with different skills to offer customers help with various projects. I am involved in marketing, writing, and blogging projects that I never knew I had the talent to do before.

I have been in business for more than 20 years, but this particular business concept is new. Prior to becoming a professional photographer, I worked for a variety of businesses in corporate America. After being laid off, I decided to start my own business. I had just moved to a new state when it happened, so I did not know many people and had time to explore. I just went around, started taking photographs, then printing and

matting them. My friends encouraged me, and I knew that they would be my harshest critics. I began going to local restaurants and bars, showing my work to perfect strangers. They seemed to like what I was doing because I would sell most, if not all, of my work.

In the beginning, I only took photos of flowers, landscapes, and anything that someone might want to hang on their walls. I began getting requests to photograph weddings and social events and, after a few functions, began receiving word-of-mouth referrals. Then, another avenue came up — my first experience with handling product photography. I have since put most of my focus on product shots for reviews, catalogs, and Web sites. I also am involved with many stock photography sites where I can upload photographs for sale.

Times have changed since I began my business. Photography is much easier than it used to be, thanks to digital. I just shoot a photo and have the ability to show the customer the photo right away to assure them that what I have captured is what they are looking for. Then, I upload the photos and my work is done. Gone are the days of waiting for film to be developed, showing customers photos, and having to make prints.

Going digital

If you decide you want to go digital, or if you already have mostly digital equipment, you will want to evaluate the equipment you have, and then determine what you need and what you can do without for the time being.

For instance, you might think that you must have the absolute best digital SLR camera and all the lenses to get started, but you can start with a decent, less expensive camera and move up. You will want to look at your equipment with an eye to upgrading or replacing certain things. One way to upgrade your overall system is to find pieces that you may be able to sell, particularly old film equipment, and use that money to buy new equipment. When you evaluate your equipment, you should be honest, but realistic. If it works and you can use it, keep it. Do not replace good

gear on a whim. You will have to make some tough calls, and there may be something you would rather have, but remember that times may be a little lean in the first few months, and you should be careful about buying gear.

That being said, if you buy new gear, buy the best quality that you can afford. Make sure you need it, of course, but do not buy junk.

Cameras

When you are considering buying new gear, you may wonder what types of cameras you should have and if you have the right cameras, or enough. The name brand of the camera is completely up to you. Brand loyalty is something that is unique to each photographer. If you have the chance, test out the different brands to see which one you like the best.

The major brand names out there are Nikon and Canon, but companies like Sony, Olympus®, and Pentax™ also make popular professional-grade cameras. When looking at cameras, it is best to determine what you will need to accomplish your work. Do you need a camera that is lighter and easier to carry because you will be on the go or out in the wilderness, or can you sacrifice weight for other features because your camera will be in a studio setting?

When you ask yourself these questions, you can start to determine the kind of camera that would be best suited for you. You will find that all the name brands previously mentioned will have a camera that meets your needs. Therefore, the real question to answer when deciding which name brand camera to use is how it feels in your hands.

If you do not have a favorite, or have not used an SLR before, you probably will become loyal to the first one you buy as you get used to shooting with it and get used to the feel of the camera.

The main thing you should do, though, is get out and use your camera after you first purchase it. Take that first weekend and shoot away. Get different angles, motion shots, still shots — anything you can think of that you might use the camera for. You have to get comfortable with your camera, and the only way to do that is to use it.

Lenses

Buying lenses is fun. But, make sure you buy the lenses you need. Think about what you will be doing, and buy the lenses that will do that. Your camera lens is your camera's eye — it adjusts, focuses, and zooms on the subject you are shooting. If you have any doubt about a particular kind of lens, wait until you say to yourself at least twice a week, "I wish I had that lens."

There are several types of lenses to choose from. Zoom and telephoto lenses are important for photojournalism and some types of stock photo shooting. Wide angle and filtered lenses are more used in portrait and gallery shooting.

When you do buy lenses, always buy the best quality. This is essential, and if that means waiting on a particular lens, it is better to wait than to buy a poor lens. Buy the best glass and the fastest lenses you can afford.

Lights

Before you buy lights for your studio, it is essential that you learn the basics of lighting. Entire books have been written on lighting alone, and reading a few of these would be helpful.

Carefully evaluate what you will do with your lighting and what you need to achieve those effects. It is easy to spend considerable money on lighting, and you want to make sure you have the equipment you need. Portrait

photographers can use a variety of light sources to achieve the optimum brightness and coloring on their subjects. You may want to buy lighting "kits," which can save a great deal of money. For other photographers, especially photojournalists, getting the right kind of flash will be important. For news photography, seldom do things happen at a pace where a flash can go off, have time to recharge, and then flash again. Purchasing a rapid flash, which can flash repeatedly, can be a great investment.

Buy less than you think you need, and then add lights and accessories as you consistently find yourself saying, "I wish I had..." That is the best way to know what you truly need.

Make sure you buy equipment that fits the way you work, which may not necessarily be the way the guy at the camera store works. Buy what you need the most, and upgrade as necessary.

Tripod

Perhaps one of the biggest mistakes many photographers make when they are getting started is buying a cheap tripod or no tripod at all. These three-legged objects are used to balance your camera, and can make a huge difference in your work, especially when you are shooting nature shots or other stills. If you are shooting fast action, like sports or other journalism photos, you could get away without having a tripod. However, for studio and commercial work, a tripod is essential.

It is possible to get a good tripod that will serve you well for a long time without spending a thousand dollars, but you probably cannot get that tripod at your local discount store. Those tripods are not sturdy or stable enough for professional work.

When you are looking at a tripod, you need stability, ease of adjustment, and something that is lightweight. You will carry your tripod frequently, so

keep in mind that the SLIK™ is heavy, even if it is the most stable tripod you have ever used.

Before you buy a tripod, try out the various types available at your camera store. One type may feel more comfortable to you than another, and that is what you should choose. Try out different sizes, from mini to compact to full-sized, to see which best fits your needs.

Tripods vary greatly in price, so shop around to find what you need in a price you can afford. But, when you can afford the best, you should invest in the absolute best tripod. You will never regret buying a good tripod.

Backgrounds

You are only going to need backgrounds, or backdrops, if you are a portrait photographer. You may want to invest in both backdrops, which have a picture on them and are fairly permanent, and seamless paper, which comes on a roll, hangs behind your subject, and drapes to the floor to act as a backdrop.

An example of a backdrop would be a screen with a painting of a bookshelf on it to simulate your subject sitting in a library. Some senior photos have backdrops like that; you have no doubt seen many others.

You can find portrait studio supplies at many of the major photography mail order houses, and your local camera shop can typically order anything you want. If you have questions about what you may want or need, you might check with other portrait photographers, especially those who are not in your area.

Darkroom

The first question to ask yourself about a darkroom is, "Do I need a one?" If you are shooting black-and-white film, you may need a darkroom, which is a room that can be made completely dark to allow light to be processed while developing film. The time and money that go into creating one might be a good investment for this purpose.

This is especially true if you are shooting fine-art photos. Developing and hand-printing your own film adds a special touch to fine-art prints that is hard to duplicate. If you are shooting color film, it would likely be wise to send your film to a lab; developing color is difficult and expensive to do yourself, and there are many good color labs that can produce excellent prints.

If you decide you want or need a darkroom, you will also need to consider where to put it. A bathroom with a blackout curtain inside the door can make a good part-time darkroom; this may be a better choice than trying to set up a full-time darkroom in an unused, larger closet or utility shed.

Rent

If you are renting a storefront, you will need to come up with a deposit on the lease, as well as the first and last months' worth of rent. It is also a good idea to make sure you have at least six months' rent stashed away as part of your start-up costs so you know you can continue to operate in that location while you get established. Having the money set aside to pay for crucial things, like rent, may seem like a frivolous view of start-up costs, but these are critical issues that need to be considered.

Photo printing and storing supplies

If you shoot with film, you will need to have enough film to get started. A good rule of thumb is that you will have one usable photograph for every 10 you take, so the number of photos you need to give a client from a certain photo shoot will need to be multiplied by 10 to find out how many frames and rolls of film you will need. You will need paper and ink if you make your prints in-house. If you sell portraits, you will need a selection of sample mats and frames.

If you sell fine-art prints, you will need to be able to mat and frame your work for galleries. If you do commercial work, you will need to decide how you are going to deliver your assignments and make sure you have the supplies you need, such as blank CDs or DVDs.

It may be a good idea to invest in a laptop if you are going to be going to galleries or people's houses to sell your photos or services. Being able to show your work on a computer will not only save you money in paper and prints, but will also show that your business is up-to-date with technology issues, which could be a plus to potential clients.

Computer Equipment for Your Photography Business

Computers are essential in the business world, especially for those using digital cameras. Through computer technology, you can store shots, e-mail proofs to customers, and market yourself through a Web site.

But, computers do more than that for the business owner. Software, such as Quicken®, can help you organize your company's finances. You can also keep track of marketing trends through the use of online sites and store invoices.

Monitors and computers

The first thing to look at, as far as computer equipment for photography, is the machine itself.

If you are planning to buy a new computer for your photography work, almost any computer you find at the local computer store would be good enough. You may need to look at how much RAM, or memory, your computer has. This is the operating memory, not the storage where you put your photos.

The hard drive is where you will store your photos. You should have at least 200 gigabytes of hard drive and a second hard drive to back up photos. If you do not understand any of the preceding paragraphs, do not worry. Just go over to the local computer store, explain what you need, and ask for advice. Do this at two stores, if possible, and do not make any immediate purchases. However, advice from computer sales associates will often be right on track.

There is a debate among photographers about whether CRT monitors (the bulky ones, not the flat panels) or LCD panels (the flat monitors) are better. If you have a preference, stick with what you like. If not, you might note that you can get quite a bit more room on your screen with an LCD for the same amount of money and get a higher-quality picture. You need to back up your hard drive often. Back-up is absolutely crucial. You can back up your photography files on an external hard drive, which plugs into your computer, or by using a back-up program if one comes with your computer. You can also use CD-ROMs or flash drives to store your work (*for more information about this, see Chapter15*).

Image processing software

For digital photographs, image processing software is a must. These programs will help you edit your photos as you import them into your computer. The different features of these programs allow you to add filters, change colors, eliminate or add blur, and add other special effects to create the desired image for your clients.

While nothing else is as good as Adobe® Photoshop® CS5, the new version of Paint Shop Pro®, Paint Shop Pro® Photo X2 (PSP Photo X2), is quite impressive. At about one-sixth the cost of the original Paint Shop Pro, it is a good choice if you cannot afford Photoshop or if you are not planning to do too much editing to your photos.

Adobe® Bridge®, which comes with Photoshop CS2 and CS3, is a wonderful tool that helps you preview your photos, move them around, and choose the ones you want to process without opening them all. PSP Photo X2 has a similar feature.

You may want to invest in media management software, plug-ins for Photoshop, and other accessory software, but if you have a good photo editing program and a way to preview and manage your photos, you should have all you need. Plug-ins, however, are useful features, as they are additions to the Photoshop software that allow you to perform certain functions and photo edits that you could not do with just Photoshop alone.

If you would like to have Photoshop, but cannot afford CS5, look into buying a used, older version. Make sure you get the original CD and serial number. This can be a good way to get a taste of Photoshop, and qualifies you for upgrade pricing on future versions.

CASE STUDY: THE ART OF TECHNOLOGY

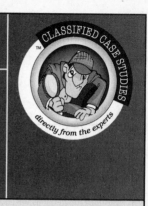

Pip Bloomfield
Pip Bloomfield Photographic Art
949 Euclid Street, Suite 6
Santa Monica, CA 90403
310-968-2406
www.pipbloomfield.com
pip@pipbloomfield.com

Pip Bloomfield's photography business was not planned. It started when a friend saw some of Bloomfield's photos, liked them, and wanted to buy one. Then, a friend of hers saw the one she bought and decided to look at the portfolio — something that Bloomfield did not have at the time. It all started from there.

Bloomfield started primarily shooting flowers and transferring them to a canvas, or produced giclées, a high-resolution reproduction done on a special large printer and on high-quality fine-art paper. "In my digital-to-canvas method, I essentially produce photographic paintings that bloom in front of your eyes," Bloomfield said. "Technology through photography has allowed me to enhance the subtle, and sometimes unknown, details within the beauty of my flowers."

Bloomfield combines simple, highly graphic images that synthesize painterly textures with photographic realism. The work is entirely hand finished and custom-sized. Some of Bloomfield's accolades include two custom chairs upholstered in painterly floral fabric at the Glabman Home, participation in the Art of Vision at the Zimmer Children's Museum, five installations at Wolfgang Puck's Spago restaurant in Beverly Hills, and 12 four-foot custom works for Steve Wynn for the Wynn Las Vegas Hotel, on permanent display. In addition, Bloomfield's work has been featured in *Traditional Home*, *House Beautiful*, *InStyle Home*, *Wallpaper*, and *Home* magazines.

Bloomfield recommends incorporating technology into photography to all photographers as a way to come up with a fresh approach. For new professionals, Bloomfield advises taking as many shots as possible. "Keep your camera with you at all times," Bloomfield said. "Crop and play with your photos, because it is both fun and addicting."

Photo printer

When you are considering buying a photo printer, you need to consider what you want to print. There is a big difference between printing greeting cards on matte paper and printing large, glossy photos. What you want to print will largely determine the type of printer you need.

Thus, the size of the print is important in deciding what kind of printer you will purchase. Many desktop printers can print up to 13 inches by 19 inches; anything larger may require a larger format printer. You will also want to consider the quality and life span of the prints. If you are selling prints, you need to use archival papers and inks. Archival paper and inks will not fade like regular ink, but they cost more. These can drive up the cost of your prints, but are the only way to go if you want to sell prints.

Once you determine what you want to print and how large to print it, consider how often you will want to print and how many prints you want to make. This will help you decide what size printer you will need, and therefore how much money you will need to spend. You do not want to buy a printer that has all the bells and whistles when all you need are the bells. In other words, there is no reason for you to buy a printer that will print 17 x 24 prints if you will never print out anything in 17 x 24.

Take all this information to a dealer that sells photo printers, such as your camera store, and ask for some recommendations. Then, do some research on your own and choose the printer that best fits your needs.

Scanner

Scanners are computerized devices that have the ability to turn slides or printed images into digital images. The most common type of scanner used in photography is a desktop, or flatbed scanner. Flatbed scanners allow the

item you want to scan to be laid on a flat glass window. This keeps the item in a stable position while the digital image is being captured.

Having a scanner will provide you with additional opportunities to work with photos. In addition to using a scanner to work with images you have taken, you can also use a scanner to make a copy of a photo from someone else. This is particularly useful if you want to add artistic options, such as color correction and photo restoration, to your list of professional services.

Like all computerized technology, scanners have increased in quality over the past few years. Buying the newest, most expensive scanner you can afford will ensure years of enjoyment. Nevertheless, you should be able to get a decent flatbed for less than $250. Make sure you choose a model with at least a 36-bit color depth, which helps to determine the range of colors that you will be able to see. The higher the color-depth, the broader the range. Also, select a dots per inch (dpi) resolution range of somewhere from 2400 dpi up to 4800 dpi if you plan on scanning photographs or other color graphics for printing. The higher the dpi, the more detail you will have. When you print, you want to have the highest quality possible so that your final image is as clear as it can be.

The software that accompanies a high-resolution scanner will also allow you to make adjustments in order to capture low-resolution images for Internet use and for creating thumbnail images, a small graphic of the file on your computer, the images used by most Web sites.

Before you go shopping for a scanner, make sure you measure the space where the scanner will be housed in your office. Also, measure the distance between where the scanner will be placed and the closest power outlet. Be sure that your computer also has an open port for connecting the scanner, and measure the distance between the port and where the scanner will be placed. Getting a new piece of equipment and putting it

in place, only to find that the power cable and connection cords are too short, can be frustrating.

Your office computer

You may want to have a separate computer for running your office, or you may find that one computer works just fine, especially if you are doing all the work. The computer you are using for your photography should work fine for running your business. The office productivity programs and accounting software you will be running are far less robust than the software you will need for processing photos, and most computers that still function well will run those programs. If you are able to use Windows® XP or a later version, your computer will serve fine for running office programs. For Mac® users, Mac OS X can be used with Microsoft Office®, join PC networks, and run Windows.

If you do not have a computer you can use in your office, or if you want to buy a new, office-only computer, go to the local computer store and purchase a computer. If you are not in a hurry, spend a few weeks checking the Sunday sale papers and seeing what the various stores offer on a regular basis. When you are ready to buy, if the store you want to buy from does not have a good deal, take the sale paper to that store and ask them what they can do. Many computer and office supply stores will give you a better deal if you can show a competing ad. This way, you can try to get a computer that suits your office and photography needs at a lower price.

If you have two or more computers, particularly if you are setting up a home office, you should consider setting up a small office and home network, which is a local area network used for communication between all of your electronic office devices. This used to be quite complicated and involved plenty of cables and effort, but with innovations in wireless networking, creating a network has gotten much easier and faster. Instructions for setting up your home network on a PC can be found at **www.**

microsoft.com/windowsxp/using/networking/setup/default.mspx. To learn how to network your Mac to a PC, visit **http://support.apple.com/ kb/HT2959**. To learn how to share your files, or network, with Macs only, visit **http://support.apple.com/kb/HT1549**.

To set up your home network, you will need:

- Internet access (with a wireless router)
- Any installation CDs that you used on your office computer
- A name for your network
- Security software (anti-virus programs)

Office printer

If you are going to have a photo printer for doing your prints, you may want to consider getting a separate office printer. While color laser printers are more expensive to purchase and run, they create beautiful printouts.

However, if you need a scanner, copier, and fax machine in addition to a printer, give some consideration to the multifunctional printers on the market. While none of them have the quality you would need for producing art prints, they are good for general office use and are quite affordable. This may also be a good option if you are not going to be printing your own prints at home. If you are paying to have your prints done elsewhere, you can spend less money on the quality of your printer and more money on adding additional features, like the scanner, copier, and fax applications.

You may find a good deal by shopping around for the latest sales at computer and discount stores. Demo printers get heavy use in the store and are prone to problems. That is not true of every printer.

Office software

Known as a productivity suite or office suite, office software packages include a word processor, a spreadsheet, slideshow or presentation software, and sometimes other programs, such as desktop publishing or database software.

The most well-known of these packages is Microsoft Office, which dominates the market. If you have a copy of Microsoft Office, even an older one, it will be helpful for managing your office.

If you are on Windows and cannot afford or do not want to use Microsoft Office, you can use OpenOffice.org, which can be downloaded for free at **www.openoffice.org**. The software is quite comparable with Microsoft Office, as it includes programs for word processing, spreadsheets, presentations, and graphics.

If you are planning to buy office software, think about what you need. You cannot get by with anything less than word processing, spreadsheet, and presentation software.

You may also need a desktop publishing software program, which allows you to make things like cards, fliers, calendars, and brochures. Microsoft offers Publisher, and a company called Serif makes older versions of their software available for free on their site (**www.freeserifsoftware.com**).

You will need a Web browser, a program that decodes and displays the coding of the World Wide Web, allowing users to access information. If you are on Windows, you likely use Internet Explorer™, which should perform all of the Web services you will need. Mozilla Firefox® is good, too, and Mac users often use Safari® as a Web browser. Some browsers come on your computer, but others can be downloaded from the Internet either for free or for a small fee.

If you are planning to create your own Web site, you will need site design software and a way to upload your site. If you know what you are doing in this area, you likely have a favorite software program. If you are new to designing Web sites, you might want to try a basic program, like Microsoft's Front Page® or iBuilt.

Other Start-Up Expenses

Marketing expenses

You will spend more time thinking about this once you write your marketing plan, but you should have some basic idea of what you are going to do and how much it will cost. This usually comes down to figuring out how much money you have left or are willing to spend at this point.

Your initial marketing expenses are a start-up cost, but your ongoing marketing expenses will also be a variable cost each month. Marketing is not something you do once; you will be marketing your business every day. *For more information about your marketing plan and determining your marketing costs, see Chapter 7.*

Office supplies

This seems like a small, fairly trivial start-up expense, until you realize that you have run out of paper for the office printer and your petty cash and start-up funds are both exhausted.

Every business needs pens, pencils, paper clips, folders, filing cabinets, desks, and phones. Photography businesses are no different. These essentials will make up a small portion of your start-up costs, but having them is a must.

Your Salary

Save the best for last, but you will need to make sure you get paid. If you have money saved to live on, you can get by if your business does not make money right away.

But, if you are going to the bank to get a business loan, your salary is something you want to take into consideration, since your company might not turn a profit right away. Of course, do not give yourself the salary of a Fortune 500 CEO, but make sure you can at least pay your bills.

Using Your Start-Up Costs to Determine a Financing Plan

Now that you know how much money you will need on the budget-planning sheet on the CD-ROM, you need to be able to secure the capital to start your business. There are several ways to get this capital, but the most common way is through small business loans. Most agreements are fairly typical. Many business owners understand that insufficient financing can be a blow to a new business. You need to look into the various types of financing and decide which one is best for you.

Equity funds

Equity is capital that is at risk. This money is risked with no guarantee of a return. These are the most common types of equity financing techniques:

- **Personal equity**. This is funded entirely with personal equity or a combination of personal equity, lease, and debt financing.

- **Partnerships**. Partners can invest together. These are active or silent partners.

- **Corporations**. These raise capital by selling stock to public or private investors.

- **Venture capital**. Professional investors or investment companies can be venture capitalists that want long-term financial gain. They might not be interested in the net profits of a new establishment.

Borrowing money

Many people believe that small business owners have a hard time borrowing money. That is not necessarily true. Banks are in business to lend money, but you need to prove that you are a good risk. One way to do this is by having a complete, accurate business plan like the one you have already created to get your business off the ground.

Lenders are most concerned with your ability to repay the loan. They will request a copy of your credit report. This information will be used with your business plan to evaluate your ability to repay the loan.

These are some of the issues lenders consider:

- How much of your own savings or equity are you investing in the business? Banks rarely loan 100 percent of the money you need, so you will have to include some of your own money.

- How does your credit look? Do you have a steady work history? How many letters of recommendation from friends, clients, and former colleagues can you produce? These are important factors.

- Does your business plan show that you understand what is involved in operating a successful photography business?

- Will the business have sufficient cash flow to make the monthly payments?

Financing options

If your answer to the last question brought you to a harsh reality, you may want to look into your options for financing to be able to cover your costs. As you could see from the previous information in this chapter about start-up costs and equipment, you are going to have some hefty fees initially. Remember that it may take a few months of operating to be able to square away those payments. To alleviate stress, try some of the following methods for financing when starting your business:

SBA Financial Programs: The Small Business Administration (SBA) has various financing options for small businesses, like guaranteed loan programs, bonding programs, and venture capital programs. In a guaranteed loan program, small business owners can receive financing for a variety of business purposes. The loans are not given directly by the SBA, but are supported by the organization. Likewise, surety bonding programs are offered through the SBA, where the SBA ensures that a contract is made and met between a business owner and a third party, the lender. This way, both parties are held accountable for the terms that the bond is issued under. If, for some reason, your business is having trouble seeking funds via traditional methods, you can take advantage of the SBA's venture capitalism programs, which are generally made through cash exchange. Any of the things that you may need financing for include long-term loans for machinery and equipment, working capital, a line of credit, and a micro-loan. Each of these options is discussed in detail on the SBA Web site, at **www.sba.gov**.

Use these questions, as listed on the SBA Web site, to help you establish exactly what your financing needs are:

• What is your need — are you going to use the money to expand, or to protect yourself against risk?

- How soon do you need the money? Usually, you will get the best financing terms when you are not looking for money under pressure.

- What degree of risk does your business have?

- How far along are you in the development process of your business?

- How does your need for financing affect your business plan? Does it fit in with the plan?

Basic 7(a) loan guarantee

This is SBA's primary business loan program. While its maximum allowable loan is $2 million, it is the SBA's most flexible business loan program in its terms and eligibility requirements, and is designed to accommodate a wide variety of financing needs. Most of these loans are given to serve functions, such as working capital, machinery, equipment, furniture, renovation, new construction, and debt refinancing. Commercial lenders are the ones who actually make the loans and the determination for who they will loan to, but the government offers a guarantee for a percentage of the loan should the borrower default. For this particular loan program, the government can guarantee up to 75 percent of the total loan made to the business if it exceeds $150,000, and 85 percent for loans less than $150,000.

The most attractive features of the 7(a) is its low down payment, low interest rates compared to most banks, and an extended loan maturity for as many as 10 years for working capital and 25 years for fixed assets. These are great perks. Should a business want to start an early payoff, a very small percentage of the prepayment amount will be charged as a prepayment fee. The early payoff can come in handy when a business is experiencing fast growth and needs to refinance to support its expansion, and the small fee required to do this may be more than worth their while.

Microloan program

This short-term loan offers very small loans up to $35,000 to small businesses that are starting up or growing. Funds are made available to intermediary lenders who are nonprofit and community-based, and these lenders typically require some form of collateral for the loan. The loan can be used as working capital to fund the operations, to purchase inventory, supplies, and equipment in order to do business, or furniture and fixtures for the business. There are intermediaries available in most states, the District of Columbia, and Puerto Rico. The states where there is no intermediary include Alaska, Rhode Island, Utah, and West Virginia; Rhode Island and a section of West Virginia are currently accessing intermediaries in neighboring states.

Prequalification pilot loan program

This program allows for a small business to have their loan applications analyzed and receive a potential blessing from the SBA before a lender or institution takes it into consideration. It covers loan applications in which the business owner is looking for funds up to $250,000, and its deciding factor involves aspects of the applicant's credit, experience, reliability, and to some degree, character. This makes it unique among many of the other loans, where the applicant must have assets in order to be qualified.

The main purpose for the SBA in this particular program is to help the entrepreneur strengthen his or her loan application. This program can be helpful for an applicant who has relatively good credit and a semi-established business looking for expansion. The SBA will ask to see the applicant's past financial records, ratios, history, and personal credit. The SBA will help determine which sections of the loan request are potential red flags for the bank, and then recommend the most favorable terms the applicant should expect.

8(a) program

This program was specifically designed to help socially or economically disadvantaged people (minority entrepreneur, business leader, or person with a disability). These loans are traditionally used for a start-up or expansion business development. To qualify, a socially or economically disadvantaged person — not just a figurehead in the position — must own and control at least 51 percent of the business. Along these same lines are additional assistance programs that are specifically targeted to veterans, women, and handicapped persons.

Economic opportunity loans (EOL)

This program is for the low-income business owner who may be experiencing even more difficulty in securing financing, despite having a sound business idea. As long as one business partner is considered to be living below the poverty level (determined by the federal government and adjusted annually for inflation) and owns at least half of the business, an applicant can qualify for EOL assistance. It is also an option for the small business that has already been declined by a conventional bank or institution. The best part of the EOL program is that the loans are long-term and offer a flexible payback rate of 10 to 25 years, depending on the type of loan.

LowDoc program

The LowDoc (short for low-document) Program is set up to make the application process much simpler and less time-consuming than traditional methods. It does this by reducing the size of the application form to one page for loans under $50,000. For larger loans of $50,000 to $100,000, an applicant receives the same one-page application, along with a request for his or her past three years of income tax returns. This program is the most popular in the SBA's history.

CAPLines

A CAPLines loan is an asset-based line of credit, allowing businesses to manage their short-term needs, such as to continue payroll and purchase equipment. Typically, a business that is unable to qualify for other lines of credit, such as a builder or small company, will use this type of loan. The payback terms of a CAPLine are adjusted to fit the seasonality and cash flow of a business, such as a business trying to complete a large project and waiting for payment.

CDC/504 program (Certified Development Company)

This is a mortgage product that supports local community developments through commercial real estate. The Certified Development Company puts up 50 percent, the bank 40 percent, and you come up with the remaining 10 percent. You must occupy/lease 51 percent of the building, and you are free to lease the remaining 49 percent of the building to another business. Also, the business must create jobs, and the more jobs the business creates, the more money will be lent to the business. The terms of a CDC/504 program are attractive, offering a generous 25-year fixed rate.

SBA lenders are not all created equal. They are separated into three categories, each category participating in the programs with different verve and commitment. The least helpful in most cases will be your participant lenders.

- **Participant lenders** are occasional participants in the programs offered by the SBA, which would be your average bank's status. These are known to be slow in processing and often impersonal. They are also not highly trusted by the SBA to determine an applicant's qualifications. For this reason, the SBA checks over each application and will have the ultimate say on whether or not the applicant meets requirements for the loan.

The next best SBA lender to use would be the certified lenders.

- **Certified Lenders** are considered certified because they are regular participants of the SBA programs. Processing time for these loans are shorter, as they are more accustomed to the processing than participating lenders. While they understand the SBA process better and complete the necessary requirement checks thoroughly, the SBA still insists on double-checking the decisions of the bank before qualifying the loan.

The best type of SBA lender is the preferred lender.

- **Preferred Lenders** know the SBA system and have a solid reputation with the SBA as being a good judge of character and risk. Because of their experience, the SBA trusts them and does not get involved in the decision-making process of acceptance. If the bank accepts the applicant, the SBA is 100 percent behind the decision. This is the quickest and most convenient way to take out an SBA loan.

Friends and relatives: You may have friends or relatives who will give you an interest-free or a low-interest loan. Be sure to put all details in writing. Carefully think through this option, too, as you may not want to jeopardize the relationship. Ask yourself if the person you are borrowing money from will want to play a role in your business and whether or not you are okay with that. Also, is this relationship strong enough to survive the stresses that financing and running a new business bring?

Banks and credit unions: The most common sources of funding are banks and credit unions. Loans are based on solid business proposals and your written business plan.

Borrowing money is a major commitment and should not be taken lightly. Talk to friends and other business owners to find out which banks they borrowed money from and how their experiences went. If you are in a new town, visit several banks and talk with the loan managers. Compare rates, services, and customer service, and be sure to check their savings and checking plans. After you have visited several banks, think about the information you found about each one and ask yourself these questions:

- What rates, services, and customer service is offered?
- Was it difficult to get an appointment with the right person?
- Were they interested in you and your business?
- Did they explain their services and requirements adequately?
- Is the bank convenient to your shop location?
- Do they have a safe place to make night deposits?

Banks are cautious when dealing with small businesses, and they require quite a bit of information. They will need to see how you intend to repay the loan. This might require several income sources and involve other factors, including:

- Sufficient collateral to secure the loan
- Your signature and credit score
- A cosigner, like a friend, parent, or relative
- Equity in real estate you own
- Your assets-to-debt ratio
- Whether or not you have a savings account
- Whether or not you have any investments, stocks, or bonds
- The cash value on any life insurance policy

Negotiating your loan

Once you have all your information gathered and have selected your bank, it is time to meet with the loan officer. Approach this meeting like a sales pitch because you are indeed selling your business idea to the officer. They need to buy into the idea that you know what you are doing, you are confident your photography business will succeed, and they will not be left with a delinquent loan.

Loan rates and terms can be negotiable. Over half the business owners who apply for loans could get a lower rate if they just asked. The interest rate and the length of the loan can both be negotiable. Listen to the offer the loan officer makes, then ask whether it is negotiable or not. Do not ask after the final papers are signed.

Here are some tips on asking for a lower interest rate:

- Ask to make the length of the loan shorter. Keep in mind that a shorter loan term will make the payments higher.

- Increase the value of the collateral you offer.

- Have a good credit rating

Other ways to finance a business

1. Give it — The primary source for business financing is ownership contribution.

2. Borrow it — Take out a loan from a family member or friend.

3. Sell it — Selling a part of your company to investors can provide needed capital, but sharing ownership has its drawbacks.

4. Earn it — Saving requires long-range planning and wise money management, but it is the most economical way to finance growth.

5. Pledge it — Private or public business development grants are available based upon your ability and willingness to "give back" to the community.

6. Share it — Find an upline sponsor (coach), employer, business, or individual who will subsidize your idea with the goal of enhancing their financial picture.

Examining your business and discovering your entrepreneurial style are the first steps in finding the funding that matches your company's needs. When the need for money arises, entrepreneurs can become consumed by raising capital. Their judgment becomes clouded and their decision-making ability becomes compromised. The cliché "the end justifies the means" is not always true. Your first step in exploring your financing options is to determine what you are willing to sacrifice, which will depend upon your vision.

Focusing Your Vision

You have the equipment, the plan, and the money to operate your business. Now is the time to start focusing on your short-term and long-term goals, develop a well-thought-out vision for your company, and start running your business. Remember that your business plan is the road map of your business, and your vision and goals should reflect that plan.

Chapter 5

Building Your Vision — and Your Business

According to the SBA, 50 percent of small businesses fail during their first year of operation. Most of the time, this is because the owners lose focus on what their vision is and do not discover their strengths and weaknesses. You started this company because you have a knack for photography. Whether or not you are good at running a business remains to be seen. You may have a background in business or business management, but for most people, the business of running a business may not come easily.

You may find that running a business does come easily to you. The key to running your business successfully is sticking to your vision and knowing when to ask for help.

What Does Your Vision Look Like?

You have probably been daydreaming about your business for years. Now your business is a reality. Most people think creating a vision is more like daydreaming, when the truth is that vision in the business world means reality.

Like your business plan, your vision helps guide your business to where it is going, but it is much more focused and fluid than your business plan. This is because the vision includes your short-term goals along with a statement of how your business operates. It is fluid because your vision can change as your company grows and different challenges arise.

For example, the vision of your business in the beginning may be to become a portrait photographer who grows business by offering unique and fun photo packages. As you grow, that vision may evolve to becoming a portrait studio with three photographers who offer customers a unique experience.

Still remaining true to your business plan and initial vision, the second vision statement reflects the new nature of your business. You have grown to where hiring additional help is necessary, and by defining what your vision is and keeping it specific, you can see exactly where you want to be.

You may not realize your vision completely in the first months, but by knowing all the details of your vision and keeping them clearly in mind, you can make sure that your business grows toward your vision, rather than becoming something completely different. Try setting goals and writing them down to help you set your vision. Keep this with your business plan so you can refer to it easily to make sure your vision stays on track.

CASE STUDY: STARTING YOUR DREAM JOB

Joy Augeson, owner
Augeson Photography
17241 Woodbine St.
Andover, MN 55304
www.augesonphotography.com
jlaugeson@comcast.net

I attained my training at the School of Communication Arts in Min-

neapolis. Before turning pro, I worked with other professional photographers to learn the wedding trade. In addition, I also worked and managed photo labs and photo studios.

When the company I was working for went out of business, I had to choose if I was going to go full-time on my own or just practice photography as a hobby. I decided to go pro, and have never looked back.

I formed Augeson Photography in 1985. My specialties are weddings, family, maternity, newborn, children, and senior portraits. I also do many non-traditional themes to capture a child or loved one's interests. In addition, I also provide commercial photography services for a variety of businesses and restaurants.

In my work, I strive to leave a lasting impression. This is achieved through personalized service and creating photos from captivating memories. I do that by using my photographic expertise and artistic perceptiveness. The result is a priceless image.

The best advice I can give to someone new in the business is not to undersell yourself to get a particular job. Stay honest and true to your beliefs. Find out what type of photography you are best at and focus on that. Remember that you can only do a few things at 100 percent. It is important not to try to do 100 things at 10 percent. Most importantly, never forget why you are a photographer, and never lose your passion for the trade.

How Much Do You Know About Running a Business?

Vision and persistence alone will not grow your business. There are forms to fill out, invoices that need to be sent to customers, and vendors who need to be paid. Keeping all this in line will take up most of your time when you run your own business, but this organization is essential.

If you are business-minded, have run a business before, or have a business education, then you are probably just where you need to be in terms of get-

ting your business off its feet and making a profit. If you are not familiar with running a business, you will need to learn some basic business skills and practices. Fortunately, these skills are learnable. You can easily access books and information, as well as take classes, which will help you learn the business techniques you need, including accounting, customer service, and marketing.

Do not feel intimidated

With your vision in hand, you can begin to set up your business. Starting a business is a big step, and it can be daunting. You may wonder if you know enough, have the right experience, are skilled enough, or can keep yourself afloat.

Running your own business is the same as learning any skill. You did not just pick up a camera one day and, all of the sudden, you could take pictures that people wanted to buy. You had to practice and, at times, the things you tried did not work out as planned. The same is true for running your business. It will be a learning process, and you may not always receive the desired outcome of your project. The important thing is to keep trying and not let yourself get down.

If you realize that the business of running a business may not be your strong suit, you can always hire an accountant or take on a partner with those skills. Another avenue that is becoming more popular is outsourcing some of these duties to companies that specialize in these areas.

Working in a business

When first starting out, you will probably want to be available all the time to learn what your customers want and begin to discern when they are most likely to need you. When building a business, you need to be available when the customer needs you, not on your schedule.

After you have been in business for a short while, begin to build in time off so you may lead a more normal life. For some photographers, a normal day begins at noon and goes until 8 p.m. Seasonal considerations are also important. Some photographers can count on working six to seven days a week during the summer, while other photographers put in the same time from October to December, as the demands for family and individual portraiture increases. Others in the commercial and advertising fields may work a straight nine-to-five, with the occasional night or weekend work year round, as they attend creative meetings in a more typical agency or business environment.

What your customers will want from you is determined by your specialty, your geographic market, and pre-existing norms within the marketplace.

Let your customers know what to expect and how they can reach you. On your voicemail and Web site, set expectations by clarifying whether a request will be responded to within hours or days. Make it clear if you are closed on Mondays or work until nine on Thursday nights.

Working for your business

To make the most out of your day, stay focused solely on business activities during business hours. This can be a challenge, especially when working at a home office. Whether a neighbor comes over, the laundry needs to be done, the dog needs to go for a walk, or your daughter has forgotten her homework and you need to rush it to her school, the distractions can be many. But, your future rests on you.

If you have been working hard, have projects booked for months, and can take an afternoon off to go swimming or enjoy a movie matinee without jeopardizing deadlines or other commitments, go for it. You want to run your business, not for your business to run you. And, being self-employed does allow for certain flexibility from time to time.

CASE STUDY: : AN INSPIRED VISION

Sara Kirk
Sara Kirk Event Photography
"Serving the Twin Cities Since 2000"
sarakirkphotography@gmail.com
320-223-9943

I was born and raised in Great Falls, Montana, in the land of blue-sky country, wind, and wheat fields. My childhood was filled with rodeos and a bit of the Wild West. People were few, and they live far apart from one another, but the land was wide-open and plenty, which allowed for great development of my imagination.

I moved to Minnesota when I was 13, and began taking pictures not long after. At St. Cloud State University, I majored in Mass Communications with a Photojournalism emphasis. I started shooting in 1998 while I was a sophomore in college.

When I first started out, Margaret Bourke-White was a huge inspiration to me. I grew up in Wolf Point, Montana, next to the Fort Peck Dam. Pictures that she shot of the dam were featured on the first cover of *LIFE* magazine, released November 23, 1936.

She was an original staff photographer for two of the most prominent magazines of her day, *Fortune* and *LIFE*. She led a life full of adventure and was a pioneer in the art of photojournalism. Her life inspired me because, as a woman, she was so successful in a job field that was primarily occupied by men. I decided that if Margaret Bourke-White could be successful, so could I. The development of digital technology has somewhat leveled the field between the sexes since I started shooting in 1998.

My photography business comprises two fields: photographing events and photographing animals. I have worked for the Minnesota House of Representatives, newspapers, public relations agencies, magazines, and corporations like Macy's, Carlson Companies, Target, and Schroeder Milk. I also document business gatherings, nonprofit conventions, and other types of events, such as Race for the Cure and *Metro Magazine's* Fashion Fight Night. In addition, I supply public relations

imaging to businesses, whether it be the annual company picnic or for the completion of a new building.

I believe the most important quality a professional photographer can have is a sense of humor. Humor has helped me tremendously over the years. Also, to survive, you need to understand business concepts. You can be an excellent photographer, but if you cannot pay attention to the business details, you will not survive. I recommend first learning your craft and then taking classes on how to run a small business.

Putting the Success of the Business First

In making decisions on how you will spend your time, put the success of your business first. Setting up a firm foundation when you first get going will take more time initially, but it will serve you best in the long run.

This will affect every decision you make. It is not overkill to ask yourself with every decision, "Is this good for my business?" It is necessary. If the question is whether or not to take this client, that answer is always yes, but other questions, including, "Do I need a new camera?" or, "Should I advertise in the local newspaper?" should be applied to the above principle. By answering these questions when you make decisions, your business will run smoothly.

How to Run Your Business Effectively

Use time-proven business tools daily to establish and operate your business. Learn from those who are successful. Surround yourself with mentors, ask questions, and implement the advice given to you with regard to how to run your business most effectively. The lessons you will learn from the mistakes of others are valuable, and will prevent you from making the same mistakes.

Everyone is unique, and we all have our own ways to stay organized. However, popular business methods are popular because they work. Do not shun advice from seasoned entrepreneurs or businessmen because you do not think their advice fits your style. Think of if the tables were turned and you were giving advice on taking photos; the business professionals would be better off listening to you — the expert — because you know how to change your f-stop to obtain a particular shot. But, regardless of whose advice you choose to follow when it comes to running your business, one thing will help you in every aspect: organization.

Stay organized

Organizing for your business is about far more than your file system. Of course, you should have a file system, and it should be well-organized so that you can find anything you need at any time, but organizing your business refers to everything, tangible and intangible.

Organize your ideas as well. Have a file where you keep all ideas about developing business, marketing, and anything else related to your photography business. Keep everything you think you might want to use in your business, and know where this file is. It does not have to be on your desk all the time, but keep it where you can lay your hands on it.

You need a file where you keep records like your business license, sales tax permit, and incorporation papers. Because you often need these items at the same time, it helps to have them all together in your files so you can locate everything quickly. You will need these documents if you look for financing or arrange business credit, and if you seek a lease on studio space.

The most important thing to keep organized is your thoughts. You need to make sure that you think straight through this process, organize your thinking, and take notes so that you do not lose track of what you are

doing. To use an old cliché: Your right hand needs to know what your left hand is doing.

Since organization comes more naturally for some people than for others, do not be afraid to ask for help if you need it. The National Association of Professional Organizers Web site, at **www.napo.net**, can link you with a helpful person in your community if you desire assistance. In addition, there are some wonderful tips through *Simplicity News*, an e-mail newsletter produced by Monica Ricci of Catalyst Organizing, who is a frequent guest on HGTV's show *MISSION: Organization*. You can visit the Web site at **www.catalystorganizing.com**.

Business planning in your state

Laws on operating a business vary from state to state. Contact your local Chamber of Commerce or business development corporation to find out what laws are applicable in your state before you start the initial phases of your photography business.

While you are doing your legal research, however, you will find that a large portion of business planning information is generic and can be used in any state. Your local library or bookstore should carry several of them. You will find that just reading a good book on business planning can help you organize your business plan and know what you are doing.

You can also find information specific to your state covering such matters as incorporation and sales tax. The first source of information on these state-specific issues should be your Secretary of State's office; many of these offices have guides on starting a business in the state, and you can either order a copy of this guide or download it from the state's Web site. By doing a Web search with the name of your state and a phrase such as "opening a business" or "business guide," you can find various links that will bring you to this information.

The library will also have information on starting a business in your state. You can also find state-specific information on the Internet, but always check the source of this information and make sure it is reliable.

Getting expert help

Sometimes you may wish you could just ask someone a simple question and get a simple answer. Good news: There are sources of information that can answer a question for you when you have one.

Perhaps the biggest source of answers is the Service Corps of Retired Executives (SCORE). There are SCORE offices in many cities, and they have a helpful Web site, **www.score.org**. SCORE is made up of retired businessmen and women who can help you with your business questions.

If your city has a Small Business Development Center (SBDC) office, this is a good source of information. They often hold small business workshops and will provide answers to your questions. SBDC is part of the Small Business Administration, and can be found on the Web at **http://sba.gov/sbdc**.

You can find excellent sources of business information on the campus of your local university, college, or community college. Business professors and instructors are usually more than happy to answer any questions you may have and are experts in their fields. If you are looking to enroll in a class, you can either enroll at your local campus, or apply to a school out of state. In 2009, the top five business graduate programs, out of 426 MBA programs included in the survey, were at Harvard University, Stanford University, Northwestern University, University of Pennsylvania, and the Massachusetts Institute of Technology, respectively, according the U.S. News and World Report.

Expert Web sites on the Internet can also provide answers to your questions, but you will need to do some research to make sure that the answers you receive are correct and that you are indeed getting expert advice. You may also want to join some e-mail lists, forums, or other special interest groups of business owners in your area. Start with your local Chamber of Commerce or business development corporation and build your list from there. You can gain considerable knowledge from these groups, but again, consider the source and make sure you verify the information you get.

Permits and licenses

City Business License

You will almost certainly need a city business license if you are operating within a city, and you may need a county permit if not located within city boundaries. You can find out more about what licenses and permits you may need, where to get them, and how much they will cost by calling your city hall or county clerk's office. Most licenses will cost between $50 and $100. In most cities, the city clerk does not issue business licenses, but can direct you to the correct office if you cannot find it on your own.

You need a city license for several reasons, starting with the fact that you can be fined heavily for running a business without the correct permit. You also need to show your customers that you are legitimate, and you will need a city business license in most states to get your sales tax permit.

When you contact the agency that issues the city business license, ask how long the license is good for, what the renewal process is, if there are levels of licensing and what level you need, how much it will cost, and whether or not there is anything else you need to do to be "street legal" as a business within your city or county.

State Sales Tax Permit

You may wonder why a photographer needs a sales tax permit. After all, services are not subject to sales tax. But anything you actually sell, such as prints, frames, and other physical items, will be subject to sales tax, and again, you could end up with a hefty fine by not reporting and paying sales tax as required by your state.

You can contact your Secretary of State's office to apply for your sales tax permit. In most states, you will need a local business license to do this. Make sure you allow time to get your city license and sales tax permit before you open shop.

Ask the agency issuing the permit if it needs to be renewed annually, how to do that, how and where to file and pay sales taxes, and if you need to know anything else in order to meet your obligations to the state regarding sales taxes.

In some states, it may be difficult to find information on the Internet about exactly how to apply for your sales tax permit. Calling or sending a written request to the state Department of Commerce for information may be the best route to obtain the information you need.

State and County Permits/Licenses

Depending on where you live, there may be state or county permits or licenses required to start a business. You should call your Secretary of State's office (or ask when you call about the sales tax permit) and your county clerk's office, just to make sure you are not missing anything you need to apply for.

How to Know You Have Covered it All

The best way to make sure you have everything done that you are supposed to is to ask someone who knows. Again, the SCORE and SBDC are good resources for this; you may also want to call your local Chamber of Commerce and ask if someone can help you make sure you have covered everything for your startup licensing and permits. Talking with someone doing business in your area can be a big help in making sure that you are complying with all the relevant laws and regulations. Talking to another photographer in your area would be even better.

Establishing Your Surroundings

With your paperwork and business practice set, another important step will be setting up the physical aspect of your business. This can be just as important as your photography prowess.

The type of environment you work in can go a long way to determining the success of your business. Environment can put you at ease, and allow you to think more clearly about your product and how to run your business. Thus, the physical aspect of setting up your business will play an integral part in how it is operated.

Photo provided by Jason Henry

Chapter 6

Setting Up Your Business

When it is time to start setting up your shop, you should be prepared to put considerable work into getting everything exactly the way you want it. This is the time to make sure your business is starting out with your vision in mind.

Nothing is going to portray your business more than your surroundings. If you run a portrait studio, your reception area and studio will speak volumes about your professionalism, which will go a long way toward getting repeat business. If you work at home, setting up your work area will be crucial to the success of your business. Having the right environment for work is key for working at home.

More than Aesthetics

For those who will work in a studio setting, the appearance of your office is critical. It is the outward expression of your vision and artistic ability. Hiring a professional interior designer who specializes in commercial areas may be money well spent.

Of course, as a new business owner, you may not have the funds to hire someone from the outside to come in and design your office. But, before you start transforming your work area, you have to keep a few things in mind.

When you think of setting up a business, you probably primarily think of things like where the business will be located and how the physical premises will be set up. Photographers think in terms of how they will set up their studios and where the customers are going to come from.

Setting up is much more complicated than when the time comes to open your business. A little planning in advance can make it easier and help you accomplish exactly what you want.

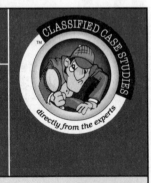

CASE STUDY: A SECOND CAREER

Tim Shannon, member, Advertising Pho-
tographers of America
Accredited in Public Relations (APR)
by the Public Relations Society
of America
(404) 815-7715

I am a commercial photographer based in Atlanta, Georgia. I specialize in publicity and advertising. My articles and photographs have been published in more than 60 newspapers and magazines throughout the United States and abroad. I work with public relations firms, ad agencies, and corporate communications people, as well as a variety of freelance designers and writers to provide writing and photography for their clients.

My education is in commercial photography from the Columbus College of Art & Design in Ohio, and journalism at Ohio State University. Because I had an avid interest in off-road car racing, I started out photographing off-road car races. After a couple of years, I was asked to handle the publicity and media relations for a 400-mile national championship series race over old logging trails through the forests of southern Ohio. I

I was able to convince a couple of sports-car magazines and newspapers to hire me to cover some events. They wanted one person who could both write and photograph the races, so I started writing the accompanying articles, too. I had been working full-time as a technical writer and editor, so I didn't really turn pro until I moved from Columbus, Ohio, to Tampa, Florida, six years later.

I later took a job photographing the "trophy queens" at a small eight-mile dirt track just outside Tampa. The track had an arrangement with a local modeling agency to provide a different young model each weekend to present the trophy to the winning driver. In exchange, the race organizers had me take the models' photos and write a brief bio for the track newsletter. The agency and model would then receive tear sheets for their portfolios.

Having worked in corporate communications [before becoming a photographer], as well as at a public-relations firm, I recognized the need for top-notch, crisp, and competitively priced assignment photography that was eye-catching enough to help tell the client's story in one frame. After gaining so much experience on the "other side of the lens" on the corporate and agency sides as someone who had been hiring and directing other photographers myself, I had developed a first-hand understanding of exactly what clients wanted. And, more importantly, I understood what they did not want. This made it easy for me to give the client just what they wanted, without giving them something so artsy that the message gets lost.

The type of photography will effect environment

When you think about what kind of space you need, you should consider what you are going to be doing in that space. For portrait photography, you will need a lobby or waiting area and a camera room for taking the photos.

For commercial photography, if you do mostly outside assignments, you may not need any space outside your office and digital darkroom. If you do tabletop commercial, you should have a good place for doing that, but

you will not be so concerned with customers coming to the studio. If you shoot for publications, whether you need a studio or storefront will entirely depend on what you are shooting; you will need to determine exactly what you are going to do. Wildlife photography does not require a studio or storefront for the photography, but you may want a gallery to show your prints. And, if you do fine-art prints, you may also want an area where you can show prints, unless you sell exclusively online or in galleries. You may or may not need studio space, but you probably do not need a "public" studio into which you invite paying customers.

Know how you will work

Your workspace, above all else, needs to be functional. It does not do you any good to have a space that looks good but does not allow you to work effectively. You do not want to have clients sitting around while you are trying to find equipment or navigate around your well-manicured space. Make sure that you set up your work area so that you are comfortable working in it. You can add the additional touches that make the space look artistic later on.

When you are designing your workspace, remember why you are in business. You are not running a business so you can take photographs. You are running a business to offer a service people need, and your public areas, or studios, should reflect that. Your private areas should allow you to conduct your business without feeling cramped or overcome by clutter. A separate office space away from your studio or some how blocked off from the rest of the area is ideal.

It is also helpful to have storage concealed in every possible area. Use every inch of space, because you will need it.

Make sure that each area of your studio and reception fulfills their functions. Or, if you want to sell prints to portrait customers, you need to have

a comfortable table and chairs. You do not want them to speed through the selection process because your stool is hurting their back. Likewise, make sure dressing rooms are private and the customer feels comfortable. When in doubt, follow the advice, "Form follows function."

Look and feel

Image matters because what your customers see when they walk in your studio or waiting room is what they will judge you by. They may have a wonderful experience, but if your reception area was cluttered and dirty, they will have less positive memories than if it were neat and clean.

Remember, you are selling yourself, your products, and your services. Photography is a field dominated by visuals, so if your work area is not visually appealing, customers are less likely to think of you as a quality photographer even if you take wonderful pictures.

It is important, though, to build the image you want, not the image you think your customers want to see. Maintaining your image will show your passion and sincerity, which are important qualities of a photographer. If your image is based solely on what you think your clients want, they will see through it, and as they work with you, your true style and ability will show. Being honest starts with the face you put forward, and how you set up your office and reception area is a big part of that face.

The goals of your reception area

Your reception area has five goals, all of which are equally important. Focus on each one until you feel your reception area is the best it can be:

1. **Impression**. Your reception area must strike new customers as being highly professional, and your work must leap out at them and make them want to work with you. Visit museums and gal-

leries to get ideas on how to best display your work to the people who come into your business. The more professional your reception area looks, the better the customer will feel.

2. **Comfort**. You must make your customers comfortable. Photography is a personal service, and you should take advantage of this personal quality. Comfortable chairs, lighting, plants, and matching furniture can go a long way to producing a comfortable, homey feel in your studio.

3. **Security**. Your customers must feel that you care about them, that your area is a good, safe choice for their photography needs and for their money. Free refreshments are always a good idea to show your clients that you care. Also instruct any employees you have to smile at customers and greet them by looking them in the eye.

4. **Sales**. Your reception area is where you make the actual sale, and it needs to be properly arranged for making those sales. Have sample books on the table, and encourage customers to browse your previous work.

5. **Referrals**. Ask for referrals before your customers leave. Make sure there is a place and a way in your waiting area to make this request. Maybe you will ask them when they are paying for the shoot or their photo packages, or maybe you will talk to them later on the phone as a follow-up interview to see how they enjoyed your services. No matter when it happens, make sure you directly ask the customer to refer you to friends. Do not hint at referrals, but come right out and tell your customers that you want a referral. If they were satisfied with your work, they will be happy to give you one.

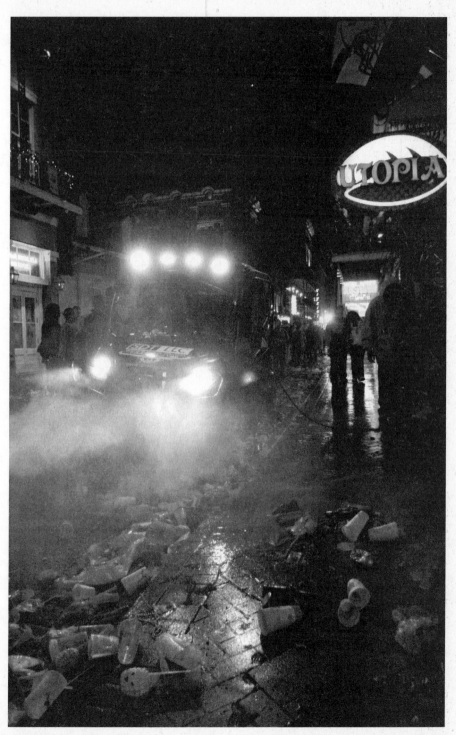

Photo provided by Jason Henry

Spending too much on your studio and reception area

Your reception area and studio are important, but, never make the mistake of spending more money on your studio than you can afford. Your dollars will be limited in the beginning, so keep in mind that you can, and probably should, update your reception and studio areas later. At the launch of your business, nice and presentable are good enough.

However, if no one comes to your studio, you will not be able to impress them with your reception area. You need to generate business, and you may need to spend some of your studio money on marketing initially. Do not let your studio go shabby, but try to cut corners in invisible ways. One way to do this is to buy used furniture and frames. You might even buy deliberately mismatched items and paint them to create a matching, yet non-matching, décor.

To decide what is essential for your reception area, you will have to experiment, of course, but start with displays of your work, sample books, and customer furniture.

Can You Succeed Working Out of Your Home?

Not everyone can afford a studio, and not everyone needs one. Journalists, photo artists, or those who deal with galleries may not need a studio. It is often quite possible to succeed with a home-based photography business. You should consider what you need and how you can make that work in your home business.

- **Can you create the space you need?** Most people find that they can repurpose a guest room or remodel a garage to build their office or studio.

- **Can you work on location?** If you work mostly outside your home, you might get away with a computer on the dining room table for a while. Most people who do not do studio portraits can do a large percentage of their work from home.

- **Do you have room?** Some photographers do not have room for a photography business in their home, but using the garage when necessary, working outside on location, or having a small area devoted to your business part-time can help you find the space you need while you grow your business.

- **Will there be a good working environment?** If you have small children at home and you absolutely cannot afford an outside office, you will have to work at home with your children. But, if the home environment makes work difficult and you can afford outside space, it is probably worth the cost to rent an outside office or studio.

- **Are you disciplined enough to work from home?** This is one of the first questions many people have when they consider working out of their homes. The fact is, some people simply cannot get past the distractions of home and need an office outside of the house to get their work done.

Collective workspaces

Are you the type that needs somewhere to go everyday in order to be more productive? You may want to consider using mobile technology to take your office with you. This could be a good option for freelancers and photojournalists who spend a considerable amount of time away from the office. This way, you can do the majority of your work on the road and some of the other tasks from your home. Also, if you do not want to pay for a studio or rent an office, you can look into using incubators, offices set

up for freelancers so they can work around other people, yet not be part of a company or collective workspace environment.

Since the technology boom in the 1990s, the concept of small business incubator programs has grown from offering support to only technology-oriented companies to offering support to businesses of all types. The National Business Incubation Association Web site, **www.nbia.org**, defines business incubation as a business support process that accelerates the successful development of start-up and fledgling companies by providing entrepreneurs with an array of targeted resources and services. Among these services is often the access to shared or sole office space.

Incubation services tend to be managed through an organizational management arm and offer a network of contacts, both within and outside the incubation organization. Accessibility to offices and meeting rooms is just one of the benefits of participating in an incubator program. Another benefit is the opportunity to network with other people in your industry who are in a similar start-up phase and have similar needs.

You may also want to consider forming a collective with other people in creative industries for the purpose of networking or sharing office space. Collectives differ from incubator programs because the workers set up the office, equipment, and working arrangements themselves, while incubator programs are set up by companies not involved in the work going on there. For instance, if you want to work in advertising, consider sharing space with a graphic artist and copywriter. It might be beneficial. Not only would you be able to share resources and split costs, but you would also be able to share leads, brainstorm, and work on joint marketing efforts.

Separation of spaces

Joining an incubator program or using a collective workspace are not your only options. If you can afford to, you can work directly out of your home.

Photo provided by Sivan Grosman

The key to working out of the house, however, is making sure you have your workspace separate from your living space. It is important to truly make it a distinct area in both its appearance and function. Do not install a television or let your kids bring toys into the room. It is your workspace, and it needs to be treated like one. As discussed above, a guest bedroom, basement, or garage may be a good place to have your home working environment. Transformations can be made in these areas without disrupting the flow of the rest of your home.

Decorate your home office in a completely different style than your home. If you have a more country feel in the décor of your house, make your office have a modern feel, so you get that sense of leaving home and entering a new environment. Also, it is important for family members to realize the boundaries of your work area. That is not to say that family needs to be excluded from your area, but setting guidelines for when is a good time to be in your space and when is not will be important. With these steps, you can make working at home a good option for your company.

Working without a studio

Many people think that if they take portraits, they must have a studio. But, the good thing about photography is that cameras, and most of the other equipment, are portable.

For example, a photographer might take photos on location in the client's home or office, but prefers to take photos in parks. This results in beautiful, casual portraits that truly capture the spirit of the subject. While this might not be appropriate for some subjects, such as pre-wedding bridal portraits, it works great for senior photos and engagement photos.

The key to working without a studio is to use the resources you have around you. Purchasing portable lights and finding creative ways to set up your shots will be a challenge in this environment. Stock your studio by

going to rummage sales and flea markets where you can purchase unique and interesting items to use in shots.

This does not apply solely to portraits. If you are taking tabletop photos, you can create a portable desktop studio. Light tents have gotten quite affordable, and creating the right lighting situation in your home studio can be affordable, too.

If you can, work outside as much as possible. The natural light is beautiful, and using reflectors to capture sunlight on your subjects will provide soft shadows and lighting that is hard to replicate with artificial lighting. Also, if you cannot afford a studio or do not want to have one, you may simply choose to specialize in non-studio work, at least in the beginning of your career.

When you do not need a studio

Many branches of photography do not require a studio, and you may already be planning to work in one or more of these specialties. A large portion of commercial work, for example, is shot on location. Doing commercial work without a large studio is quite feasible.

As you might expect, wildlife photography does not require a studio and allows you to spend a great deal of time outdoors enjoying nature. Most publication photography can be done without a studio, too; you can capture much of the world for publications without ever setting foot in a studio. Architectural photography, of course, is done on-site, so you would not need a studio to become an architectural photographer. Journalism is also a studio-free photographic specialty and can be a nice sideline to a professional photography business. You can even become a full-time freelance photographer, which would mean you do not need your own studio.

Let them know you are there

Now that you have set up your work environment and created an inviting work area (if you need one), you have to let people know you are there. The only way to do that is by marketing. Marketing is much more than advertising, which will soon be discussed, as well as ways to get your company name out there.

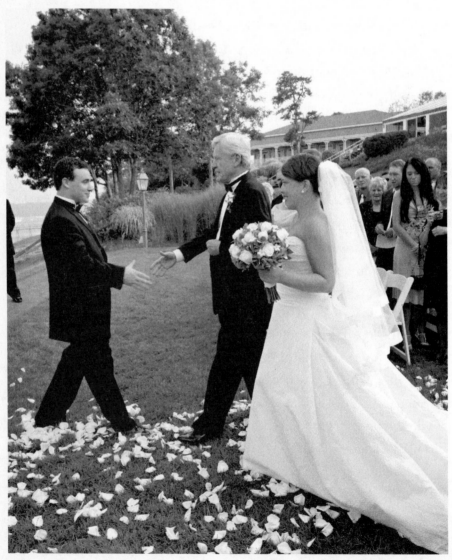

Photo provided by Emily Sommer

Chapter 7

Getting Started in Marketing

Marketing is the lifeblood of any company. You can have the greatest product in the world, but it does no good if no one knows about it. Marketing does not mean just taking out ads and putting your face on billboards. Marketing also includes how you package your products, spreading the word about your company, and networking. There are many marketing mistakes people make. By being aware of the common mistakes and forming a marketing plan, you will be able to develop your business in the public eye.

Marketing Mistakes

For a photographer looking to start a business, marketing may not come easily and may seem like a nuisance. Because of this, there are a lot of mistakes that can be made when trying to market your business.

Marketing is a tricky business and it is possible to market too little, just like it is possible to market too much. The key to marketing is finding the right balance between what amount of exposure and advertising brings in the maximum amount of money at the minimal cost.

...ost common marketing mistake. When starting a ...mportant to get your name out any way you can, but ...t back and wait for word of mouth to spread, or they wait ...get a few clients before starting to market their company.

...at can be a fatal flaw. Marketing may be the most important thing you can do in your first six months of business — when you are getting started, you should focus on building your new customer list, but even once you have a customer-base, you should never stop marketing.

Your marketing budget should be a significant part of your overall budget from the beginning — at least 15 percent of your operating budget or more, if you can afford it. The point is that if you do not have customers, you do not have a business; you need to bring in those customers.

You want to make an impression with your marketing, but you want to make the right impression. To make sure you do this, conduct some market research. Ask yourself, "Who do I want my customer base to consist of?" This will relate closely to your vision. What type of photography are you doing? Are you going to photograph portraits? If this is the case, you can market to anyone. But, if you want to photograph nature, you will want to market yourself to people and organizations who are interested in or work with nature.

If you are marketing to businesses, cold calling — calling companies you have not had contact with before — is a good technique because businesses who hire photographers expect calls from photographers. However, never cold-call individuals. You will make them mad and may violate the Do Not Call List, a list compiled by the Federal Trade Commission to prevent U.S. citizens from receiving telemarketing calls at home.

Direct mail works well; you might create packages with a sample of your work and a coupon. You can use glossy paper and have photos of your best work, as well as send coupons with a place for mailing information and postage. They are beautiful and attention-getting. They can also be placed in an envelope, if desired.

Market online as much as possible. Publish articles about your photography on article sites, try to enhance your search engine rankings for your area, and advertise on good local sites. Put your Web address on every piece of paper that leaves your office, and offer Web-only specials.

Setting up a Web site is essential because potential customers are accustomed to making quick decisions. If you can get your work in front of them via a Web site, it will make their choice easier. Other avenues all businesses should use are social networking Web sites (*for more information, see Chapter 9*). These sites, such as Facebook® (**www.facebook.com**), LinkedIn® (**www.linkedin.com**), and Twitter® (**http://twitter.com**) provide a platform on which to show your work and connect with potential customers with no cost. Flickr® (**www.flickr.com**) is a site that will work particularly well for your Web site, as it allows you to upload your own photos and create photostreams, albums, and more to showcase your work. With the Internet population at more than one billion people worldwide in 2009, building your own Web site or profile with a social networking site can open you up to exposure beyond your business' location.

Market wherever and whenever you can, and test everything. Know exactly what the results are for each marketing effort so you are not wasting money on things that do not work. This will help you create that balance where you are getting the most for your money.

CASE STUDY: ESTABLISHING YOUR REPUTATION

Darin Back
Darin Back Photography
121 Washington Ave. South, Suite 1709
Minneapolis, MN 55401
(763) 807-6564
darinback@yahoo.com
www.darinbackphoto.com

After college, I did an apprenticeship with Annie Liebovitz and worked for four years as an assistant with esteemed photographers, such as Dewey Nicks, Wayne Maser, and Greg Gorman.

I began my professional photography business 15 years ago and primarily focused on musicians, sports, advertising, and editorial projects. To build my business, I went out there and hustled. I kept at it, and then it finally started paying off. I saved my money so I could buy more and more lighting equipment. It really is what you need to make your own way.

I started out shooting skateboarding, snowboarding, and music and just fell in with it. I had to turn it into a business; otherwise, everything I was shooting was done for a friend, and everyone wanted me to do them a favor.

I have enjoyed the opportunity to travel with this job. My work has appeared in publications such as *Rolling Stone*, *Spin*, *Harp*, and *Uncut UK* in Europe, and I have done corporate work for places like Snowshoe Ski Resort and Beacon Snow Clothing. With one of my accounts, I shoot about 7,000 photos in the period of a week to get everything that is needed.

The best advice I can give to new photographers is to know how to present and brand yourself. More than anything else, the quality of your work should stand out as yours, and yours alone. Build your reputation. Realize also that it will take a lot of money to get things off the ground when you first get started.

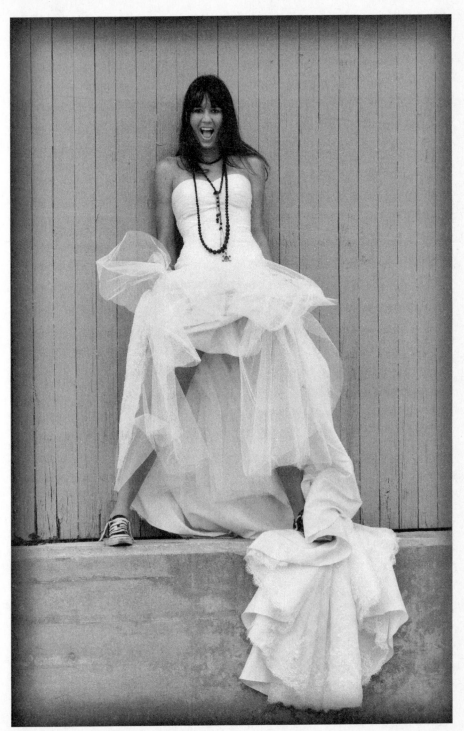

Photo provided by Sivan Grosman

Marketing to the wrong people

While marketing too little is a common mistake, you want to be careful not to over-market, which most likely results in marketing your business to the wrong people. The wrong people are any people who are not likely to buy your products and services. There is nothing wrong with them as people, but as prospects for your business, they are a drain of your time, effort, and money; and you do not want to squander anything. They are the wrong people because they do not want what you offer at the price you offer it. They may not want it at any price. Fortunately, it tends to be easy to find the right people with a little research.

You need to know what the right people want. Do they want your service because of your style, price, or the variety you offer? Start thinking about this, and ask every customer. Find out what people want.

Once you know what your customers want, you then have to let those people know where you are and what you do. Your Web site can help with this by attracting search engine users. This will require you to set up a search-friendly Web site using keywords. Your keywords should include the types of photography you specialize in, as well as the types of people to whom you are marketing. Putting a continually updated blog on your Web site with information about photography and your business will help your search rating, meaning people will find your Web site easily. Direct mail works well if you buy a targeted list from a good broker.

Find a list of advertising agencies in your area, a list of new parents if you shoot baby portraits, or a listing of photo galleries that may want to hire you. Scanning newspapers, finding marketing or research companies to do research for you, and checking with your local county government for demographics in your area are all ways you can generate these lists. Find out who and where your target people are, then market to them.

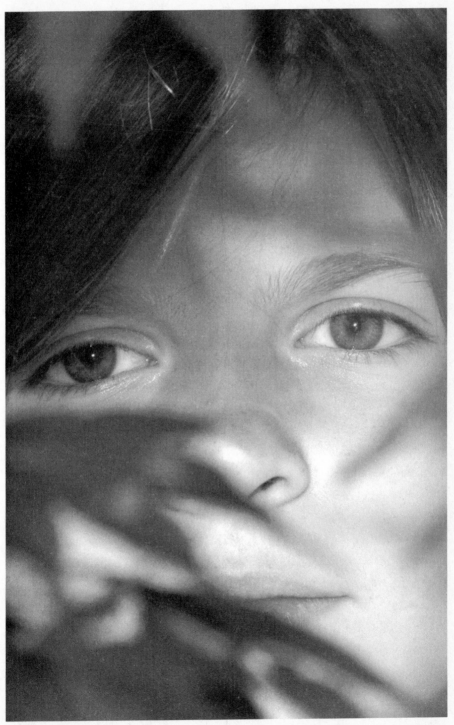

Photo provided by Diana De Rosa

Not selling your clients on your services

Your customers want to get the best service at the best price. That is what we all want when we are shopping for something. Good service providers care about providing what the customer wants. You and your customers are not on opposite sides of this transaction. You both have the same goal: trying to get the customer the best possible service or product at the best price.

Your customers want you to show them what they need. They do not want a hard sell, or to feel like you have pushed or tricked them into buying something they did not need.

Not getting enough referral business

Referrals are the key to continuing success in business. It costs much more money to go out and track down prospects and convince them to buy from you than it does to use your existing customer base as your sales force. People listen to their friends, and they will buy from you if they are referred to you.

Your clients need to know that they can help you with referrals, and how they can help. They need to know who is a good referral for you and what they should tell these people when referring them to you. If you can offer a discount, that is even better.

The best way to get referrals is to get names from your customers and follow up personally, offering them a discount or free gift. Your customers may have the best of intentions, but referrals are more likely to fall through if you leave it in the hands of your customers. Get names, and follow up with referrals. Aim for one successful referral from each customer, and you can painlessly double your business. Plus, referrals can

generate publicity for your business, which also increases your chances of gaining new customers.

If someone does not currently have a referral to offer you, and they are pleased with your product or service, ask for a testimonial. A testimonial is a written statement of endorsement. You can use the verbiage of these testimonials on your Web site and in brochures to help you, and potential clients, determine exactly how customers perceive the value of doing business with you. If you are fortunate enough to get a testimonial from a client with an established reputation, it can serve as an endless referral and help you in growing credibility. These types of things can help put you ahead of the competition.

Marketing Yourself and Your Photography

Most people who go into business are surprised at how much marketing is involved in any business venture. Marketing is usually thought of as a business on its own, and while it is its own business, it is also a huge part of every business' success.

Marketing yourself

Because you are a photographer, your business and your identity are tied up in each other. When a person goes to a grocery store, he or she often will not know the name of the owner; but, when this person gets his or her portrait taken, he or she is buying the photographer's identity as much as the services.

In any field of photography, this is true. You cannot separate yourself from your photo. Whether you are dealing with clients who are coming in to have a portrait taken, or you are working for an editor at a newspaper, the way you present yourself in terms of acting and dressing professionally will be key for repeat business.

Always keep in mind that it is not bragging when you are dealing with your business. If you won an award or did a particularly good job on a recent photo shoot, make sure everyone knows it. Although this may come off as conceited in personal conversation, in the business world, people want to know they are purchasing a product from the best.

Marketing your photography

It may be tempting to believe that people should know you are a good photographer because they know you, and you say you are good at photography. Sometimes that will happen, but normally you will have to prove you are good at what you do and prove that you follow through on commitments.

That said, you have to market your work as well; people might like and respect you personally, which is an important part of making your photography business successful, but they also need to know you can do the work they need done.

You will find yourself simultaneously marketing your name and your work, building both your personal and professional reputations. Web sites are a good way to get your photos out in front of the public, and for potential clients to see the quality of your work. Again, do not be shy with how you present your photos. Include a caption describing how you took the photo, why you took it, and why you like it. Explaining your work to people will make you seem more professional. Even if they do not understand what you are saying, they know you understand it, which gives you credibility.

When and how do you self-promote?

Self-promote at every opportunity you get. This does not mean you have to go around wearing a sandwich board saying, "Hire me as your photographer," but you should spend considerable time networking. Always have

photography business cards with you, and try to let people who already know you know what you do. That is what self-promotion is all about. Methods for self-promotion include:

- Starting a Web site and including client testimonials

- Joining social networking sites

- Writing regularly in a blog to talk about your work and posting shots you have done

- Contribute to local newspapers and magazines; write articles related to your business

- Do interviews with the local media — radio and television stations, newspapers, etc.

- Start speaking in public

- Volunteer to teach a school photography class (or somewhere else related to your field)

To self-promote, you can also make yourself available to various media outlets, as mentioned in the previous list. If you have an event planned, or are simply trying to get exposure for some of your photographs, you may want to consider sending out a press release to your local media. Editors and producers are constantly looking for content to stack their publications or shows with, and having something that already includes all of the details, like a press release, will be an easy way for them to have content while getting you the publicity you need. When writing your press release, the two most important parts are the news element and the call to action. In other words, you do not just want to send a press release out because you have a nice photo. But, if you have a photo that connects with a cause, like images of cancer survivors for Cancer Awareness Month, you can organize a small event for the photos, write a release, and send it out, connecting yourself with a timely, newsworthy event. Your call to action is also

important because it tells why your photographs are important, as well as what you want people to do. In the case of a cancer-related event, you may want to offer to donate a part of your profits to a relevant foundation, or encourage people to come to your event. Use the following template for your press release:

Press Release Template

Media contact:
Your name:
Company name:
Phone number:
Fax number or e-mail:

TITLE OF RELEASE

FOR IMMEDIATE RELEASE: DATE — CITY, STATE

In one to two paragraphs, introduce who, what, where, when, why, and how. Include why your photographs or event is important now.

Insert personal or supporting quotes, facts, and statistics.

Call to action.

-XXX-

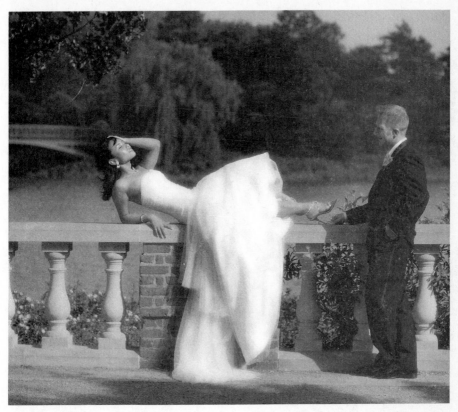

Photo provided by Argentina Leyva

Putting It Together

Now that you know the mistakes and a few simple ways to market your business, you can begin putting together your marketing plan. Like a business plan, this will also be your road map. Only this is more specific, as it deals exclusively with promoting your business. A marketing plan should be concise and to the point, but should include the different forms of marketing, including word of mouth, networking, and advertisement. This plan is your next step to launching the business you have always wanted.

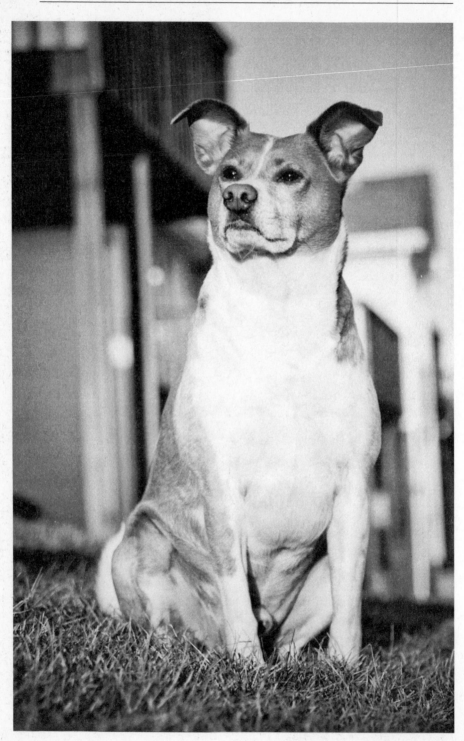

Photo provided by Sara Kirk

Chapter 8

Putting a Marketing Plan into Effect

Putting a marketing plan into place will be one of the most important things you can do for your company. You have to get your name out into the public to attract new customers, but you also want attract those customers by spending as little money as possible. By developing a good marketing plan, you can find the right balance to draw the customers in while saving your company's bottom line.

Starting Your Marketing Plan

No matter what your business is, the first question you should ask is, "Who are my customers?" You should know exactly what kind of person is looking for your services, what they want, why they want it, what their economic status is, where they live, and anything else that is possible to know about your target audience.

Try to describe your customers in as much detail as possible. Try to figure out their likes and dislikes. What do they do during the week or on weekends? What magazines do they read? What is their economic status? These are all questions that will help you better tailor your marketing strategy to meet your specific customer.

What is the best way to reach your customers? That will vary depending on who and where your customers are and what you are offering, but one of the best ways to find out is to talk to other photographers who are offering similar services.

Marketing is going to require hard work, but you will appreciate it later. If you market successfully in the beginning, you will have much less marketing to do in the future because you will build a referral-based business, meaning that you get repeat business from people who know people who have used your services. Establishing yourself takes work, but the unfortunate fact is that if you do not do this work now, you will have less work in the future.

Your final objective in marketing is to be the photographer that people think of in your area or within your specialty when they have a need for your service. To reach this objective, you will need to set smaller goals, which will chart your course along the way. The goals should fall into two categories: short-term and long-term. Setting goals is a time-proven method to ensure you actually reach your goals, particularly when you write them down.

When developing goals, they should be:

- **Specific**: Make sure goals are precisely defined.

- **Measurable**: Such as percentage of growth, number of clients obtained, leads followed up on, or dollars in products and services sold.

- **Achievable**: If your goals involve other people, are they committed, too?

- **Realistic**: Within the realm of practicality.

- **Time-bound**: Meaning that the completion of the goal must occur within a particular time or deadline.

Sample goal: *I want to establish myself as the number-one portrait photographer in my area. I want to shoot at least 70 percent of all portraits sought out by clients in my area by the end of this year. My staff will conduct follow-up questionnaires to get testimonials, and will seek to make my business the best local photography business.*

After writing down your goals, break them down into action points for further analysis. To achieve your larger goals, completing mini-goals is necessary.

For instance, your smaller goals might encompass marketing efforts, such as mailing 50 postcards per week, attending five networking events per month, and participating in a trade show on a quarterly basis to attract new leads for business. This will lead to the big goal of becoming the premier photographer in the area, or at least the one that people first think of when they need your service.

CASE STUDY: ESTABLISHING YOUR REPUTATION

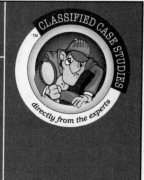

Darin Back
Darin Back Photography
121 Washington Ave. South, Suite 1709
Minneapolis, MN 55401
(763) 807-6564
darinback@yahoo.com
www.darinbackphoto.com

Through its unique business practices and focus on education, Photo-Shelter prides itself on aiding the evolution of stock photography.

Allen Murabayashi and Grover Sanschagrin met in 2002 as members of a popular photography community called SportsShooter.com. Sans-

chagrin, the founder of SportsShooter.com, had previously served in management roles at several large-scale online productions, including ChicagoTribune.com, NBCOlympics.com, NCAA.com, and Altpick.com. Murabayashi had served as a founding employee and senior vice president of engineering at HotJobs.com, where he assisted in the company's massive growth from a four-person start-up to a publicly held company with more than 675 employees.

Together, Murabayashi and Sanschagrin acknowledged the stranglehold larger stock photography outlets had on photographers, offering diminished rights and paltry profits. They knew there was a better way, so in February 2005, they founded PhotoShelter.com. Their unique business model focuses heavily on education to help the world of stock photography evolve.

The PhotoShelter Collection is a global stock photography marketplace where more than 32,000 photographers from 130 different countries contribute over 4,000 new images daily, for rights-managed and royalty-free licensing. Unlike traditional agencies that keep 60 to 70 percent of each sale, PhotoShelter gives photographers 70 percent of every sale.

Clients include Houghton Mifflin, Disney, Polo Ralph Lauren, Fortune Small Business Online, Tracy Locke advertising for Delmonte, *Travel + Leisure*, Obama for America, and Crispin Porter Bogusky advertising.

Where Are Your Customers?

Determining where your customers are will guide you further in determining how to allocate your resources and time. While you would not attend a monster-truck rally to drum up potential new architectural photography clients, it might be a good place to pass out business cards or to sponsor program advertising if you shoot automobiles or sports entertainment as a specialty.

Clusters of good customers can be found using the components of basic customer research. Understanding your customers is crucial if you wish to

do business with them. Begin this process by asking yourself the following questions about your average prospect:

- How old are they?

- In what type of industry do they work?

- What is their educational level?

- What is their approximate income range?

- What is their specific occupation?

- What are their buying preferences as it relates to your product or service?

- What products, services, and benefits do or might they buy from you?

- What are their buying patterns?

- How can you profitably reach them through promotion and advertising?

- How can you find more people like them?

Conducting occasional surveys with your existing client base is a good way to accurately know and understand the commonalities and differences between your clients and potential clients. Surveys also provide a good way to open the lines of communication, which may result in more business or referrals to you.

The questions you ask in a survey should cover the following:

- Descriptive information, including demographics, how the client found out about your business, and what influenced decision making

- How the customer uses products and services of photographers (buying behavior, traits of use)

- Customer perceptions, such as likes and dislikes and perceptions of value, benefits, and flaws

By opening up lines of communication with surveys, you will also let customers know that you care about their experience. Throughout the life of your business, their thoughts, opinions, and ideas will serve as a valuable tools to help you grow.

Be open to the feedback you receive, but also take it with a grain of salt. Not all feedback will be a rosy endorsement of your photography ability. Take into account criticism, and adjust your style when you feel it is warranted. But, always remember that photography is art, and art is subjective. Do not wildly change your approach because of one bad survey, as it may cause you to lose potential and existing customers down the road.

Once you have established who your customers are, their dislikes and likes, and where you can find them, you can start looking at your marketing mix. No business becomes successful by advertising to one group in one manner. Businesses need to attract customers from several areas and use different types of communication.

Your marketing mix is not set in stone, and using the survey discussed above is a good way to gauge how well your mix is working. You should review your marketing mix periodically to make sure it is best for business and for the community you are trying to reach.

Your "marketing mix"

Product, pricing, place, and promotion are known in the business world as the four P's that make up the marketing mix. These will help you strategically market your product and service. By offering the right combination, you will consistently experience positive results and effectiveness with your marketing efforts. Use the four P's to determine your marketing mix:

- **Product**: What are you selling?

- **Pricing**: How much will the client pay, and why?

- **Place**: Where can it be purchased?

- **Promotion**: What are the methods of communication that you will employ to let people know about your product, pricing, and place?

Each of these requires the others to make your business successful. Marketing is a strategy to make your business more successful by informing potential customers of your products and services.

Fundamental to the growth of any business, the action of marketing discerns the wants of a customer and focuses on a product or service to fulfill those wants, moving them toward the product or service offered. People who market create awareness of the product or service through marketing techniques, such as public relations, advertising, direct marketing mailers, branding, events, and market research.

Aim to inform customers of the benefits offered by your products or services. It also gives the customer what they need to know to make a solid buying decision. By remembering the four P's, you can give the customer the information they need on all your marketing materials — who you are, what you can do for them, where they can get your service, and how much it is going to cost them.

Your Marketing Budget

Costs for marketing can vary, depending on what type of photography business you have. If your business focuses on bringing in the public and taking portraits, you will want to get your company's name in front of as many people as possible. Newspaper ads, radio spots, and other types

of mass-media advertising may be the best way for you to promote your company. If you plan to work for galleries, shoot stock photos, or become a photojournalist, ads in specific trade magazines or direct mail advertising may be a more cost-effective route. Regardless of how you choose to market your business, it is essential that you come up with a plan.

To stay on track with your marketing, budget your money, as well as your time. The industry's average marketing budget is for 15 percent of every dollar you bring in to be reinvested in yourself for marketing your business. Note that industry averages base the 15 percent on gross, not net revenue. By doing this every time you are paid, you will have money earmarked for doing everything from sending out mailers to updating your Web site to attending a trade show.

Again, how much you spend in each form of advertisement depends on the type of photography business you are running, so be sure to break down your budget into different areas. For example, you could have categories, such as newspaper advertisements, networking, and direct mailers.

Determine how much you spend in each area, and be sure to review how each channel is working. Do not stick with channels that are not bringing in a good stream of customers to your business. That money would be better spent in the areas that are bringing in the bigger returns.

Also, no matter how busy you are, it is a good idea to put aside 15 percent of your time every week for marketing. It will pay off in the long run because it will keep the clients coming in, even during traditionally lean times.

Testing your marketing plan

In developing a marketing plan, you will need to estimate how many sales you expect to get from the strategies implemented, and how many dollars will be brought in as a result.

The first year you are in business, it is a good idea to experiment with a variety of methods, and then calculate the numbers. Electronic media, e-mail providers, and Web site hosting companies offer products that can help you track results through these methods. Knowing where your money is going and where it is having the most impact can help you adjust your marketing plan to get the most out of the money you are spending.

Your marketing plan should include many aspects of your business, including an estimate of how many sales you expect to gain with your marketing strategies and how much money these sales will generate. Then, compare your business' projected sales revenue to the cost of the marketing techniques you used to get these sales. By comparing the two, you get a sense of whether or not your company can expect to make money with your marketing effort. The ideal relationship would be a low marketing cost with high returns. This comparison will also be put in your business plan to show that, through your marketing efforts, you can expect the business to be profitable. As you have noticed from creating your marketing budget, the cost of doing business includes more than just the cost of selling the product — it includes the costs of production and operation, too.

Your long-term marketing strategy

Going through the above steps will dramatically improve your understanding of how your business will operate. Your purpose is not to simply produce a marketing plan, but to gain knowledge and insights about your customers and their needs. You will then need to determine how you will

meet those needs to be successful. Effective marketing research and market planning will serve as a foundation for your business for years to come.

Marketing is the lifeblood of any business. Successful businesses have a good marketing plan and, therefore, a good grasp of what their customers need. Over time, your marketing plan and strategies will change as new technologies and customers require change. Being able to adjust to these changes is an important part of your long-term strategy. Marketing cannot be a "set it and forget it" kind of approach. It takes considerable diligence on your part to keep your company's name at the top of your target audience's mind.

CASE STUDY: SPREADING THE WORD

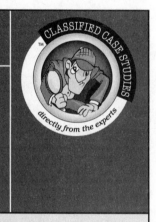

Richard Brown, principal, member
Canon Professional Association
Richard Brown Photography
1109 Elliott Avenue West
Seattle, WA 98119
richard@digitalvivid.com
www.richardbrownphotography.com
206-281-8943

I began shooting images when I was 12 years old as a hobby, and became published when I was about 21. At the time, I was helping run a family road construction business, working in a camera shop, coaching a ski racing team, working in the windsurfing industry, and running a small business of my own. I thought that, at that point in my life, it was time I picked one career and got serious about it. Photography was it.

I broke into the business by working with other established photographers, and then later went out on my own. Clients slowly started coming my way, with word of mouth being my best form of advertising.

Growing up in the country around Mt. Hood, Oregon, I shot a lot of nature and outdoor scenery in my early years. All the masters, including Ansel Adams, had a great influence on me. As time moved on, I became inspired

by fashion photographers, such as Richard Avedon, Albert Watson, Helmut Newton, and Bruce Weber. One of my favorite current photographers is Matthew Rolston.

Presently, I run my own 3,500-square-foot digital studio in downtown Seattle. I do not specialize because doing commercial and advertising work has made me good at many types of photography. To be successful, I am adept at quickly understanding marketing and visual communication issues and executing a wide range of photographic solutions. The setup I have, which includes full-service digital and traditional still photography, means that I own a lot of gear for the studio, as well as for location and travel shoots. My clients include the Bill and Melinda Gates Foundation, Microsoft, Amazon.com, Starbucks, Northwest Airlines, *Forbes Magazine*, the Seattle Seahawks, and many national advertising and design firms.

Targeted Marketing

When you start your business, you have a base customer in mind. This is the customer you believe will be most likely to use your services. As you start working in your field, you may find that your prediction was right on and your customer is who you thought they were. Other times, you may find that your customer is someone completely unexpected. You may have opened up a studio thinking you would photograph senior pictures for the local high school, but an increasing number of families are showing up at your door, not just high school seniors.

Whichever path your business follows, marketing specifically to these groups is a smart use of resources that will ultimately pay off. This specific type of marketing is called targeted marketing. Targeted marketing allows you to focus your time and money on a niche of individuals that are shopping for your services. The most common error new business owners make is assuming that everyone is a prospective customer.

Identifying your targeted market

Think of your prospective customer group as a large bulls-eye target. The center of the target is your ideal customer. Always focus your efforts and aim at the center of your target, and you will hit your mark.

By analyzing your customer base, you have been able to hone in on the best group of clients available to you. By aiming for the middle of the target, you are sure to find some success for your efforts.

Finding your target market involves more than simply looking at the customers coming through your door. There are other ways to find a customer base on which you can focus your energy and resources.

Finding out who the competition is marketing to

The best way to determine your target market is by researching your competition, or other photographers in areas with similar businesses. To determine your target market, make a list of these companies. For each one, ask the following questions:

- Where are they located?
- How is the business structured?
- How successful is the business?
- How long has the business been in existence?
- What do I like about their operation?
- What do I dislike about their operation?
- What seems to be working?
- What does not seem to be working?
- Who are their customers?
- Where do they find their customers?

THROUGH THE LENS

Photographs from Professional Photographers

Photo provided by Jason Henry

Photos by JASON HENRY

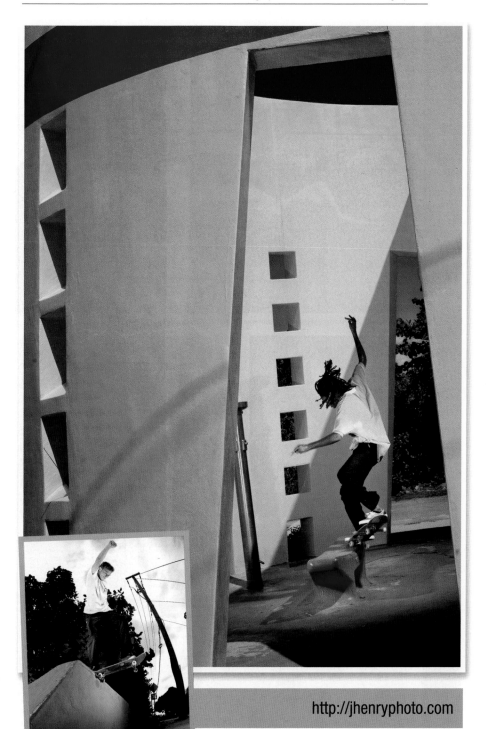

http://jhenryphoto.com

Photos by SIVAN GROSMAN

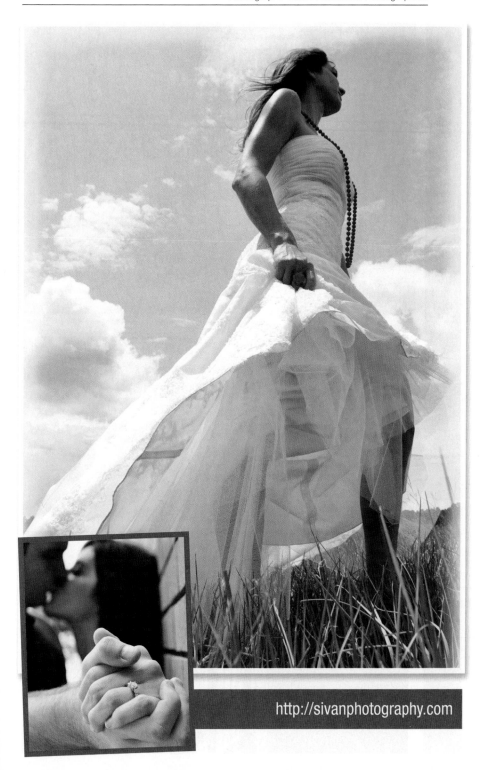

http://sivanphotography.com

Photos by JACK WATSON

www.jackwatsonphoto.com

Photographs from the book *Hidden Cuba: A Photojournalist's Unauthorized Journey to Cuba to Capture Daily Life 50 years after Castro's Revolution*

Photos by PIP BLOOMFIELD

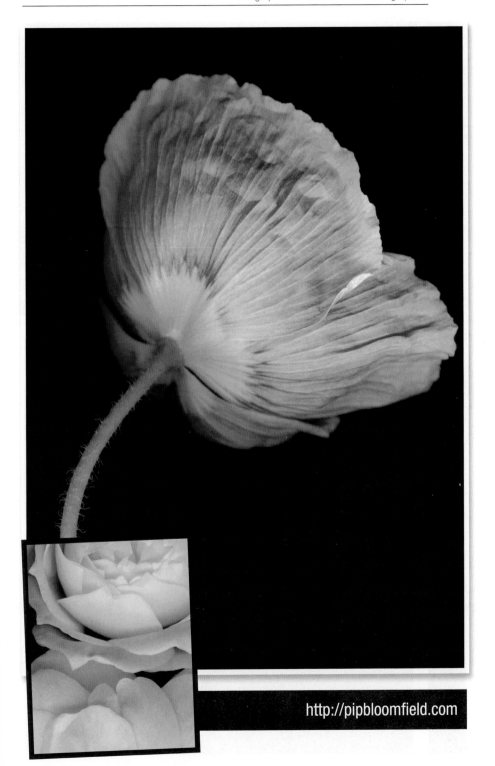

http://pipbloomfield.com

Photos by BILL LEMON

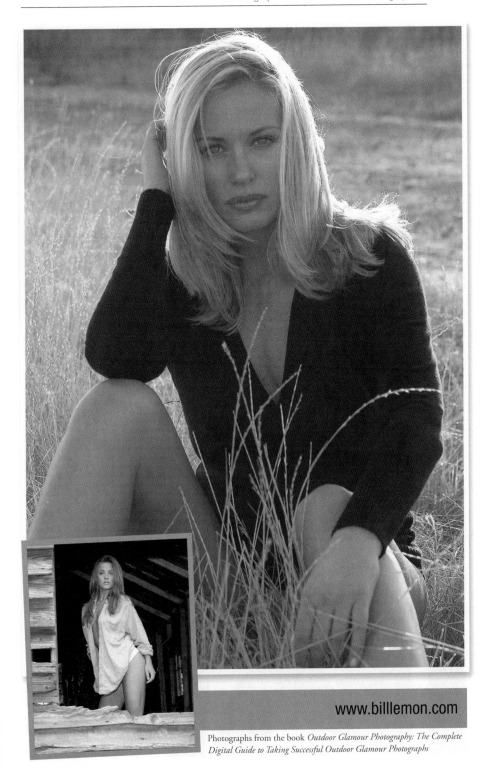

www.billlemon.com

Photographs from the book *Outdoor Glamour Photography: The Complete Digital Guide to Taking Successful Outdoor Glamour Photographs*

Photos by KAREN BRIDGES

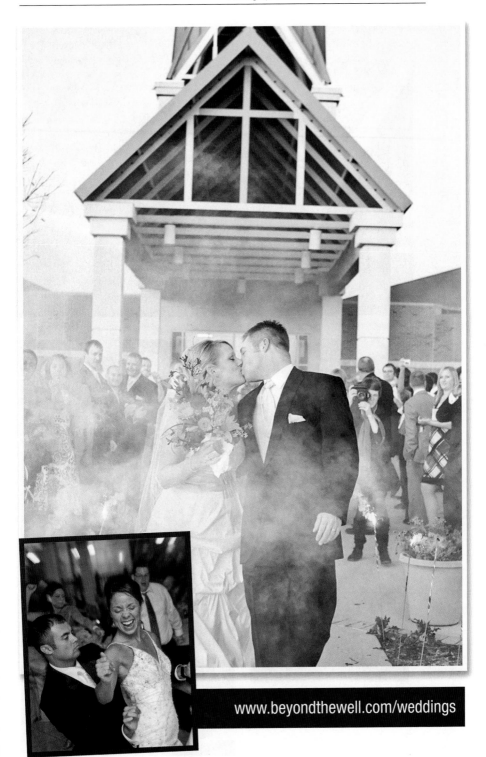

www.beyondthewell.com/weddings

Photos by JOY AUGESON

www.augesonphotography.com

Photos by EMILIE SOMMER

www.emilieinc.com

- What is their pricing structure?

- Aside from price differences, how do they differ with regard to goods and services offered?

If you do not know the answer to some of the questions, check the Web site for the secretary of state's office where these businesses are located. Basic business information may be accessible on the Internet. Some financial records can also be easily accessed, depending on the structure of the business. Your local library may have access to online business directories that will give even more detailed information. Searching your competitors' names on a search engine might uncover things that you do not already know, such as tips on how they are advertising, outlets for publicity, and professional organizations. If your competitor belongs to the Better Business Bureau, they also may have information posted on that Web site.

By looking at the preceding questions, you can determine whether or not these businesses are comparable to yours. Then, by looking at their customer base or getting in direct contact with them, you can find out who they target.

Once you have established that the businesses you have looked at are comparable, think about your business in contrast to your competition:

- What are your strengths?
- What are your weaknesses?

Looking at your answers to these two questions, you will be able to more accurately use appropriate verbiage and tools to maximize your strengths and minimize your weaknesses to draw the attention of new customers.

Getting in front of your market

There are many good marketing tools you can use to make potential customers aware of your products or services. These include, but are not limited to: publicity and advertising, Web site presence, e-mail campaigns, direct mail, trade events and gallery shows, and pro bono work. Marketing is all about creatively focusing on your goal and your targeted audience. Try to find new ways to get people thinking about your business.

Get their attention

Inspiring potential customers to do business with you instead of your competition may be as simple as educating them with details or entertaining them with your dazzling photography work.

How can you "wow" a potential customer about your products or services? And, after you have created the initial "wow," how will you keep the attention of the customer or develop the relationship until they choose to do business with you?

In the creation of marketing materials, sell your benefits. Surprise a customer with your approach or innovation, or give a new twist on an old theme. If you are going after commercial work, try injecting irony or shock into the visual, whether that be in the verbiage or the image. Get creative and have fun. The point is to get someone's attention and be remembered.

Opening doors and establishing relationships

No one likes cold calling, but it is a commonplace technique in establishing new business for one reason — it works. Once the door is open, use your marketing tools often to keep in touch with your potential customer.

The sweetest sound a person can hear is his or her own name. Simple things, such as calling someone by their preferred name, and doing it often, can make a big difference.

If you and a potential client grew up in the same town, you share a common bond. Through nurturing common bonds, and possibly even sharing similar memories, sales are made and new customers are born. This personal information is collected using a 66-point customer profile questionnaire, and then documented and tracked using customer contact management systems, such as ACT!™, Goldmine®, and Outlook®.

Looking at the value of a customer

Now that you have begun to outline your marketing plan, it is time to start looking at your customers and why it is important to keep them happy and have them become a large part of your marketing plan. Never underestimate the power of word of mouth and the things that a favorable recommendation can do for your company. Approach each customer as though making them happy will lead you to three more customers. The reality of the situation is that if your customer is a happy customer, he or she will tell friends or colleagues, meaning that you will get more business.

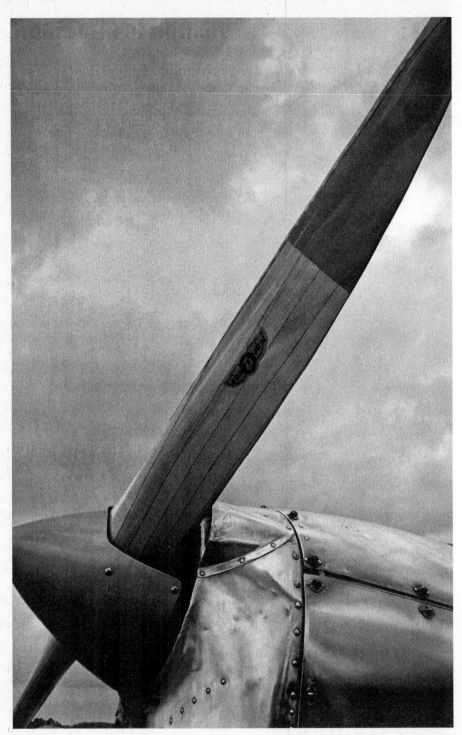

Photo provided by John Slemp

Methods to Include in Your Marketing Plan

You can market to the right people, put your ad in the right trade magazines, and hit all the radio spots you had targeted, but none of these techniques will benefit your business more than a happy customer will.

Keeping your customers happy is important to your business for two reasons. The first is that if they are satisfied with your work, there is a good chance they will come back to you the next time they have a need for your services. The second is because word of mouth will drive a lot of business to your company.

In both of these scenarios, your dollar-to-customer ratio is quite good. Whether it is a repeat customer or a customer you picked up because of good word to mouth, it did not cost you anything in marketing to get them into your business.

The Cost of Acquiring a New Customer

Getting customers to think about your company is the number-one goal of your marketing strategy. Most of the time, however, getting those customers will cost you in ads or other marketing techniques.

It is important to know how much it costs to acquire a new customer so you can budget and plan accordingly for the short- and long-term. How many customer contacts are required before a sale is made depends on many factors, including your specialty, target market, and the methodologies you are employing to reach out to that customer.

For instance, if you are cold-calling and it takes 50 cold calls to make a $5,000 sale, then every time someone tells you "no," you should reply, "Thank you" instead of being discouraged. Think of every "no" as being one step closer to hearing "yes" from someone else. Every "no" in this scenario could be equated to someone handing you a $100 bill.

This is where keeping your customers happy will yield you the most benefit. As you start gaining repeat customers, or your business grows through word of mouth, the effort and cost you need to put into getting new customers can start to go down.

The key to running a successful business is getting your loyal customers to keep coming back, while attracting new ones to your business. If you just attract new customers without retaining some of your former clients, it can hurt your bottom line.

Cost of Replacing a Customer

In 1906, a French-born Italian economist named Vilfredo Federico Damaso Pareto began noticing commonalities in business that still ring true more than 100 years later. The Pareto Principle equation essentially states that 80

percent of your business will be derived from 20 percent of your clients. In the same measure, 80 percent of your incoming business will result from 20 percent of your marketing efforts.

Unfortunately, you cannot get rid of 80 percent of your customers and just keep the most profitable 20 percent. Every client matters, and customer satisfaction can make or break your business. Furthermore, it is far more expensive to lose an angry customer than a happy customer.

Consumer research shows that it costs five times more to get a new customer than it does to keep an old customer happy. Marketing techniques, advertisements, and flyers take money to produce, but, through providing competent, courteous service, you can generate customers through word of mouth advertising, which costs you nothing. If someone has had a good experience with you, they will tell others. Thus, you will keep old customers happy, and potentially gain new ones. But the reverse is also true. Dissatisfied customers will also share their unpleasant experiences with others, which harms your business.

Findings from a 1985 study conducted for the White House Office of Consumer Affairs, as reported by the Research Institute of America, back up this statement:

- 96 percent of unhappy customers never complain about rude or discourteous treatment; but

- 90 percent or more who are dissatisfied with the service they receive will not buy again or come back;

- Each unhappy customer will tell his or her story to at least nine other people; and

- 13 percent of those unhappy former customers will tell their stories to more than 20 people.

Customer feedback should be seen as an opportunity, even if a customer is terribly upset. You cannot make 100 percent of the people happy all of the time. Offer substitutions, discounts, or freebies to keep customers happy if they are disgruntled.

Note that some people are just complainers, and nothing you do can change that. You may never be able to make some customers happy, no matter how hard you try. But, what you can do is be proactive and keep improving your methodologies, services, and communication in the areas over which you do have some control.

The Lifetime Value of a Customer

Repeat customers are your steady income. Companies that believe in service excellence put the customer first because they want their customers to come back. Those companies consciously create a feeling in their customers that their service exceeded that of the competition, and therefore, the customer does not need to go anywhere else to purchase your product or service.

How long you can expect to do business with your average customer varies. For some, the lifetime value is short — a one-off situation for a special event, such as a wedding. From planning to event, the lifetime could be anywhere from days to months. In other specialties where there is little client turnover, the lifetime value of a customer could range into the decades.

Knowing how long, on average, a customer goes away before they come back to you can be a useful promotional tool. For instance, Illinois-based photographer Argentina Leyva *(Chapter 12)*, has grown the lifetime value of customers by staying in touch with her wedding clients. After the weddings, Leyva's clients started to have children and asked the photographer to continue the professional relationship by photographing their new family. Leyva has begun to implement marketing efforts based on the trend.

In order to calculate the dollar lifetime value of a customer, you must first calculate an average customer value. Ask yourself: What is the average sale you make, or expect to make, in your business?

Take the average price and deduct your costs, including marketing costs. The number you are left with is your net profit per customer.

If you have repeat customers, multiply the average number of purchases the customer makes with the net profit per customer number. What is revealed will be the lifetime value of your average customer.

Use customers to get customers

Some photographers grow their businesses based on customer request, which is just one of the many ways to increase customer retention. Some value-added strategies that will keep them coming back for more include:

- Offering your customers special offers, discounts, or preferential treatment

- Sending thank you notes, welcome letters, and other acknowledgements of recognition

- Communicating with your customers about special events or workshops in which the customer may be genuinely interested

- Administering after-sales satisfaction surveys and complaint inquiries

The more you can get your existing customers to spread the word about you and your business, the better your chances are of expanding. Use your existing customers to create buzz about your business.

Asking for referrals

Your clients are your best sales staff. They know what you can do, they understand the value of your services, and they know people who would be interested in those services.

There are two reasons why your customers may not be automatically referring their friends and colleagues to you. First, your clients may not think about sending referrals your way. They just do not connect you with their friends because you have not informed them that you are a referral-based business. One way to get your clients to refer you is to ask them specifically about an activity they are involved in, like a civic club, and then ask if anyone they are close to in that group might have a need for a photographer. All you have to do is ask. If your services met or surpassed their expectations, they will be happy to refer their friends, family, and colleagues.

The other reason your clients may not be helping you grow your business is because of how they are referring their friends to you. The first way to overcome this barrier is to determine the ideal client you would gain from a referral. What are you looking for in your new clients? Are you looking for someone who can attest to your skills as a photographer, or who can tell about how well you worked with their children? Share these things with your current clients, and be specific. Ask them to call the people they have thought of and ask whether or not you may contact them.

What Exactly is "Word of Mouth" Advertising?

The best way to build word of mouth is by providing good service to your customers and working hard to meet their needs. Develop a dialog with your customers. Spend time educating people about who you are, what you do, and how you are unique.

Do not be afraid to have a stack of business cards ready to give to a satisfied customer and ask them to help you out. By engaging them in your business, you are giving them a share in the business, and they will not be afraid to spread the word.

Do not hesitate to ask for help from others to find different ways to spread your company's name through word of mouth. Sometimes the best ideas will come from other people, not from your own experience. Asking other people for their perspective not only helps you, but it enlists other people in your process so they, too, are invested in your success.

Building word of mouth

There are many ways to start building word of mouth other than just through satisfied customers. Most of these techniques are the opposite of the targeted marketing strategy. With word of mouth, you want as many people as possible to know about your business, what you do, and what makes you unique. The idea is that if they are at the supermarket, a dinner party, or maybe a child's function at school, and they overhear someone talking about having a need for your services, they will speak up and talk about your company. The best source for word of mouth is through people you already know.

Consider hosting a series of informal pizza nights, where you gather together friends, family, clients, or colleagues with the purpose of helping you come up with new strategies for getting the word out. Then, implement the ideas and give feedback to those whose opinions and input were valuable to you. While you are undergoing this experiment and information-gathering session, do not hesitate to ask for referrals.

It is okay to brag about yourself and your capabilities. At the same time, when asking for advice, it is important to listen to the experience and stories of other people whose opinions, referrals, and ideas may be of benefit

to you. Referrals cost you nothing except the time to follow up and thank the person who gave you the referral in the first place.

Practically outrageous marketing

One of the good things about photography is that it is art and, depending on what your business is focused on, people may expect you to take a little artistic license with your advertising and how you call attention to yourself.

If your business involves taking family portraits or portraits for executives, outrageous marketing is not the way you want to call attention to yourself. Those customers are looking for a down-to-earth, highly professional photographer who will take a nice, tasteful picture. But if you are trying to sell your work in art galleries, taking photos while standing on your head in downtown Manhattan might just create the buzz and media coverage you are looking for.

Of course, not all off-the-wall marketing schemes need to be as dramatic as this example. The key is to think beyond your comfort zone and do something most people would not expect.

Madcap marketing ideas have the potential to draw attention to your business through use of inexpensive, eye-catching trinkets, verbiage, or photographs. For ideas, peruse your local dollar or discount stores and check online vendors, such as eBay®, for items that you can give out or mail to potential clients without breaking your budget. For instance, if you are starting a baby photography business, consider mailing out miniature rattles with an announcement that you have birthed a new venture, and invite potential customers to check out your bundle of joy online. If you work in a studio space, host an open house with a clever theme. You may even want to be provocative or silly in your approach.

Building special offers into your marketing strategy

Not only are clever marketing ideas a good way to bring attention to your business to attain new clients, they are also a good way to keep your business constantly in the minds of potential clients.

It is a good idea to have promotional items printed up, such as writing pens, T-shirts, and refrigerator magnets that contain your contact information and Web site address. You may also want to consider going the extra mile for a client by having their favorite photograph printed on the front of a shirt and putting your contact information and logo on the back. Unique items like these will start conversations and lead to others talking about your business, and there are no ends to the possibilities when working with promotional items. Get your name, logo, and images out there, and then periodically review what works and what needs to go.

It would be easy to lose money by offering coupons and certificates. The key is to make sure that, when you determine your projections for income during the year, you plan on offering coupons and certificates, and you plan those into your financial and marketing strategies. These promotions can then help you improve your income, rather than cutting your income by taking in "less" than you originally planned. You are not going cut-rate in this case; you are doing planned promotions — there is a big difference.

Special offers

The value of a special offer for building relationships is often overlooked. Many businesses do not continue offering specials to their existing customers because they figure those customers will come back solely based on their previous experiences.

Although the truth is that they probably will, you still want to offer perks to them, too. Convince them to come back to you soon and cement your

position as their photographer — it is important that you are the one who comes to mind when they need someone to capture a special occasion. You also want to make them feel as though you are reaching out to them, as one of your customers, and are offering a special exclusively to them because you want their business.

Even the simple act of offering a coupon to customers once a year can vastly improve your relationship with them. Even better, however, is offering a certificate (use that word instead of coupon) for their wedding anniversary, or perhaps their children's birthdays, to have family portraits taken. You will be amazed how many of your previous customers will come back for more photos, and how many of those will say they would not have thought of taking a family portrait for that occasion if it had not been for your offer.

Introductory offers

You have probably received plenty of introductory offers from businesses wanting you to try their services or products. The goal of these offers is to get customers in the door, knowing that once they try your product, they will keep coming back for more. It gives the customer less of an investment so they may be willing to try your services since the price is reduced.

There are various ways to do this, but a direct mail strategy usually works well, especially if you are offering services to local customers who fit a specific profile, such as ad agencies or couples with new babies. You can use the social network that you created on Facebook or Twitter to send out offers, or you can take out an ad in the newspaper. You should also put the introductory offer prominently on your Web site so those browsing the Web for photography services will see they can get a discount if they go with you.

Regardless of the way you choose to offer an introductory service, be cautious. Take, for example, the new pizza place in town that mailed postcards for a free pizza to residents in the restaurant's surrounding area. They went out of business within three months because of that mailing. They did not make a practice of collecting the postcard when it was used, and many people redeemed it five or six times. They lost too much money in ingredients and could not sustain the business. The moral of this story? If you send out a free offer, make sure you collect the coupon.

Sales

Many photographers do not have sales, but offer coupons or certificates instead. The prevailing opinion seems to be that the word "sale" makes them seem less like a professional and more like a discount store. Certainly, some photographers have sales, but the majority prefer other types of marketing and discounted offers, like a free photo or proofs.

There are many ways you can get more sales as a photographer, no matter what kind of photography you are doing. There are many options for photographers to sell more of their work, which will be discussed in a moment.

Referral organizations as marketing strategy

Of course, the goal of your marketing efforts is to create more business from former clients, current clients, or potential new clients. Although organizations that you already may belong to and people in your existing sphere of influence — such as your friends and family — can be wonderful sources for referral business, it is sometimes a good idea to look outside who you already know to broaden your options.

Referral organizations, also known as leads clubs, are a valuable way to meet new people and attain pre-qualified referrals to potential new busi-

ness. Many of these groups meet on a weekly basis, allowing members the opportunity to learn about each other and pass referrals on from person to person over breakfast, lunch, or drinks. The idea is that regular communication between members increases understanding about each others' businesses, ensuring that the leads are fresh.

The relationships are reciprocal in nature, and only one person of each business type tends to be allowed per leads group. For instance, if you are a wedding photographer, you may be able to act as a conduit between your wedding client and a real estate agent that specializes in selling houses to first time home buyers. At the same time, a person in the group specializing in makeup who recently did business with a woman who is planning a wedding would pass the information off to you as a valid lead.

To find organizations in your area, run the terms "leads clubs" or "referral clubs" through a search engine, or check with your local Chamber of Commerce.

Marketing on the Internet

The techniques previously described are low-cost ways to get your name out to the public, and another low-cost marketing alternative is marketing on the Web.

Internet marketing provides a wonderfully inexpensive and noninvasive way for potential clients to check out your work at their convenience, 24 hours a day, seven days a week. Web sites or e-mails are tools that can prequalify potential clients before you meet with them, and save you even more time and money in the building and running of your business. Free and low-fee advertising listings get your name out there on the Web.

Statistics from a May 2008 study conducted by Forrester Research indicate that 48 percent of companies currently marketing through social net-

working sites, such as Facebook, MySpace, Classmates.com, and Twitter expect to increase their advertising spending via these avenues (*for more information about social media avenues that you can use for your business, see Chapter 14*). Businesses of all sizes have been reaping rewards from marketing efforts through these channels. Specifically, the benefits reported — according to a 2008 report by eMarketer — are due to ads on the sites targeted to express interests and advertising to a local market segment. For instance, people who are getting married may see your ad on Facebook and want to hire you.

Even the free services featured on these social networking sites offer great benefits, as is the case with Nathan and Karen Bridges of Beyond the Well Photography (Chapter 4) in Bloomington, Illinois. The Bridges have built a large social network on Facebook.com, and Karen attributes it as a key piece of their Internet marketing success.

"I use it to connect with friends from high school and college, as well as family members," she said. "Now, just about everyone knows what I do for a living and can see photos that I post from weddings online, as well as have the option to refer people that they know by drawing attention to our photos and profiles with a link or blog mention."

Karen said she believes the people who have the most success with this type of marketing are "young, Internet-savvy types" who have amassed a large social network instead of a random collective of names. "In our case, these are certainly people who would not have otherwise known that this is my career," she said. "Thanks to Facebook, they now know that I am an option if one is engaged and planning a wedding."

Getting customers to your Web site

Just because you build a Web site or create a profile on a social network does not mean that the customers will come flocking to you. Instead, you

will have to work the system regularly. Bear in mind, also, that technology changes constantly, and what works today might not work a month from now. This is particularly true within the realm of search engine optimization (SEO) — the process of increasing volume and traffic to a Web site from search engines using algorithmic formulas of targeted keywords or phrases.

Search engines are tools that people use to explore the Internet. Depending on the type of photography business you operate, different keywords will be needed to optimize your search engine placement. For those businesses that operate within one area or field, including your geographic location or your specialty will be key to helping customers find your Web site. For instance, if you are a wedding photographer based in St. Louis, Missouri, you may have the words *wedding photographer, St. Louis, wedding St. Louis, photographer St. Louis, wedding services St. Louis, creative photography, artistic photography, digital photographer, St. Louis bride, bridal photos*, and *St. Louis bride and groom* tagged in the creation of your Web site.

Since the combined list of words is endless, employing the assistance of a professional SEO consultant can help focus the words that will provide you with the greatest impact to increase the draw to your site. They have access to tools that run statistical analysis on data and word combinations.

The reality

Without a strong online presence that potential clients can find, you will be wasting your time. This warning comes directly from Chicago photographer Rob Domaschuk. Domaschuk spent approximately 20 hours with a Web site developer establishing his initial Web site's search engine to be customer-friendly. He spends anywhere from one to five hours each week working on SEO.

What is wrong with most sites

The Web offers the ability to store, share, and distribute information pertinent to marketing your services. It serves as an online brochure that can be updated frequently. The most obvious problem with Web sites is, on the surface, poor design. The best way to overcome this is to hire a designer whose work you like, or to build your own Web site through a hosting service or other template. If you want to do it yourself and do not presently know how to do so, take a class in Web design at your local university or community college.

On your Web site, include as much information as you can so potential customers can get a sense of your personality in addition to your work. Think about the navigation of the site. Will people be able to find the galleries, FAQ section, or contact information easily? Or, will they get confused? Does it take too long to load? Does it work with every browser?

For some reason, many companies go out of their way to keep Web site visitors from making contact, either via phone or in person. Although leaving this information out may initially seem like a good way to increase your productivity, it is off-putting to many potential customers and is reason enough for someone to choose another vendor. Post your contact information on multiple pages so you are easy to reach. It need be nothing more than your name, e-mail address, telephone number, and city and state.

You are selling your photography, so there is no reason to make your site content-heavy with fancy copywriting. Keep it simple. Introduce yourself. Show your work. Share the benefits of doing business with you instead of your competition. Give pricing so you do not attract people who cannot afford you. Give your contact information. Also, make sure you have a Web site address that people will easily remember.

CASE STUDY: LIFE'S MOST STUNNING MOMENTS

Sivan Grosman
Sivan Photography
http://sivanphotography.com
SivanPhotgraphy@gmail.com

For college student Sivan Grosman, it all started with the birth of her niece. Since she was born, Grosman took pictures of her every chance she could, realizing how much she enjoyed working with kids, and how much she enjoyed capturing special moments for her family.

After working at a portrait studio for a few months, Grosman's love for photography grew even more, prompting her to get outside and photograph people in places other than a studio. In June 2009, Sivan Photography was born with the mission of "capturing life's most stunning moments," especially when it comes to special engagements, expecting parents, newborns, and children. While Grosman enjoys shooting all types of subjects, she is particularly fond of her work with children.

"Children are so full of love and energy, and to be able to capture those pure moments for their parents is a great feeling," she said. "I love being silly in an attempt to make them laugh."

As a small, new business, Sivan Photography relies on current clients to tell their friends and families about their experiences in hopes that when that special occasion arises, Grosman will be the photographer they choose to hire. Because there is always someone looking for a photographer, the young photographer said she has been able to use this word of mouth marketing technique, but she has taken other measures to show off her work.

Grosman purchased a template and built her own Web site (**http://sivanphotography.com**), putting everything together herself. Her site includes various albums, separated by category, as well as a section about her and her contact information. One of the most important parts of her site, she said, is her testimonials section, where clients share their experiences with Sivan Photography.

The magic and menace of e-mail

If you want to reach a large number of potential clients inexpensively, e-mail is useful, but does have limitations. Unless you are already in a person's address book, your e-mail to them could bounce back or not be delivered at all due to SPAM filters. E-mail also requires the recipient to click on and open up what you have sent to them, so there is no guarantee that the people you are contacting are actually reading your messages.

However, sending e-mail costs nothing except the time to set up and maintain a contact list. Once the setup is complete, you can reach a mass amount of people with just a few clicks of a mouse.

To increase the likelihood of people opening your e-mail, put together monthly or quarterly newsletters and send them out. Make sure the newsletters contain useful information about you and your business, and give the reader a reason to want to read it by offering them some type of benefit. What will a person learn from opening your e-mail newsletter? Include news that will entertain, inspire, or educate.

Avoiding the label of spammer

Unsolicited commercial e-mail, or SPAM, is not only irritating, it could be illegal, depending on your Internet service provider (ISP) user agreement. To keep from being labeled a spammer, make sure you only send marketing e-mails to people who have opted into your mailing list through your Web site, by being an existing client, or from a source or referral where there has been a request made for you to be in communication.

Building your opt-in list

To begin building your opt-in list, contact everyone that already is in your address book and ask them whether they would like to receive peri-

odic communication from you about your photography business or not. If the person says "yes," add them to your opt-in list. If they say "no," be respectful and adhere to the person's wishes. This is similar to the small checkbox you often see when you are ordering something online that asks if you wish to receive a certain product from that company, or from a related company.

When you meet someone new, ask if they would like to be added to your e-mail list, and then use e-mail to follow-up. Also, at the bottom of marketing e-mail, always include a line that gives instructions for how someone can opt out. A lot of businesses simply ask for an e-mail back to the address of the sender with the word "remove" in the subject line.

By taking these steps, you can maximize your return on your marketing dollar. Using low-cost techniques and getting current customers to come back and bring new customers with them can grow your business while shrinking your marketing budget.

Photo provided by Sivan Grosman

Chapter 10

Setting Your Rates

ustomers are flocking to your company after putting your well-planned marketing strategies into effect. Now, you need to determine what you are going to charge. You can find the cost of running your business day-to-day and find a number that will help you meet those needs, then add a little more for profit. But, more thinking than that will need to go into your rates.

A group of employees at a catalog company were discussing the sales performance of a particular golf gadget. They had originally sold the golf gadget for under $10, and it did not sell very well. Recently they had raised the price above $10, and it was suddenly a hot-selling item.

Common sense would say that this should not be. The lower price should equal more sales. The explanation they discovered was that golfers expect their equipment to cost a little more. The customer looked at this product and the price tag and concluded that, at that price, it must be a piece of junk.

When the price was raised, it then became more in line with what the customer was expecting when they were looking to purchase an item for use

on the golf course. The lesson here is that charging less is not always better if it cheapens your product in the customers' eyes.

In the photography field, customers will expect to pay a little more for your services to get quality work. So, not only do you have to worry about being overpriced, you have to worry about being underpriced.

Common Mistakes of Creating a Price List

Charging too little

It is easy to price yourself too low. In addition to possibly cheapening your reputation, there are two other consequences. The first is that you do not make as much money as you could, and the second is that you end up working primarily for price shoppers, who tend to be high-maintenance customers.

To determine what you should charge, find out what the going rates are in your area, and price yourself at about the middle of the pack. Do not try to compete on price, but also do not price yourself with the superstars until you are one; most people will not question your rates if they seem reasonable.

The main question is, "Are your rates reasonable?" If they are, you should be able to sell yourself based on your work, without having to justify your rates at all.

You will have better customers and enjoy your work more if you charge higher, but reasonable, rates because you will attract customers who value your work. The bottom line is that if price is the main consideration, people will go to the Walmart portrait studio, and you can never compete with that.

Giving overly generous terms

You should give terms if it is customary for your type of business with your type of customer, but you should make sure you adhere to industry standards and do not loan your customers interest-free money by giving terms that are overly generous.

Enforce your terms, or the criteria customers must meet to receive your services while deferring pay to another date. Do not continue to extend credit to customers who have not paid, or those who are slow at paying. You are in business to make money, and you do not want, or need, customers who do not pay on time.

The amazing thing about weeding out customers who do not treat you well is how much energy and time you have for your good customers, and how many more good customers you have when you have the time and energy for them.

Lowering prices too quickly

You should maintain your prices at their initial level because lowering them sends the wrong message, both to your customers and to yourself. If you need to generate funds quickly, have a sale or offer a special, but do not permanently lower your prices. If you do, your customers will come to see you as a low-price alternative, and many may question the quality you can provide if you have to lower your prices soon after going into business. There are always alternatives to lowering prices, and you should always take the alternative.

Stating a day rate

Many commercial customers will ask you for your day rate, or how much you charge per hour or for a day's worth of work. If you give these custom-

ers a day rate, you may be costing yourself money. This is because some customers will start haggling with you over how much of the day you actually worked, and many will object to anything other than photography being included in the day rate.

Instead, quote a creative fee based on what is involved in the project, and include your time planning and processing images on the computer. Include any time you will spend on the project, and always insist on quoting for a specific project. The rule for creative fees is that anything you do toward the project is billable and should be included.

Not justifying your rates up front

One of the problems you may face when you start your photography business is that people may not feel that what you are offering is worth what you are charging. If you believe your rates are fair, you have to convince other people of this, preferably before they have time to think about it.

The first way to do this is to look like you are worth what you charge. Everything about your business — from your lobby to your camera bag, your wardrobe to your business cards — should scream "professional photographer." You have to look like a pro to charge like a pro.

Back up your initial image with a portfolio of fantastic work. A few amazing pieces will do this much more effectively than 20 or 30 good pieces. Do not allow room for doubt. In other words, just state your prices. Do not backpedal or try to justify your prices at this point. Do not go back over your portfolio to try to justify your rate. State the prices, and let your customer absorb them. Do not act nervous or as though you do not think you are worth what you are asking.

You may have to justify your rates at some point, but when you are first starting out, it is important that you do not apologize for your rates or

offer to lower them. Have a printed fee schedule that states your rates. If someone asks for a discount, offer to give a new quote on a smaller range of services, but do not lower your prices.

Pro bono work

It will always build your professional character, reputation, and portfolio to work for a good cause without a fee. But, you should recognize that pro bono work costs you time and takes you away from other work that would pay. You need to understand what you are getting from the arrangement, and make sure that you always get public credit for your work.

Taking photos at an organization like the YMCA or the Boys and Girls Club could be a great way to get your name out there, and is an example of pro bono work. For studio photographers, you will be reaching many parents and guardians who may want photos of their children taken. If you are a freelance photojournalist, encourage these organizations to send your photos to local newspapers as a press release. This will get you published and get the editors at the newspaper familiar with your name.

Fee Structure and Price List

When starting a new business, it is good to have a general idea of how much you want to charge, taking into account market values and your costs of operating your business. Your fee schedule can be your guidepost, but should be able to be adjusted if market conditions warrant either increasing or decreasing your prices.

For new photographers and business owners like Sivan Grosman (Chapter 9), coming up with packages and fees can be difficult. In Grosman's case, the Orlando-area photographer had to learn more about the field before putting a price on her work. But, because there are so many photographers out there, she said she learned early on that it was important to learn the industry and be aware of

the competition in her area. She ultimately created a fee schedule, which included packages. "I include images that are fully enhanced on a disc," Grosman said. "This part is important for my clients to see because they do not have to worry about ordering expensive prints. Once they have the CD, they can do whatever they please with their photos."

Your "private" fee schedule

You should know what your hourly rate will be, though you will not be sharing this information with your customers. This is information you need to determine what you are going to charge, but not information your customers need — they only need to know what your final fee to them will be.

Make sure you add the cost of your materials when figuring your fees; you should get paid for what you have put into the project. Also, include your overhead because you are running a business. Be realistic about how much time things take, and pad your fees a little in case something takes longer than you expected.

Creating a fee schedule

For portrait sittings and the like, have a fee schedule that describes the type of sitting, what is included, and the fee. If you offer extra services, such as hand-tinting or retouching, list these separately on your fee schedule.

Price lists for products

Add a reasonable markup to your products. You can ask around to find out how much other photographers are marking things up and get a feel for how much customers expect to pay for the items you are adding to their package. Keep in mind that you are selling more than the sum of the parts, and you should charge accordingly.

You should make a healthy profit for just that reason. You are not selling a picture and a frame; you are selling a professionally framed picture, which is worth far more. Your customers understand this and expect it to cost more.

Justifying Your Rates

At some point, you will be called upon to justify your rates. No matter what service you offer, no matter how good your photography, someone will always want a better deal or think they are getting ripped off. Knowing what to do if this circumstance arises will keep you prepared and level-headed when you need to defend your livelihood.

"My nephew takes pictures"

Some people always try to get a better deal by trying to downgrade what you do. You will probably encounter potential clients who will say, "My nephew takes pictures (and I do not want to pay you this much)." The correct response to this is, "I'm sure his pictures are very nice. Is he a professional?" You may also say, "If you would prefer to use your nephew's services, that would be perfectly understandable."

Never lower your prices because someone has a relative who takes photos. You are the professional, and what the client is paying for is professional-quality work. If he or she wants their amateur nephew's work, that is their choice. They are not paying for just photos; they are paying for the quality of the photos.

"If you are using digital, that should be cheaper, right?"

This question usually comes from people who do not know anything about photography and honestly think that if you are not paying for film and developing, you should charge less.

The best way to handle this objection is to explain, honestly and politely, that digital photography involves as much work, if not more because of the editing and retouching phase, and that your rates are competitive with other photographers using digital cameras and processing. Remind customers that they are hiring your creative mind and eye, and not the camera that you are using.

Justify your rates with your work

If customers see work that is absolutely outstanding, they will want you to work for them. Hopefully, any doubts will evaporate in the face of your skill and value. Really strut your stuff in your portfolio.

Refuse to play games

In the end, some customers will always try to talk you into lowering your rates for some reason. Do not play games. Do not lower your rates; adjust your quote to reflect less work for less money, but do not discount your work. Customers who convince you to lower your rates will always consider you less than you are.

What You Are Truly Selling

When coming up with your rates or having to justify your bill to a customer, it is easy to lose track of what you are actually selling the customer. You are an artist, and your work cannot be measured in just how many batteries you used and whether or not digital photography is cheaper than film photography.

CASE STUDY: ADDITIONAL CONTENT MEANS HIGHER FEES

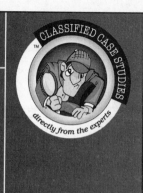

Diana De Rosa
Diana De Rosa Photography
http://presslinkpr.com/gallery2/main.php
diana@presslinkpr.com
(631) 773-6165
45 Sarah Drive
Farmingdale, NY 11735

It has been more than three decades since Diana De Rosa started taking photographs professionally. A board member of the Press Club of Long Island, De Rosa is an active journalist who found her niche early on in packaging her stories with pictures to help tell the story.

The result? She sets herself apart from other photographers, and her pay reflects that. With her journalistic style, she usually shoots on location and does not have a studio. In shooting, she prefers natural light, and does minimal work with editing programs, like Photoshop.

While her specialization is in equine photography — shooting horses and horse events — she also shoots a lot of even photography, including her coverage of six Olympic Games.

"Shooting the Olympic Games is a trip because you are up close and personal," De Rosa said.

Over the years, De Rosa's business has grown. She started out just shooting for newspapers and other media outlets, but now she also does work for people who like her photos, she said.

Creative vision

You offer something totally unique because no one else sees what you see. You have developed a style that is completely yours, and no one else is as good at that style of photography as you are. Others may do "similar" work, but similar is not the same.

Your creativity is valuable, and you are worthy of being paid for doing something that no one else can do in quite the same way.

Technical know-how

You are a professional photographer, and that makes you an expert at what you do. You are experienced, and your time is valuable — you have made it valuable by learning and developing your talents. Good customers understand the value of hiring a professional.

Talent

You are good at what you do primarily because you have a good eye and know what makes a stunning image. That is not something that can be trained, and you are selling this talent on the open market when you become a professional photographer.

Experience

Obviously, the more experience you have, the better. Play up the background you have and the years you have been taking photos. Remember that you do this for a living. You are a professional.

Unique images

Again, no one else can produce the images you can. You are your own photographic muse, and you are unique. Your style cannot be faked. To get what you offer, customers need you.

Paying Yourself

One of the most overlooked areas for new business owners is paying themselves a proper salary. Sometimes photographers get caught up in the fact

that they are the business, and put the needs of the business before their own. But, it is important to remember that this is still your job, and the purpose of a job is to make a living.

Why this is crucial

Your time is valuable. If you were not running your own business and were working for someone else, you would be earning a salary, which would allow you to take care of your personal expenses.

At first, you may not be able to pay yourself the same salary you would make working for someone else, but you must budget a salary for yourself from the beginning; make sure you pay yourself.

If you do not pay yourself from the beginning, it will be much harder to do so later on, and you absolutely need to make a living wage from your business. Plus, there will be a time when you need more than a living wage. Remember, you are the most important part of your business. Pay yourself accordingly.

How to pay yourself

Set up a salary and pay yourself on a regular schedule, just like you would to an employee. There may be times when your salary is delayed or is short. Ideally, these times will be rare, and you will be able to make up the shortfall later.

The important thing is to make sure you get paid regularly. Your salary is an important cost in running your business. If you have a problem with the idea of paying yourself, remember that you would be paying someone else to do these same tasks. Pay yourself from your business account.

Do not forget taxes

Small businesses file taxes on a quarterly basis. You will file and pay estimated quarterly returns. You will need to consult with a tax advisor to find out how and when to do this, and how much you can expect to pay. This is not something to just guess at; get professional advice. Guessing can lead to government penalties and possibly legal action against you. The IRS and local governments do not tolerate mix-ups on taxes. (*For information about employee taxes, see Chapter 12. For information about sales tax, see Chapter 15.*)

Set up a retirement plan

It is tempting to put off setting up a retirement plan until you can "really afford it," but that never happens. There is always something else you could spend the money on, and it is easy for you to spend the money you planned on using for your retirement. You need to set up your retirement account now, and again, you should hire professional assistance with this to make sure you set up the best account for you in the best way. For business owners doing it alone, setting up an IRA or a 401(k) is the best way to go. But, there are other options, like annuities, that you could take advantage of. Talk to a professional financial advisor to see which method best suits your needs, or visit the Department of Labor's Web site at **www.dol.gov/ebsa/ consumer_info_pension.html**.

Take paid vacation time

You should be paying yourself a salary, and that salary should include at least two weeks of paid vacation time. Pay yourself a regular salary for every week, and take off time for vacations. Also, take time off when you are sick. Do not work yourself to death; you will end up destroying your business.

Running Your Business

N ow that you have determined how much you will charge for your services, you need to figure out what you will do with the money you have coming in. For some people, accounting and determining money flow may come easily. For most, learning to have good accounting practices may be one of the toughest things about starting a new business.

The important thing to do if you struggle with accounting is to seek help until you are on your feet. Even if you do not want to hire an accountant to do all your accounting work, setting up an initial consultation where you can ask questions may be a good use of your funds. The growth of your company and its fiscal stability hinge on the money you spend on setting up a good accounting system; this is crucial.

Your Accounting System

Every business has an accounting system that is unique to the business owner. And, like other areas of your new business, it is important to test out what works and does not work for you.

Software or paper?

When you ask business owners what their favorite accounting system is, some will automatically give you the name of the software they use. But, there are still many business owners who will tell you they write everything down in ledgers and do it all by hand with a calculator. It really is a matter of personal preference. Either way is fine. If you are comfortable using a computer, and you manage your personal accounts using a software package, you are probably going to find it easier and more effective to use a computer to keep your business books.

On the other hand, if you are skilled with using paper journals or accounting pads, and you are comfortable working with pencil and paper to keep accounts, you may choose to go ahead with the paper method for your business accounting. You may be surprised to hear this from someone who uses a computer for practically everything, but it does not matter whether you do your accounting on a computer or by hand. Software and computers are tools; so are journal pads and pencils.

What is important, however, is that you understand basic business accounting principles and can effectively keep track of your business' money. If you do not have these skills, you may want to read a basic business accounting book or take a class in business accounting at your local community college. When it comes down to it, whether or not you can keep your books straight depends far less on computer use and far more on whether you have the skills or not.

How can you choose the right software?

Assuming that you do choose to use a computer and software for your business accounting, there are two major business accounting packages, QuickBooks® and Peachtree®. Either of these would be a good, solid choice; they have been around for many years and get good reviews from users.

You need to know which package to choose; QuickBooks has several versions for different types of businesses with different needs. To choose the software that will work the most effectively and easily for you, you need to know what you need.

If you are planning to have employees, now or in the near future, you will want a software package with payroll. If you do not need payroll now, you can upgrade later to a version that includes more features, if necessary. You will probably want to be able to invoice customers, and you will want accounts payable and receivable, which keep track of invoices and costs, which are standard on all packages.

The Web sites of the software vendors (**www.quickbooks.com** and **www. peachtree.com**) should help you choose the package you need, and if you are uncertain, a sales rep at your local office supply store should be familiar with the various packages available.

Try any software you are considering before you buy it, if possible, or make sure it has a satisfaction guarantee. You can download demos of software from the various production companies. Accounting software is too expensive to buy without knowing it will work. The software can run anywhere from $30 to upwards of $250. So, finding the best fit for you will be key to controlling costs.

Invoicing, accounts receivable, and all the rest

Invoicing may be a major part of your business, and if you are relying on customers who pay invoices — rather than on portrait customers, for instance, who pay at the time of purchase — you should give serious thought to your invoicing.

Most companies do not pay invoices more than once a month, mainly because invoicing weekly or semi-monthly can become a major hassle when

you get more than a few clients. Your time is probably better spent creating the images your clients hired you for, not sending invoices every few days.

Your invoice goes out to your customers and is the face of your business. Take the opportunity to make your invoice into a marketing tool, but be sure to give it the proper creative treatment, with your logo properly displayed and an easy-to-read layout. Do not overdo the creative marketing side, as your invoice needs to be quickly and easily read and understood. Think of your invoice as another way to show off your customer service skills by giving the customer the information they need up front and in an clear format.

You need a system for creating and tracking invoices. If you are using a major software program, like Quicken or Peachtree, it should handle creating your invoices for you, but if you need to do this yourself, you can probably purchase a good invoicing software program for a relatively low price at your local office supply or computer store.

If purchasing an expensive accounting program is not a good fit for you, professional invoices can be created using programs like Microsoft Excel. If you choose to go this route instead of purchasing an accounting software package, make sure the invoices you create look professional, and that you check the spreadsheet on a regular basis to keep track of accounts receivable.

Once you have designed your invoice templates, you will need to set payment terms for your clients, which will define how payments can be broken down over time. This may take some experimenting, but most of your business customers will expect 30 days net, which means they have to pay the full amount of the invoice within 30 days to avoid late fees. You may want to offer a 2 percent discount for clients who make payments within 10 days; this will motivate some customers to pay early.

Most of the time, larger corporations take longer to process invoices than smaller companies. Small business clients can use PayPal (**www.paypal. com**), a secure Web site that facilitates monetary transactions on the Internet, to put money into your account within hours of receiving your invoice. On the other hand, major corporations can take 90 days to cut a check. This type of inconsistency is one reason why many photographers like to work with a diverse client base. Although the large corporation's name will look better on your résumé, the money you receive from the small businesses will be what allows you to pay your bills a week early that month. Every client is valuable.

Who should do the books?

If you have a spouse or business partner who is skilled at bookkeeping, you might consider asking him or her to take responsibility for keeping the books in order. Most partners of either type will be happy to make sure the business' accounts are in order because they will be directly affected if they are not. But, if you do not know anyone who is a qualified bookkeeper, you may have to do the books yourself or make the decision to hire a professional. If you decide to outsource, you may find that it is more affordable than you think. If you can save time or money by letting someone else handle the accounting, it may be worth hiring an outside bookkeeper or accounting service.

Choosing an Outside Bookkeeper

If you are thinking of outsourcing all or part of your bookkeeping, the first thing you should do is decide what you want to outsource. You may want to outsource everything, including accounts payable, or you may only want to outsource some functions, like accounting and accounts receivable. The more you can do yourself, the cheaper it will be to hire an accountant because that person will have less work to do. What you want to outsource

will help you determine what kind of outsource you need and help you choose an appropriate candidate.

You will need to decide whether to use a bookkeeper or an accountant. Small businesses tend to get by with a bookkeeper or a bookkeeping service because they are small and have less paperwork, but you should talk with both bookkeepers and accountants to determine what they can offer and how they can meet your needs.

You may also wonder if you should outsource everything or just hire a business manager. Business managers oversee all of the financial and marketing aspects of your business. In most cases, you will save money by outsourcing, and you can use that money to grow your business or hire employees to fill other functions. However, if you prefer to hire a business manager, remember to hire for talent and motivation, and hire someone who is eager to help you run your business.

When you choose an outsource, it is often a good idea to toss out the highest and lowest bids and choose someone from the bids in the middle. If you choose the lowest bid, you may well end up getting exactly what you pay for, and the highest bidder is almost never worth the cost. Choosing a reasonable bid, and a company or individual you feel comfortable with, will give you a better chance of choosing someone who can help you accomplish your goals within your budget.

CASE STUDY: MORE THAN
JUST TAKING PHOTOS

Gail J. Berg, owner, photographer
IceBerg Pix
PO Box 390010,
Mountain View, CA 94039
650.625.1860
contact@icebergpix.com
http://icebergpix.com

I am more than a photographer. My other titles include: photographic assistant, Web mistress, order processor, production, shipping department, receptionist, publicist, travel agent, purchasing manager, and accountant.

Before becoming a photographer, I had a career in software engineering and software configuration management. Although I have been a photographer since 1972, I became a professional in 1988. After college, I bought better film cameras, eventually getting a nice 35mm SLR. I went to night school to help me become acclimated with the settings.

I started going to hockey games and taking pictures and purchased my first digital camera in 2002. Over six months, I saved enough money from film, development, and print costs to pay for a nice, high-end digital camera.

My specialization in sports photography — specifically ice hockey — began in 2004. I am licensed by the ECHL (formerly the East Coast Hockey League), the premier AA hockey league in North America. I attend dozens of games each season, making images from those games available for sale. At each game, I may take 500 to 3,000 images. Then, I cull anywhere from 10 to 100images, prepare them for Web viewing, upload them, and integrate them into a Web site. When orders are received, I print the images, prepare them for mailing, and ship the order out. My photographs are on display in 10 countries.

Financial Statements

Although you want your art to be about photography, your business should be all about the money. To ensure that your financial goals are

met, it is important to take off your photographer's vest and put on your business coat. To keep track of your business monetarily, it is important to create financial statements. It is crucial to plan out how much money you need every month to help you determine what it will require to make a living as a photographer. Fortunately, there are many resources and tools available to help with this process, many of which are available on the companion CD-ROM.

Cash flow projections

The cash flow projection is a predictor of the future based on a current situation. The report can be created to show a tally of projected revenue and expenses. This report predicts liquidity over a specific time frame, such as 30, 60, or 90 days.

Take the cash figure, often determined by a bank statement, and subtract the figures of short-term debt. The larger figure is the gross, and the amount after subtraction is the net income; in other words, it is the amount you have after all of your costs have been subtracted. For example, say you made $1,000 on a project and spent $600 on setup and equipment. The $1,000 would be your gross income. When you subtract the $600 from the $1,000, you have a profit of $400 on that project, which is the net.

Finances are not a strong suit for everyone, so in order to keep this straight, you may find it helpful to think of the number of letters in the words "gross" and "net" to remember which is which. Gross contains five letters and is the larger number on the statement, and net contains three letters, meaning it is the smaller of the two words and, likewise, the smaller number on the statement.

Profit and loss

A Profit and Loss statement (P&L) is a report that shows whether your company made or lost money during a particular time. It calculates your net income or net loss by looking at the past.

While most companies create a P&L on a monthly basis to help in planning purposes, you may want to create P&L statements on a more frequent basis to help determine whether or not your goals have been met or if you needed to work a little harder to achieve them.

This type of knowledge can come in handy when you are running a small business and plan on taking a vacation and want to ensure that you have enough money in the bank to pay for all of your expenses and enjoy a little time away.

Balance sheets

Balance sheets list the business's assets, which can either be physical or tangible, liabilities, or ownership equity pertinent to a specific date on the calendar. It is the only financial statement that applies to a single point in time, such as the end of the financial year. To coincide with personal income tax cycles, you will find that many small businesses choose to set up operations to begin a new fiscal year on January 1 and end the year on December 31.

On a balance sheet, most companies will put their assets on the top, followed by the liabilities. This is most logical way to set up your balance sheet. The top number subtracted by the bottom number. The difference between the assets and the liabilities is the net assets, or the net worth of the company.

For example, say you take the value of your equipment and what you have been able to put away for income and add them up, and the number comes to $10,000 in assets. Then you look at what you owe. Again, as an example, you owe $6,000 on a business loan, which is your debt. When you take the $10,000 in assets and subtract the $6,000 in debt, you come up with $4,000. That is the net worth of your business.

Accounts payable and receivable

Simply explained, accounts payable and accounts receivable reports list all monies your business owes (payable) and all monies owed to your business (receivable).

Accounts payable reports list bills that are due, the date payment is expected, and contact information for the payee. Accounts receivable reports monies owed to your business through sales contracts and outstanding invoices that have not yet been paid.

Billing and Collecting

It is one of the most unpleasant aspects of business, but it is an essential task: collecting your money from a source that has been more than a little reluctant to pay in a timely manner.

You have some options when it comes to this, but the most important thing is to not back down to make sure you get paid. Do not be afraid of losing this type of customer because you are persistent in your calls about receiving your money.

This type of client is probably not one that is worth having as a repeat customer because having to track them down, badger them for their payment, and finally collect can be a waste of your time and resources that could have been spent growing your business.

Should you offer credit?

You may not have a choice in whether or not to offer your customers terms; most businesses will expect to pay their vendors, including you, on net 30 terms, or full payment by 30 days after billing.

One way to make sure you are extending credit to creditworthy businesses is to set a limit on their initial credit; allow them to make a few small purchases, then extend more credit as they earn it. Keep track of what each company owes, and how quickly they are making their payments if they are made over a period of time. This will help you weed out the companies you should avoid, which are usually the ones that take a long time to reimburse you for your services.

Another way is to require payment with the order for the first two or three purchases and then extend credit. That would mean that the first two times you work with this company, they pay you up front when the work is done. Then, once you have established a relationship with this company, you can start extending them credit.

Either of these options may be objectionable to certain customers, but most will be glad to work with you, and it is always worth a try. If a particularly important customer refuses, you will have to make a decision, but the positives of this approach tend to outweigh the negatives.

Customers who do not pay promptly

Every once in a while, a customer will not make payment by the 30-day period stated on the invoice. You should always assume the best; most people are honest, and you will be better off treating this as an honest mistake, which it probably is. You do not want to antagonize a customer over a misunderstanding or absentmindedness.

Use the 10-day mark as a general guideline. If the invoice is not paid within 10 days after the due date, simply send another invoice, with the amount and due date highlighted. You may want to write a quick note on the invoice to the effect of, "Just a reminder invoice," or something of that nature. The 10-day model will give time for your customers to respond to the invoice and send in their payment.

If the second invoice is not paid within 10 days, send a letter asking if there is a problem with the order and if you can help the customer resolve it. At this point, most people will pay the invoice. If not, make a phone call. This is easier if you are calling a large company, but can be done with an individual, as well. Keep it professional. Do not use the word "you." Say, "I am calling about my invoice number (give the number), dated (give the date). I am concerned that we have not received payment and wondered when I can expect payment on this account."

These measures will resolve the majority of your overdue accounts without creating further conflict or endangering your relationship with your customer. If not, you may need to take more drastic measures.

Collecting on seriously overdue invoices

Sometimes a customer just does not respond when you try to collect on an invoice. This can create serious cash flow problems for you, and you must resolve the issue.

The first thing to do is set a limit before the fact as to how much credit you will extend, and for how long. Decide that once a debt is X number of days old and not resolved, it goes into your "collection" pile.

Try to resolve the debt using the previously described methods; this is always the best way to deal with a delinquent customer.

If your customer does not respond to your gentle collection efforts, send a warning that you will be forced to place the debt with a collection agency if you do not receive payment. Word this warning impersonally, but make it clear that you will have to take stronger measures.

At this point, if the customer has not paid, they probably will not. You have three choices. You can let it go, which may be the best option if the amount of money owed is small. You can hire a collection agency, which may net you a portion of the amount you are owed. Or, you can take the customer to small claims court if you feel you have a good chance of collecting some or all of the money.

Income and Outflow

Balancing your income and outflow, or the money you make and spend, respectively, is a major part of the accounting process. By being intimate with your accounting, you can make sure this balance stays favorable to your company.

You do not want to spend more money on equipment, advertising, or other areas when that cost is outweighing the money you have coming in. By watching this ratio, you can have a better idea of where you need to spend your money and time and what steps you need to take to keep your company profitable.

Controlling costs

While this sounds a little forbidding, it is relatively easy. It is not just a matter of spending less, but primarily of being conscious of what you are spending on and why.

The first step to controlling costs is to keep track of all your expenses. Once you have established a tracking system, a spreadsheet, or by using account-

ing software for even the smallest expenses, then it is time to start analyzing your spending so that you can literally watch your spending. You will want to cut back on unnecessary purchases, like extra lenses or lighting, and find ways to save money on necessary items, such as photo paper, batteries, or office supplies.

One way to effectively control costs is to buy in bulk, particularly things like office printer ink and paper, which can be much less expensive in bulk. Another way to control spending is to buy wisely. You may find outlets or online suppliers that can provide your essentials at lower prices than your current vendors. Wholesale clubs are also good places to purchase essentials at a discount, as well as to comparison shop for furniture and electronics.

Increasing profits

Profits are revenues minus expenses. Business schools teach how to figure profit on variable expenses and the like, but the main thing you need to know is what constitutes profit. For example, if your business revenues are $2,000 and your total expenses, including equipment cost and other costs to keep your business and studio or office functioning, are $1,200, then you have a profit of $800.

You have two ways of increasing profit. You can decrease costs or you can increase revenues. In many cases, you can do both by finding less expensive alternatives to certain items and by raising your fees or your markup on services and products.

Cash flow is key

Many businesses fail in the long-term even though they are making a profit because they do not have the cash flow to pay their vendors and employees, including the owner. It is not just how much money you make, but how much money you have when you need it.

The bottom line is that if you cannot pay your bills, you cannot stay in business, so you will need to pay careful attention to cash flow, or the amount of actual money you have coming in. There are two things that can negatively influence your cash flow. The first is to take on work you cannot afford. This may sound counterintuitive at first, but work you cannot afford is simply work that either does not pay enough for the time you put in — but keeps you from doing other work during that time — or work that will not pay in a timely manner. For example, you may be hired to take on a project that will require you to work for three months before completing it. Because the terms of your agreement with the client specify that you will be paid upon completion, you work for three months without receiving any profits. This is an example of work that does not pay in a timely manner. This type of work could also be so time-consuming that you are not able to do work on other projects at the same time. Thus, a long-term project that will pay only at the end of the project may be good for your business once you receive the money, but not at the expense of paying your bills in the short-term. Sometimes, you may want to map out a payment plan with your client before you begin such long-term projects so you can be sure that you will be paid in percentages of the full amount as you work.

The other trap in terms of cash flow is taking on a prestige or pro bono assignment that does not pay. While there are good reasons for taking on no-fee work, you should only do so when you can afford it.

Preparing for the unexpected

Your business account, as well as your personal account, should have a prudent reserve, an amount in savings that is enough to prepare for an emergency, but not so much that you are taking away cash that could be spent to grow your business. What if your camera breaks and you have to pay for repairs? What if you break your hand and cannot work? How will the business survive? You do not know exactly what will happen, but you

can think about what *might* happen. You might have a large repair bill. You might miss work due to illness or injury. Think about how your business will weather these possibilities, and if there is anything that you can do to prevent any of these things from harming your business financially.

One step you can take is to make sure you have adequate insurance, both on your business property and on your home, in case something happens that should be covered by insurance, like a break-in or fire. This is crucial; there is little excuse for not having adequate insurance.

Know what your options are if something does happen, and have a plan for the most likely scenarios. If your camera breaks, how much is a new one? What would it cost to fix it? Also, have a backup of all your images and customer files somewhere off-site where you can reach it in case of an emergency. It is a good idea to buy an external hard drive, too, to store your photos in case of a computer malfunction. Also, using jump drives or flash drives and other mass storage devices can save you space on your computer and save your images in the event of your computer malfunctioning. Make sure you also have a recent backup of everything on your computer. Assume that you will lose your hard-drive data at some point and prepare accordingly.

DIY Accounting

Assuming you are knowledgeable in accounting practice or have gotten the proper training, doing your own accounting can be a good way to run your business. By staying in the loop with the numbers, you can quickly react to situations affecting your business, rather than waiting on someone else to tell you there is a problem. Your reaction, if you can do your own work, can be instant.

Why do your own books?

There are several reasons for doing your own books. The first is simply that you enjoy doing your books, you are good at it, and you want to. If you want to do your own books, you certainly should. At first, you may also feel you cannot afford to outsource, and that is also a reasonable explanation for doing your own books.

Balancing billable and non-billable hours

If you have never run a business, you may be surprised to learn that you cannot bill 40 hours a week, at least not unless you plan on working 65 to 80 hours a week. Most new business owners find that when they are splitting their time 50/50 between billable work (work they can charge their customers for) and non-billable work (work that cannot be charged, like doing bookkeeping or creating invoices), they are quite successful. Reaching 50/50 should be a primary goal. When you can split your time 70/30, you are probably at peak billable hours, at least by most people's standards.

Outsourcing and hiring can be important here because there is creative, billable work that only you can do. You should make it a rule to always do your own photography and either hire someone to do the other work you cannot do yourself, such as accounting or bookkeeping, or see if it can be left undone. You will be amazed how much does not need to be done at all.

What can you do?

You can only do a few things at 100 percent. It is important not to try to do 100 things at 10 percent. Every business needs certain tasks completed in order to get up and running, and to stay operating and profitable. Take a few minutes to ask yourself these questions: What are you good at doing? What do you have experience doing, either from school, past jobs, or purely from interest? Then, make a list of what you know needs to be

done to make your business a success and compare that with your self-professed strengths and weaknesses. Where does it make sense for you to do the work? When does it make sense for you to outsource?

What do you want to do?

There are only 24 hours in a day; you will have to prioritize in order to get anything accomplished at all. Out of the task list you have created, ask yourself what it is that you want to do. Then, take it a step further. Is it possible for you to do the things that you have listed, or do you need to give up some of the things you want to do? Have you agreed to do too much, and will you be stretched thin when the time comes to be creative? If you only want to be a photographer and you do not want to have your hands in the business end of things, is there someone that you know and trust who would be interested in handling the other responsibilities of running a business?

Discerning what you can do, what you want to do, and whether or not any of it is feasible is crucial to your success. Taking the time, asking these questions now, and setting up a firm foundation upon which to build your business will save you headaches in the long run.

Managing Cash Flow

Cash is the lifeblood of your business. It flows in and out, keeping the business alive and moving forward. Without cash flow to do what you need to do — make purchases, pay bills, repair equipment, and even put gas in your car — your business will surely die.

Prudent reserve

To keep your business going, you must have cash reserves for expenses and inventories. No matter what your accounts receivable journal says, if you

do not have monies on hand to take care of your responsibilities, you will not remain in business for long. Getting behind, even temporarily, can make things difficult by causing the additional aggravation of accumulating late fees due to vendors as a result of slow payment on invoices. In other words, not having cash can cost you cash, and it may even tarnish your reputation and ability to seek credit in the future.

It is important to have a financial cushion to fall back on. To decrease the likelihood of problems, save money and create a reserve account when your business is at its busiest. That includes saving for taxes. You may also want to look into establishing a line of credit in case you fall on lean times and need some emergency reserves.

Every specialty of photography has its busy months and slow months. Learn what you can expect based on your market, and make appropriate provisions. Preparation that includes long-term and short-term planning through a business plan can help keep you from veering in the wrong direction when times are tough.

Estimating expenses

The first step in planning involves estimating your expenses. You already looked at some of this information in your business plan, but it does not hurt to write down your answers again to remind yourself of your expenses. You need to keep these costs in the back of your mind at all times, as they are a key component of your inflow and outflow ratio.

How much do you think you will need on a monthly basis to take care of:

- Salaries?
- Rent?
- Supplies?
- Office equipment?

- Photography equipment?
- Utilities?
- Travel?
- Business entertainment/meals?
- Insurance?
- Marketing (this includes your Web site or Web advertising)?
- Legal and accounting fees?
- Subscriptions and memberships?
- Repairs and maintenance?
- Taxes?
- Other items not listed above?

Predicting Your Income in the Foreseeable Future

The dollar figure you calculated from above could be considered the absolute lowest amount you will need for income. This would mean your business is making enough to support you, but is not saving any money for an emergency.

Assume that you have already made your first sale, which is why you are considering opening your own photography business. What did it take for that sale to come about? How many people did you have to talk to? How long did it take you to complete that sale? If it took three weeks and talking to 200 people to make a $3,000 sale, then you have the beginnings of an initial formula to predict your income.

Now, ask yourself how much you want to make on a monthly basis. If you want to make $10,000 a month, then you will have to talk to around 500 people in order to work toward that goal, based on what has worked for you previously. Using the following formula, you can calculate this:

Goal = (time in weeks) X ((5) X (number of people you talk to))

You already know that you made $3,000 in 3 weeks, talking to 200 people: $3,000 = (3) X ((5) X (200)).

So, if your goal is to make $10,000 in one month, or 4 weeks, you can use the same equation:

$10,000 = (4 weeks) X [(5) X (x people)]

$10,000/4 = 5x

$2, 500 = 5x

x = 500 people; therefore, you need to talk to 500 people to meet your goal of $10,000 in four weeks.

As you grow in reputation and stature, the dollar amounts should grow while your output for seeking new clients will decrease. The result gives more income per month. But, it is not uncommon for new businesses to have roller coaster periods of income and loss, particularly in the first three to five years.

Should You Purchase Business Needs on Credit?

Instead of going into debt and purchasing business needs on credit, like office supplies, try to work within your financial limitations. Use the rule of 10 before making any new purchase — particularly if it is a large purchase, such as new equipment. Ask yourself whether buying a particular item or piece of equipment will pay for itself 10 times over the course of the next 12 months. If you believe that it will, based on pending contracts or other criteria, make the purchase. However, replacing items that may be

old and starting to wear is another matter entirely. If something goes wrong with your camera, computer, printer, automobile, or telephone, your business comes to a screeching halt. In these cases, it is important to monitor your cash flow, and to monitor your net profit so that you can accumulate a savings for such unpredictable events. Doing this will protect your business in the long run and give you peace of mind in knowing that you can handle any challenge that faces your company.

Photo provided by Darin Back

Chapter 12

Growing Your Business

Running Your Business Day-to-Day

With your accounting system in place, it is time to start focusing on the day-to-day aspect of running your business. This involves taking everything in the last few chapters of this book and applying it toward your everyday business. You will start implementing your marketing plans, keeping up on the accounting, and, of course, taking pictures.

For most new businesses, the first year can be a struggle to get your name established, grow your customer base, and discover which marketing venues work best for your company. But, as your business grows, you will be faced with new challenges, like staying organized and deciding whether or not to hire office help or even another photographer.

Staying organized

In the last few chapters, we have discussed setting up business plans, marketing plans, and accounting systems. With so many different areas to worry about, it is easy to get overwhelmed as a new business owner, which is where having good organizational skills comes into play. Keeping your

different business systems organized and having a schedule of when you will work on the different areas each day can save you many headaches. Set aside time each day to work on marketing your business and to make sure your books are up to date. Depending on how experienced you are in marketing and accounting, the time you spend on these things will vary. A good starting place is to dedicate about one hour each day to these things. Remember, by taking the time to stay on track every day, you will prevent yourself from falling behind, which will only cause you more work later.

As you go through the first few months of your new business and are trying to understand the market and where your niche is, review your business and marketing plans often — probably at least once a week. This will ensure that your business remains on track, and you can respond to changes that need to occur. For example, maybe your marketing plan of sending mailers to potential clients in the area surrounding your business is not as effective as you had anticipated. The mailer that you are currently sending is simply a brochure of the basic information about your business and fees, but there is no way for your customers to see your work. Once you can conclude that this method is ineffective, you decide to try marketing to the same group of people through mailers, but your objective is to drive them to your Web site where they can view your portfolio. You may want to take an extra step and include a coupon code on your mailer, which will allow customers who enter the code on your Web site to receive a special rate or package for choosing your services. You would market this as a deal that is exclusive to your mailer. That way, you can track and, therefore, correlate the effectiveness of your mailers based on how many people used the coupon code.

After you have established your business, know your customers, and have an accounting system that works for you, you can review these areas less and less. Do not forget about them, though. You should try not to go more than a month without reviewing your marketing plan to make sure it is still working for your company and the goals you have set, as discussed in the previous paragraph. Also, make sure you review your business plan

to make sure your business is in line with your goals at least every two to three months.

Keeping your schedule, workspace, and documents organized can help you reduce stress and make better use of your time. Nothing looks more unprofessional than rifling through a box of lens filters to find the right one while a family of five with small children sits in your portrait studio holding their smiles. That does not create a positive customer experience, nor does it create a professional image for you, which may cause you to lose repeat business or referrals.

Another reason to keep these areas organized is so that you can quickly answer your customers' questions when they arise. If a customer calls to complain or ask about an item on your invoice, you do not want to have them sit on the phone while you rummage around your office for 20 minutes looking for a copy of the invoice. Again, this is not a good customer experience, and it opens up the door for negative feedback.

For some people, staying organized is easy to do and comes naturally; for others, it is a struggle. Do not fall into the trap of believing that you are unorganized because that is just the way you are. Believing you work better in a chaotic setting can be fatal for your business. Successful businesses are well-organized and run efficiently; you cannot run efficiently in a chaotic environment.

Remember, it is not about you; it is about the customer. Their experience is what you should be worried about most, and they will not feel comfortable in a messy studio or waiting around for you to find your résumé in your briefcase. If you find that you need help getting started with an organizational plan, there are professional organizers who can set you up with a system. They are organizational consultants, and most work independently. But, they are trained to help you set up your office and put a daily schedule

into place that can work for you and keep you on track. You can even take an online course on organization at **www.progessionalorganizers.com**.

Staying organized may seem like a simple thing, but many businesses fail because of lack of organizational skills, which can lead to poor customer experiences and lack of return customers. Work hard at staying organized and it will pay off in the long run — especially if you look to expand.

Expanding Your Workforce

As your company grows and your workload becomes more than you can bear, it may be time to look into hiring outside help. The first instinct may be to hire an additional photographer, which may be a good option if the money to pay a quality one is there. However, for most companies, the best move may be to hire an office or business manager to take over the less creative areas of your business.

By hiring a business or office manager, you can accomplish two things. First, it will free you up so you can concentrate more on your photography. This is a big deal because, in the end, it is your photography skills that will sell your product. The more time and effort you can put into your art, the better the final product will be and the happier your customers will be.

The other positive from hiring a business manager is that you can hire someone with the necessary skill sets to better accomplish those tasks. Look at your weak areas, and look to the person you are hiring as a way to strengthen that area of your business. If you are not good at organization, but have a solid accounting system, hiring someone with good organizational skills will be a plus to your business.

It is important to determine what you can afford when hiring a business or office manager and how much time you need them to spend in your business. It could be a smart move to hire someone part-time at first to avoid

paying a full-time salary and benefits. A lot of times, you will find that the work for which you are hiring does not warrant full-time status.

Often, you can find retirees who used to work in a certain field who are looking for a supplemental income, and they will want to work 15-20 hours a week. This will save you money and time while getting your office work done.

CASE STUDY: FROM A HOBBY TO A GROWING BUSINESS

Argentina Leyva, Portrait Artist
Argentina Leyva Photography
Downers Grove, IL
630-667-4633
photographer@argentinaleyva.com
www.argentinaleyva.com

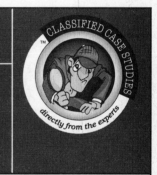

It has now been 10 years since I officially got myself business cards, a portfolio, and started promoting my business. I became an LLC company a few years later.

Prior to becoming a professional photographer, I worked as a chemical engineer. I came to America from Mexico in 1994 to attend graduate school, and I began playing around with photography in 1996. As an engineer, learning the technical side of photography was easy.

At first, I experimented with taking family photos. Then, a friend of mine decided to get married, but she had a very small budget for photography. She asked me if I would consider photographing her wedding, which is what got me excited about other possibilities.

When I decide to do something, I do it right or do not do it at all. So, I flew to New York to take a workshop with renowned photographer Doug Gordon. Because of what I learned, my photography was transformed in a matter of weeks. This gave me even more enthusiasm, so I started taking local classes, as well as flying to other places to study with other photographers. I observed carefully how my mentors created their images.

By observing, I was able to reproduce their techniques; however, I developed my own style.

After the weddings, my clients started to have children and asked me to continue the professional relationship by photographing their new family. I trained in wedding photography and also in photographing pregnant women and babies.

I enjoy being able to make people comfortable and going out of my way to give them the best photo experience they have ever had. I believe that when you have the talent, it is easy to be a great photographer; but in order to succeed financially, you have to be a businessperson first.

Working for myself, the possibilities are endless for creativity and expansion. Currently, my sister, who is an attorney, and I are working on a business plan to have an international company that has studios in the US and Mexico, and will specialize in weddings at Mexican destinations.

Hiring an additional photographer

If your business is doing quite well, and you find that you do not have time to serve your customers in a timely manner, it may be time to hire an additional photographer. While adding photographers to your staff is mainly for those in the studio or commercial fields, it is not out of the realm of possibility that you could start a freelance photographer service with other freelancers working under you.

When adding a new photographer, it is essential that you hire someone with values in line with those of your company. Also, photographers in the same company often need to work together on projects, so you need to know that you work well with that person.

Hiring a friend or a colleague that you know and have done work with in the past may be a good way to add additional help. When hiring a friend, it may be a good idea to look at the hiring as more of a partnership in order to keep a pleasant working environment. So, instead of acting as though

you are the boss, it is important to make your freelance photographers feel almost as if they are your equals. This will ensure a good working environment that enhances creativity.

Another way to make sure you can work with the person you hire is to set up a probationary period, or have them come in for a project to see how it goes. You can advertise for a photographer to come in and shoot a one-time project to get the feel for how they operate. If you like the photographer, you can ask them to join your staff.

As with a business manager, do not hire a full-time photographer when all you need is someone to pick up a few additional hours. You might end up with a new photographer who is trying to break into the field. While they may be inexperienced, they may work harder to impress you in the hopes of getting full-time employment. Again, it will be up to you to get a feel for the candidate and determine whether or not they would be a good fit for your company.

Labor Issues

Deciding whom to hire is just half the battle when it comes to hiring new employees. A whole set of laws and regulations govern the employee/employer relationship. Knowing these laws and regulations, and knowing how hiring additional help will impact your business is an important step to expanding your company.

When thinking of employment issues, many employers immediately think of paying employees and keeping them happy. Although the pay will weigh heavily on your decision to hire additional employees, being an employer is much more about the people than about the numbers and the rules.

You want your employees to give you their best effort and help you run your business effectively. In exchange, you pay them a fair wage. But, most

employees want and need more than just fair compensation. They want to be seen as contributing to the business, they want your respect, and they want you to treat them well.

None of these are unreasonable expectations. All your employees are asking for is a fair exchange of respect and responsibility, and in return, many employees will give you an even better effort than you expect. People want to be respected and appreciated, and they tend to reward respect and appreciation with extraordinary effort.

The consequences of not treating your employees well can be serious. Low morale and high turnover in your employee corps can seriously hamper your business's effectiveness, driving off customers.

There are also money and legal issues. If you are starting to think that being the boss is hard work, you are getting the right idea. As soon as you move from being a sole proprietor where you run the whole business by yourself, you move into a whole new realm with more for you to consider than just the bottom line.

Employee taxes

As an employer, you are going to be responsible for figuring and withholding Social Security taxes, state income taxes, workers' compensation, and any other required withholdings. You will need to consult your state's employment bureau to make sure you know everything that should be withheld and the amounts of the things that are withheld. You may also wish to hire a bookkeeper or payroll service to handle this part of your business, both to avoid legal obstacles and to save your time and effort for things that only you can do.

Keep in mind that payroll involves a considerable amount of paperwork, and you may face legal penalties, like fines, if you miss something that

is required by your state or the federal government. Make absolutely sure you know what you need to do to stay in compliance and pay your employees properly.

This would be a good time to sit down with an accountant and hash out what you need to do in terms of payroll and taxes. Seeking the advice of a professional in this situation will make it much easier for you to get the right steps in place and avoid penalties for incorrect payroll procedures. Spending a little money up front and hiring a consultant will benefit you in the long run.

Labor regulations

Many federal labor laws, including the Family and Medical Leave Act, which permits employees to take a leave of absence for medical reasons without losing their jobs, apply only to companies with 50 or more employees. However, there may be regulations in addition to workers' compensation and unemployment insurance that do apply to your business. The best way to make sure you are in compliance is to check with your state's labor or employment office and the U.S. Department of Labor; they should have all the answers you need, and may even have the answers in an easy-to-find form on their Web sites. Use the following chart to determine which laws apply to you based on the number of employees you have.

Number of Employees	Applicable Statute
100	WARN — Worker Adjustment and Retraining Notification Act
50	FMLA — Family Medical Leave Act
20	ADEA — Age Discrimination in Employment Act
20	COBRA — Consolidated Omnibus Benefits Reconciliation Act
20	OWBPA — Older Workers Benefit Protection Act
15	ADA — Americans with Disabilities Act
15	GINA — Genetic Information Nondiscrimination Act

15	Title VII of the Civil Rights Act of 1964
15	PDA — Pregnancy Discrimination Act
1	EPPA — Employee Polygraph Protection Act
1	EPA — Equal Pay Act
1	FRCA — Fair Credit Reporting Act
1	FLSA — Fair Labor Standards Act
1	IRCA — Immigration Reform and Control Act
1	OSHA — Occupational Safety and Health Act
1	PRWORA — Personal Responsibility and Work Opportunity Reconciliation Act
1	USERRA — Uniform Services Employment and Reemployment Rights Act

As the owner of a photography business, you also need to be aware of where your employees will be working. If they are freelancing for a newspaper or need to travel to photo shoots, you may be responsible for what happens to them while they travel and are off site. You are at the mercy of your employee — that they know what they are doing and will be safe at all times.

Spending time with a lawyer to discuss what local, state, and federal regulations will impact your business is a good step — especially if you are hiring more than one person and are looking outside of trusted colleagues and friends to find employees for your business. Knowing what you are responsible for, and what your company needs to provide for an employee who travels, is essential to keeping your business secure.

Payroll and paperwork

If you do your own payroll, even if you have only one employee, be prepared to spend time doing paperwork before payday. There are two simple rules to payroll: it must be on time, and it must be correct.

You will need to keep track of payroll information in some way. If you are using an accounting package, it should be able to track the data you need, like pay and the taxes you withheld, or you can use a bookkeeper or payroll service. A good rule of thumb is that you should use a payroll service when payroll takes up the time that could be spent making more money.

When you are setting up your payroll, consider offering direct deposit into your employees' bank accounts, either as an option or as the only method of payment. Most people have bank accounts and appreciate not having to go to the bank. The bottom line is that however you pay your employees, whether by check or direct deposit, you must pay them on time and in the correct amount.

Recruiting and retaining the best

There are two things that will help you more than anything else when it comes to hiring, and keeping, good employees.

The first item is how you treat your employees and the work environment you provide. If you are seeing a lot of turnover in the employees you hire, meaning that they do not stay with your company for a long period of time, you may need to look at the environment and ask yourself if this is a place you would want to work if you were in their position. If your work environment is hostile or chaotic, it may be an incentive for your employees to find another photography business to work for.

Benefits are another important aspect in keeping good employees. While it may seem expensive to offer benefits, such as health insurance, profit sharing, or retirement accounts, these perks can help you keep employees and save you money in the end. One good employee is a valuable asset, and keeping an employee long-term is much less expensive than having high turnover and having to hire and train new employees.

Hiring the right person may be easier than you think. Many employers look primarily for experience, but this can be a major mistake for two reasons. The first is because there may be too many things experienced photographers have to unlearn before they can learn the photography style that your company was designed to create. Photographers who have been in the business for a while have certain ways of doing things. If it does not match up with your company's vision, this will be a problem. The person you hire will either have to unlearn his or her old ways, or be willing to adjust to the methods you have in place for your company.

In most cases, the skills your employees need to have can be taught. You can train someone who has the ability to learn the skills, but no amount of experience can compensate for not being suited for the job. There is a certain amount of natural ability that goes into being a photographer, like having a good eye in terms of color and form. Those without that ability, no matter how technically savvy they are, may not make good employees.

Hire for talent, with talent being defined as the motivation and natural ability to learn the job, as well as the desire to do that job. Many people think of talent in terms of creative ability, but true talent is more than that. Some people have a talent for customer service and are inherently customer-service oriented. For example, if you locate someone who is customer-service oriented, and your opening is for someone to work with customers, you should hire that person if you can, even if their primary experience has been working in a call center for a vacuum-cleaner manufacturer. The talent is there, and they can learn the photography business.

The key to keeping good employees is to hire good people, treat them well, and, of course, pay them what they are worth. In many organizations, pay is based on rank, but with your own company, you have the freedom to pay each individual based on what they are worth, rather than being forced to promote someone in order to increase their pay. You should pay what you believe the individual earns. Remember that one good employee can

improve your business immeasurably, and a bad employee can destroy your business. The pay of your employees, therefore, should reflect this.

If you find that you are able to afford one or more employees, the best rule to follow is simply to treat them the way you treat any other stakeholder in your business, including vendors and customers. Remember that everything from the work environment to payroll and compensation will affect your relationship with your employees, and will in turn affect the work they produce.

Hiring employees

Once your business is underway and you start going out to quote jobs or work in the field, you may decide that a phone answering machine is not enough. There are definite advantages in having someone in the office to answer the phones, call vendors, do phone marketing, or set schedules for bidding. Some of this work cannot wait until dark when the outside jobs are done.

You may want to tiptoe into the role of employing an office worker. Part-time help is usually easy to come by. You may simply ask around among friends or relatives. Or, if you are reluctant to take a chance on a friend's recommendation and you live in an urban or suburban area, place a classified ad in your local paper or online publication, or on a local/national site such as Craigslist, at **www.craigslist.com**, or Monster, at **www.monster.com**. You will probably receive more job applications than you can handle.

Start the selection process before you place the ad by describing exactly what you want this employee to do, what experience he or she will need before starting, and what software programs or equipment skills the person will need to have. Also, remember that your office helper may become the "face and voice" of your business. So, the person you choose should be able to get along with the public in person, and especially on

the phone. You may want someone who can also do cold calling to solicit business for an extra bonus if an appointment is actually set. Or, perhaps you would rather have a bookkeeper to take over some of the data entry responsibilities. Whatever it is you want, write it down, read it over several times, and picture the kind of person you would feel comfortable with. Personality counts.

Discriminatory practices

Under Title VII, the ADA, and the ADEA, it is illegal to discriminate in any aspect of employment, including:

- Hiring and firing
- Compensation, assignment, or classification of employees
- Transfer, promotion, layoff, or recall
- Job advertisements
- Recruitment
- Testing
- Use of company facilities
- Training and apprenticeship programs
- Fringe benefits
- Pay, retirement plans, and disability leave
- Other terms and conditions of employment

Discriminatory practices under these laws also include:

- Harassment based on race, color, religion, sex, national origin, disability, or age.

- Retaliation against an individual for filing a charge of discrimination, participating in an investigation, or opposing discriminatory practices.

- Employment decisions based on stereotypes or assumptions about the abilities, traits, or performance of individuals of a certain sex, race, age, religion, or ethnic group, or individuals with disabilities.

- Denying employment opportunities to a person because of marriage to, or association with, an individual of a particular race, religion, national origin, or an individual with a disability. Title VII also prohibits discrimination because of participation in schools or places of worship associated with a particular racial, ethnic, or religious group.

Employers are required to post notices to all employees advising them of their rights under the laws that EEOC enforces and their right to be free from retaliation. Such notices must be accessible to persons with visual or other disabilities that affect reading.

These guidelines should be followed by all business people, even small start-up businesses like yours. Once you select a person to hire, you will need to set up a personnel file for him or her, prepare the appropriate government paperwork for tax withholding, and other new-hire policies. If you are not sure what is required, your accountant, state tax officer, or local Chamber of Commerce can point you in the right direction.

You will also want to set aside some concentrated time to train your new employee in the way you want the business to be handled. He or she may be spending a lot of "alone time" in the office if you are out in the field. You will want to closely monitor the results of the office work you assign to be sure the job is done. With any luck, there will be no problems, but if there are, you will have to retrain or fire the individual. Neither of these tasks is much fun; it is much easier to pick your employee carefully from the start.

Finally, since you hired an office worker to take the burden off yourself, you will want to see some payback in terms of increased revenue within a fairly short period of time. Be sure to do a cost analysis of your hiring experiment to see if it is bringing in more income, or costing you more money than you expected.

So, where do you find employees for your business? It is not unusual for prospective employees to contact businesses looking for work. They may see your truck or notice you at a job site and offer their services. Eager, experienced workers may drop into your lap, especially when the economy is not doing well. When times are good, you may have to be a little more proactive in your search.

Newspaper or Internet ads are effective. Put an ad together that outlines exactly what you are looking for, as well as the work and hours, but consider whether or you want to put the hourly pay in the ad. In some areas of the country, help-wanted ads for companies routinely contain the starting hourly wage. In others, a wage range is listed, and in still other places, words such as "competitive hourly wage" are used instead of specific numbers. Get to know the pay scales in your area for the work you want done, check the ads being placed by your competitors, and use those standards as guides. Be sure to state in your ad that applicants must be currently eligible to work in the United States for any employer.

This is the only "pre-screening" you can legally do to make sure you are not hiring an ineligible worker. If you live in a large metropolitan area, you may get better results from community papers than from the large dailies that cover areas 100 or more miles. Online services, such as Craigslist and its local competitors, may be a cost-effective form of advertising. Just be sure your applicants are local. It is not wise to employ someone who lives

two hours away and drives an old car, which may or may not start on any given day.

Interviews

The interview process begins on the telephone, as you are setting a time for a personal meeting. The first thing to consider is the attitude of the person on the other end. Is he or she friendly or surly? Do not confuse an inability to articulate with a bad attitude. Someone may not have much formal education, but have experience and a positive attitude that will overcome poor grammar. What is the overall demeanor of the person you are talking to on the telephone? Does this sound like a person you would like to be around? Some people may be shy about admitting they do not have much experience or some other negative. Lack of experience is not as big a drawback as someone whom you suspect is being evasive, trying to pass off work experience at a fast food restaurant as a qualification to work for you as an employee.

Why do they want the job? Do they have an interest in photography, or do they just need some money? Select the most suitable applicants before you schedule face-to-face meetings. You will want to know whether they have experience with the tools and equipment they will be using as your employee.

During the personal interview, apply the same standards you would expect your customers to use. How is this person presenting himself or herself? Is the person clean? Is his or her clothing torn or dirty? Does he or she look you in the eye? If the prospective employee claims to have experience, ask them two or three questions that require some knowledge to answer. You do not have to be challenging or harsh in your questioning. You can be friendly, even funny. You simply want to determine to the best of your

ability if this person is being honest with you. You might want to present a scenario and ask how the applicant would start, perform, and finish the task you describe.

Review the applicant's résumé and ask questions about gaps in work history or lack of recommendations or past employers. Someone who tries to turn that work history into a major qualification to work for you might not be as desirable as an employee. If you have the sense that your candidate is lying, be cautious about hiring him or her. It is easier to not hire someone in the first place than to fire him or her after the fact.

Before you interview anyone, read up on rules about discrimination in hiring. Some questions are forbidden. You may not ask about a person's religion, politics, or sexual preference. Your questions should track the qualifications for the job, not outside interests or qualities the prospect has no control over. That same standard would not apply to an office worker whose most challenging physical effort will be moving paper from one side of a desk to another or using the telephone.

With each job applicant, try to objectively see the person. Is this someone you want to be around every day? Someone a customer would like and trust? Someone you believe can help your company grow? All of these things matter.

Hiring people you can promote is important because it gives employees reassurance they can grow along with your company, and provides incentives for superior performance. Ambition can work for you. Do not be reluctant to hire the smartest people you can find.

Once you have narrowed your list and found the person or persons you would like to hire, check them out. Call former employers to inquire about their work history and performance. Be aware that many former employers

will be reluctant to offer bad news about someone. Know the qualities you want to inquire about and ask specific questions. If you just ask, "What can you tell me about Bob?" you will probably get an answer as general as the question. "He was all right." You want to know if Bob showed up on time, did what he was supposed to do, and if he caused any problems. Listen for what Bob's former employee is not telling you. If his former employer is distant or does not seem as though he has much to say about Bob, this may be a warning sign. On the other hand, if he says, "I would hire him again in a minute," you have the answer you need.

Once you have made a decision, call Bob and give him the good news. Tell him clearly, as you should have done during the interview, that you have a probationary period, 60 or 90 days (longer or shorter as you chose), during which he can quit or you can let him go with no hard feelings and no obligation on either side. Send him a confirmation letter outlining your work policies and what is expected of him. This can be a separate document if you like. As with customers, it is best to have all requirements and expectations in writing.

Contact everyone else you have interviewed and explain that you have made a decision to hire someone else. Wish everyone well and thank them for their time. Keep the résumés of people you think might be suitable in the future.

Even after you select a candidate, keep the other appropriate-seeming résumés and contact information. You never know when you may need another employee, and if someone who applied previously happens to be available, you will save yourself time in finding your next hire.

Some communities restrict how many employees a home-based business can have. Check your local zoning restrictions and other regulations before

you commit to a number of people parking their cars and doing other business-related activities in the neighborhood. If you face such restrictions, you will be forced to either rent business space or arrange to meet all of your workers at job sites or other locations.

New employee paperwork

No matter the employee you hire, you will have to fill out and either send in or retain certain government documents. These include W-4 forms, the Employee's Withholding Allowance Certificate, and the W-5 for employees with children, if they qualify for advance payment of earned income credit. Check the IRS site or **http://business.gov/business-law/forms/** to download forms.

Keep going and growing

With your business running smoothly and new employees hired, it is important not to sit back and rest on what you have done so far. Keeping a successful business going is hard work and will require you to keep focused on your goals.

Adding a new employee could help you reach the goals you set for your business by giving you the free time you need to work on the other aspects of your company. Hiring the right employee, and following the laws and regulations in place, is essential.

Chapter 13

Putting Your Business to Work for You

S tarting a business is a sacrifice. As the business owner, you give up hours and hours of your time, far beyond the typical eight-hour workday. The reason the business owner goes through those sacrifices is in hopes that one day, the business he or she started will become profitable, allowing for the business owner to lead the life he or she has always dreamed.

That does not mean, however, that once the business starts making a profit, the business owner can just sit back and watch the money roll in. The challenges faced by the established business owner and those faced by the new business owner are sometimes the same, but sometimes quite different.

Growing Your Business for the Long Term

While in some ways, keeping an established business running is easier than starting one from scratch, running an established business comes with its own set of hurdles.

Owners of existing businesses that are becoming profitable do not need to go out and find a customer base that is not yet familiar with their

product, and they do not need to worry about starting capital and developing their vision.

Now that you have established your business, you can work on growing it for the long term. Owners of existing businesses need to find ways to keep their business growing and avoid becoming stale. Existing business can do this in two ways: offer new products and innovate the way they do business. The owners of existing businesses also have to seek out new clients and keep an eye on changing trends, just like owners of new businesses do.

CASE STUDY: FINDING A NEW APPROACH

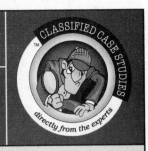

Trista Blouin, Photographer
Look Who Just Blouin Photography, Inc.
www.lookwhojustblouin.com
(850) 712-1513

I am an on-location portrait and editorial photography artist, who works primarily with children and their parents.

Although my first official month of business was in October of 2003, I have had a camera around my neck since I was a young girl. My grandfather was an on-location portrait photographer, so I have always been around the business. I knew I wanted to photograph children when I had my own.

My work has appeared in the books *Faces of Life* and *A Slice of Life*, as well as in many magazines, including *Professional Photographer*, *Parents*, and *NW Florida's Business Climate*. I was also honored with being named one of five finalists for the 2008 Small Business of the Year award, presented in Pensacola, Florida.

I find that what makes a really great photographer — no matter what the specialty — is the quality of remaining true to oneself as an artist. I have seen photographers who try to be everything to everyone, and they not only do a disservice to their clients, they are losing their own sense of what brings them passion.

How can you have beautiful, meaningful art when it comes from a place of superficiality and obligation? I have, on occasion, started to feel like I was losing my spark. What I have done in those circumstances is taken on a photo project outside of my business. It always happens that in the process of reconnecting with my love of photography through these projects, I discover a fresh approach to my love of working with children. It never fails.

Establishing Relationships

Relationships, such as those made through participation in various professional associations, will help you build your business, improve techniques, and solve technical issues. They may even qualify you to purchase and sell items or equipment below retail. Although most organizations charge a small annual fee, they provide access to a plethora of free information and connect you with people and resources that you would normally not be able to attain on your own.

Major trade associations, such as The American Society of Media Photographers (ASMP) and The Professional Photographers of America (PPA), provide members with a wealth of educational information to help with virtually any problem — from technical to operational to legal.

Also, get involved in your community. Joining a professional group of local businesses can help you run your own business. By building relationships with other business individuals around you, you can establish a network of resources that will help you with business questions and problems you may encounter.

CASE STUDY: JOINING PRO-FESSIONAL ORGANIZATIONS

John Slemp
John M. Slemp Photography
75 Bennett St. NW, Suite H-2-1
Atlanta, GA 30309
(770) 493-9727
www.johnslemp.com
www.aviationfineart.com

Before turning pro, I completed my college degree in Psychology and was a lieutenant in the Army. I served in the United States and abroad for more than 10 years. I shot some photographs and, at the encouragement of others, entered the slides in a U.S. Army-Europe Photography competition while I was in West Germany. I then left the post and spent 45 days at a battle position about two miles from the German border. When I returned, I was told that I needed to go to Heidelberg, Germany, because I won first place in the people category for the photographs I had taken. I entered images again the next year and that time won first prize. It became obvious to me at that point what I needed to investigate as a future career.

I left the service in 1989 and went to school at the Portfolio Center in Atlanta, Georgia. After getting out of school in late 1991, I assisted a wide variety of well-known advertising, corporate, and editorial photographers to gain practical experience in the art and business of commercial photography. Once I got going as a freelancer, I was working 17 out of 20 days a month, which was pretty good. I officially launched my business in 1992.

Currently, I create location and studio images for commercial clients across the nation. Although I am a generalist, I find myself being increasingly drawn to aviation, so I have been moving toward that niche. I am also a former member of the American Society of Media Photographers (ASMP).

The best advice I can give to people new to the business it to get involved in an organization, such as ASMP. These types of professional

organizations can help with everything, from keeping you up-to-date on industry trends to linking you with mentors, to giving access to group-buying power for insurance and providing business and legal resources specific to the needs of photographers.

In addition to building a network of business resources, you can also get your company name in front of business and community leaders where you live. This can be important, especially if you are working in a studio and doing portraits, as it may lead to more clients. Business and community leaders many times have portraits taken for biographies on Web sites and in directories. If you are working as a freelance photojournalist, building a relationship with these individuals can help in the long run if you need to take a photo of their business or need a photo for a story that can be hard to get.

Keeping Your Customers Happy

In the United States, statistics reveal that approximately 25 percent of purchases or transactions made involve some type of customer problem or complaint. Complaints come in many forms, ranging from polite questions to aggression. Versatility and patience in learning to deal with customer complaints is a part of normal business. This is important because return customers and spreading your business reputation by word of mouth are two goals that are likely to be in your marketing plan. Ultimately, keeping customers happy will help fulfill those goals.

Although complaints are part of every day business, many people may not know how to deal with unruly customers. There are steps to follow to help you cope.

To handle a situation where a customer is not happy, you must:

- Remain calm, even if you feel like you are being attacked or insulted.

- Listen to the complaint.

- Acknowledge the anger or upset that a customer may be feeling.

- Respect the customer's feelings.

- Come to an agreement by saying words such as, "I understand" or, "I know you are upset, and we have a problem. Let us see what we can do."

- Apologize when necessary, even if the situation was not your fault.

- Take ownership of the problem so you can come to a peaceful resolution.

- Be an active listener, and do not interrupt the customer. Let them finish speaking.

- Always thank the customer for bringing the problem to your attention.

Customer service keeps customers happy

Respect and listening are key tools to providing excellent customer service, and one way to measure excellence is through reputation — the belief that a company consistently satisfies its customers. Customers are the lifeline for any business. If they are not satisfied, future clients will go to a competitor.

Another important factor of customer services has to do with the quality of work you produce. You and your employees should strive to complete projects not only in a timely manner, but also in a way that reflects your best work. While this is a general standard for any business regardless of the industry, it is particularly true for photography businesses. People are seek-

ing your services because they want something more artistic, more focused, or more professional than what they can do on their own. Thus, quality will be a driving factor in ensuring good customer service and, ultimately, the success of your business.

Make sure that your customers are happy, and provide them with a wonderful experience. Illinois-based photographer Argentina Leyva (Chapter 12) said, "Throughout the years, I have made sure to provide my customers with a great experience, personalized service, and a great sense of worthiness on investing in photography."

Leyva's business is comprised of 60 percent wedding clients, 30 percent pregnancy clients, and 10 percent general clients. Most of her business comes from referrals from previous clients because, she acknowledges, she caters to the wants of women.

People tend to want a more personalized experience instead of being just another customer these days. "Customized and personalized service is what my clients look for, and they are my best promoters among their acquaintances," Leyva said.

Becoming More of What You Want Your Business to Be

Sometimes you have to fake it before you make it big. Learn from others, and mimic the attributes you find desirable so you can become more of what you want your business to be.

When starting out, it may be beneficial for you to take whatever business comes your way. In an earlier example, you imagined that you opened a studio in the hopes of taking senior portraits for the local high schools, but your business began attracting families and children more than high school seniors. In the beginning, it is important not to turn away those clients, and you will probably want to hold on to them for the rest of your career to build that relationship and keep them coming back.

But, once you have established your business, you can start working your way toward your initial vision. To do this, look at your marketing plan and figure out how you can attract these customers to your studio. At the same time, however, do not alienate the customers that you have already acquired by ignoring them and focusing on your original idea. If you have decided to hire an additional photographer, you can have that person be in charge of the family portraits, allowing you time to grow your high school senior client base.

Once you have established your business, you can start moving in different directions with your photography, provided you keep your core clientele. In other words, you can experiment with new techniques or different types of photography. But, it is important as a business to try new things and tap into different markets to diversify your income because, while a certain market of customers may be available at the present time, that may not always be the case. Having a diverse business will help you survive if the culture changes and the type of photography you were doing is suddenly no longer in vogue or needed. Do not be afraid if some of your new directions do not pan out. As long as you have planned properly, taken a realistic look at the market you are in, and kept your core clientele in place, your company should be able to take the hit in stride.

How Do You Talk About Your Business?

How many times throughout the week does someone ask you, "What do you do for a living?"

Answer the question by sharing your benefits and selling yourself as an expert. A common tool to help you stay focused is known as an elevator speech. It is a short blurb and should take approximately 30 seconds to say — just enough time to create interest and attention and inform the listener. It gets its name from its shortness. The rule of thumb is that when

you describe your business, you should do so in the time it takes to ride in an elevator.

The typical elevator speech consists of about 100 to 150 words. There is a memorable introduction, an explanation of benefits and solutions, and a definition of what makes you unique. You may want to say that you help solve a particular problem, provide prompt service, or offer money-saving methods.

Some common ways to open your speech can include the following:

- "I help parents save their sanity."

- "I have a two-year-old business called Shake, Rattle, and Roll Photography. We are a boutique photography studio dedicated to creating and capturing timeless images of babies and children under the age of 12."

- "Busy parents appreciate us — we value their time and money by providing images on a CD-ROM so they may custom print, e-mail, or upload images to a Web site for viewing by family and friends."

Establishing Successful Product and Service Lines

The best way to ensure the success of your company is by providing quality products and services that meet your customers' needs. Like any business, those needs can change as the years go by, but being ahead of the curve when it comes to industry trends will help you continue to stay profitable.

Giving the customer a quality product is why you started a business anyway, and is the most basic form of customer service that you have estab-

lished. You had a talent and wanted to provide that service to others. So, providing customers with something they will love should be a fun and rewarding step you can take.

Evaluating the present

Now that you have the tools and reports you can use to determine what you need to start and operate a successful photography business, ask yourself:

- Where are you today in making your plans?
- What is going right in your business venture?
- What areas do you need to improve?

These are all questions you should ask yourself as you move through the process of running your business. Capitalize on your strengths, and learn what you do well so you can apply those principles to your future business.

Review the work you have done so far. Are you creating the product you envisioned when you started your business? What can you do to improve? What are your strengths? By evaluating these questions, you can make sure the product you are putting forth is something you can be proud of, and is something that your customers will keep coming back for.

Seeing the future

Your future relies on the day-to-day choices that you make about how you invest your time and money. Starting and running a business is scary and exciting, but you do not have to do it all in one day. Plan, prepare, and project what you need to be successful. Write down your goals, and then break down the steps into small nuggets to easily reach them.

Photographer and author Vik Orenstein equates the life cycle of business to that of a person in his book, *Photographer's Market Guide to Building Your Photography Business.*

GESTATION:

This is the idea phase, where you are both excited and worried. This is where the "what ifs" are imagined and different scenarios are played out in your head. This is when you started thinking about starting your own business.

INFANCY:

This is the start-up phase where all of your time and energy are consumed by the business. During this phase, you will be working hard. This is when you laid the groundwork for you company. This is also the time when you started to identify your customers and come up with your marketing plans.

POST-INFANCY:

In this stage, the business is beginning to walk upright and gain momentum, only to fall down after a few steps are made. Picking up speed means we run right into a wall as our enthusiasm increases our desire to take risks. This is the stage when your business is taking off. You have a few clients and are learning what they like and what will keep them coming back.

THE AWKWARD STAGE:

This is also known as the pre-teen phase. One day you are the most popular person around, the next day you are unsure of yourself. You know everything; yet you know nothing. This is the phase where it

looks like your business will become successful and you are trying to determine your niche.

YOUNG ADULTHOOD:

The mood swings, doubts, and insecurities of your awkward phase are behind you. Your business is stabilizing, but you are still excited and engaged because every job is a rewarding challenge. This is the time when you decide how your business will grow. Will you add employees? What are the other markets you can break into?

MIDDLE AGE:

Boredom begins to set in because you are confident and have successfully tackled the necessary challenges in order to grow your business to a level of comfort and security. You know your business and now the challenge is to keep reinventing yourself. Make your product standout.

THE GOLDEN YEARS:

Unless you build a large photography business for the purpose of selling it somewhere down the line, you most likely will begin to cut back on business in order to retire comfortably. If you have planned well, saved, and invested in yourself, this stage is indeed possible to reach. This is the phase we all strive for. Your business is running well and you have a strong client base.

Realize your value as you grow. Increase the rates of your products or services from 5 to 7 percent every six months to a year to adjust for cost of living increases. That way your income grows as your company matures with the previously described life cycle. Spending more on the basics and not passing down the costs will hinder your abilities to thrive and be prosperous.

Spotting trends and getting in front of them

To grow and sustain until you reach The Golden Years, read trade magazines and get active in professional organizations to spot the trends that are out there.

Working in an industry where work produced six months ago is old news. Fashion photographer Ingrid Werthmann (Chapter 13) advises that the best way to stay ahead of the current trend is to create a trend. Always test, create, and try new things. "Never follow, and always lead," she says. This may be accomplished by developing your creative vision and refining your style and skills every time you get behind the camera.

Avoid becoming yesterday's news by continuing to generate fresh ideas and by staying passionate about your business and craft. One way to remain innovative is to try to solve problems. Brilliant ideas are born using the combination of logic and imagination.

In the stock photography business, the executives at PhotoShelter in New York see plenty of what is hot today, without much consideration for the market of tomorrow.

Staying in tune with your customers

Listen to your customers. Look at what they need, and then cater to their desires by providing benefits to the way you deliver your services and products.

CASE STUDY: GETTING BACK TO THE BASICS

Ingrid Werthmann, Ingrid Werthmann
Photography
Fashion, Beauty and Advertising
681 17th Avenue NE, Studio 414
Minneapolis, MN 55413
612-237-4949
ingrid@ingridwerthmann.com
www.ingridwerthmann.com

For more than a decade, Ingrid Werthmann has stayed in alignment with the needs of her customers by maintaining technical proficiency with the latest media and editing equipment for fashion photography.

As digital technology has progressed, she has trained extensively in the different applications, incorporated digital use in all formats, and shot and designed print and Internet campaigns. For photo retouching, she has followed the evolution of Adobe Photoshop and, in order to fulfill customer needs, has been responsible for creating image sheets and preparing product prior to capture. "As my customer base has grown and changed, the majority of my time has been spent in post-production — editing, retouching, color-correction, printing, and image delivery," she said.

As the owner of a professional fashion photography business, Werthmann is most recognized for her mastery of lighting technique. Over the years, her roles have included lead fashion photographer for *Industry Minne-zine*, acting as an adjunct teacher for the Art Institutes International Minnesota, and acting as an adjunct teacher for the Dakota County Technical College. After doing an array of things, Werthmann started teaching, consulting, and shooting for a number of local and national magazines, agencies, and boutiques.

When she was first getting started in the industry, Werthmann assisted Kevin White, Bob McNamara, and nearly 40 other photographers from the Minneapolis and St. Paul areas, as well as visiting photographers from other places, even Europe. Under the guidance of experienced professionals, she was taught to accept direction and to assist other members of a photography team.

Her skills were tapped with regards to lighting, model direction, technical knowledge, equipment maintenance, transportation, and film editing. Before she knew it, Werthmann had quit assisting, opened her business in the same month, and began marketing the business. Slowly, it grew.

It is easy to get lost in the glamour in the operation of her day-to-day business, but Werthmann reminds herself, as well as other photographers, to go back to the basics — the love for photography. "I consider the most important quality a professional photographer can have as an undying, all-consuming passion for shooting and experimenting. One must have a continued curiosity about past and present photography," Werthmann said.

Using Technology to Grow Your Products

Photography is a field that is greatly impacted by technology and technological improvements. Not too long ago, film was thought to be the best way to capture pictures, but through the development of better digital technologies and software programs designed to help enhance your photos, digital photos have become king.

Learning these trends in technology and how they affect you can save money and make your job easier. Do not be afraid to embrace new technologies or be intimidated to learn how to use new programs or techniques.

Save time

At an increasing rate, photography businesses are turning to the Internet to save time. What used to take hours in the dark room now takes minutes on the computer screen.

Beyond the Well Photography (Chapter 4) uses an online lab to fulfill all of their print orders, which saves time from being on the road dropping off and picking up images from a local vendor. The Bridges

host their photos at Smugmug.com at a special address linked to their business Web site (**http://clients.beyondthewell.com**).

The images are hosted for a full year, which allows family and friends of newly-wed couples to order prints. They also use Smug-mug.com to print images used in the physical portfolio they show to potential clients when meeting with them face to face.

Karen Bridges advises professional photographers to avoid big-box, retail photo department machines because they are inconsistent in quality due to infrequent use and little maintenance. Therefore, what seems like a time saver — printing photos at a store that seems close by — may wind up costing you time, as your pictures may be printed in poor quality, forcing you to have them reprinted.

Another time saver involves the use of technology service companies for marketing. Although he does not advertise it, Minneapolis photographer Darin Back (Chapter 7) does work with a company that handles marketing for weddings. The marketing company links him with the work request and the engaged couple. He makes contacts, photographs the wedding, and uploads the images to a server. Someone else handles the details, and he gets paid. "It has been a good arrangement," he said.

Save money

One of the biggest money wasters a photographer can experience is the crashing of a computer system and scrambling to recover data and files, while also trying to move forward with your work responsibilities.

Fortunately, the costs and difficulty of backing up your work continues to decrease as technology and portability options increase. Sources contributing to this book shared their horror stories. One photographer's computer experienced a virus that corrupted his marketing contact information.

If your systems fail, the loss of income can cost hundreds of thousands of dollars, depending on the extent of failure, loss of data, and how much your reputation suffers with clients before you are able to complete the job they requested. To avoid this, some photographers use off-site backup systems that offer digital storage via a Web server that is accessible anywhere. This is a good option, particularly when you do considerable travel in your work.

Other photographers use different options, such as implementing an initial four- or five-tier backup of all their images:

1. Memory cards serve as first place of storage, directly from the digital camera

2. A handheld backup device duplicates information from all the memory cards onto a backup system

3. The files are copied to a computer

4. The images are burned onto DVD

5. Sometimes, the files are also backed up to another computer hard drive, making five copies

After the files are edited, the images are uploaded to the Internet for the client on a secure system, often a portal within your own Web site. Then, they delete the other backups, leaving them with DVD backups of both the raw and the final JPEG files and one copy of the final JPEGs on the computer for portfolio or album design use.

Produce new products

Technology increases the possibility of producing new products, as it has in the world of stock photography. The PhotoShelter Personal Archive is an online solution that allows photographers to sell their images directly to

clients. The system includes tools for image storage and protection, searchable galleries and slideshows, and e-commerce sales. Users looking for stock photos can also sell prints online instantly, as well as download digital images and usage licenses. Designed to make the business of photography easier to manage for independent business owners, the Personal Archive offers security and marketing tools, allowing photographers to make their images work for them.

While dollar signs often appear in a photographer's eyes when hearing the word "licensing," Pip Bloomfield (Chapter 4) debunks a common myth: Licensing is a get-rich-quick option. "Licensing work brings your name to the forefront. It is a wonderful way of getting out there, but if you think there are big bucks attached, there are not, unless you have a big name, like Martha Stewart," she said.

Bloomfield transformed her career as an interior designer working in hospitality, to one as a photographer by grabbing the attention of other designers, public relations specialists, and the media. The boldness, color, and size of her pieces, which normally average about 48 inches x 48 inches, helped launch new ventures, which have proven more profitable.

Offer new services

As your business grows, it goes through many changes. Some of the changes can be joyous and others painful; some can thrust you into a place where you will have to leave one specialty and focus on another, or where economics necessitate that you add another specialty to your line of business to increase profits. Try these ways of expanding your photography business to increase profits:

- Portfolio photography — headshots for professional models, actors, and artists.

- Limited edition fine-art prints — developing something that is different from what you usually shoot or edit.

- Taking photographs of locally made products — for advertising purposes for the businesses that make those products.

- Producing mugs, plates, buttons, and other products that contain your photographs — for an additional option to standard services.

- Multimedia production — another additional option to standard services.

- Car and motorcycle club photography — for avid collectors or automobile connoisseurs.

- Racing photography — automobile, boat, and dogsled competitions.

- Aviation and aircraft photos.

- Extreme sports photography — skydivers, hang gliders, surfers, and sailboarders.

- Medical and dental photography — before and after shots, office and staff photography for marketing purposes.

- Athletes in action — for publication, stock, school, and family.

- Used car photography — for car dealers.

- Custom matting and framing services — for an additional package option to offer your customers.

- Photo restoration — another additional service to your customers' old photographs.

- Documentation and contractor work — for government agencies at the city, county, state, and federal levels.

Stay connected

Another great way to use technology to grow your business is through the use of blogs and social networking. As your business grows, you will be viewed as an expert in photography just by being involved in your industry in the online arena. By writing a blog, you can share that expertise with the virtual world, while calling more attention to your company at the same time.

Sites like Facebook and Twitter help keep you connected to customers and can be a great way to offer discounts and tell them about up coming promotions. By forming "friendships" with people on Facebook, or by "following" them on Twitter, you can form networking relationships that may result in an increased client base. A site like LinkedIn can connect you to other photographers or professionals in the photography industry, as well. Use the following chart of popular social networking Web sites and their functions to determine which sites are best for your business:

Orkut® is a popular social networking site owned by Google. This social networking site has millions of users; 63 percent of Orkut traffic originates from Brazil, followed by India with 19.2 percent. Like other sites, such as Facebook, Orkut permits the creation of groups known as "communities" based on a designated subject and allows other people to join the communities. Orkut is an online community designed to make your social life more active and stimulating.

Facebook is the leading social networking site, with more than 250 million active users at the time of publication. Initially, Facebook was developed to connect university students, but over time, the site became available publicly and its popularity exploded. The majority of users on Facebook are college and high school students, but this trend is shifting rapidly to people of all ages and backgrounds. On Facebook, it is extremely easy to add friends, send messages, and create communities or event invitations.

MySpace® is a social networking Web site that offers an interactive platform for all its users. It allows the sharing of files, pictures, and music videos. You can view the profiles of your friends, relatives, and any other users; you can also create and share blogs with each other. Users often compare Facebook to MySpace, but one major difference between the two Web sites is the level of customization. MySpace is a large social networking site that allows users to decorate their profiles using HTML and CSS, while Facebook only allows plain text. The most prominent feature that makes MySpace unique among other sites is its affiliate program. If the affiliate product you are selling has a broad appeal, you may want consider using MySpace to market your product, as you will be able to reach the largest crowd quickly.

YouTube® is another social networking site owned by Google. To become a member of YouTube, go to the "Signup" page, choose a username and password, enter your information, and click the "Signup" button. YouTube is the largest video sharing network site in the world, and it is a great place to do video marketing.

Digg is a place to discover and share content from around the Web, from the smallest blog to major news outlets. Digg is unique compared to other social networking sites because it allows you to directly network with people and directly sell products. Once a post is submitted, it appears on a list in the selected category. From there, it will either fall in ranking or rise in ranking, depending on how people vote. Digg is actually what is known as a "social bookmarking" site. You submit your content to Digg, and other Digg users — known as Diggers — will review and rate it. Once it is rated high enough, your content may get posted on the homepage of Digg, which gets thousands of visitors a day, potentially driving tons of traffic to your Web site or blog.

TwitterSM is different from other social networking sites, and the popularity of Twitter has grown at an amazing rate. With Twitter, you can let

your friends know what you are doing throughout the day right from your phone or computer. When you sign up with Twitter, you can use the service to post and receive messages (known as a "tweet") with your Twitter account, and the service distributes it to your friends and subscribers. In turn, you receive all the messages sent from those you wish to follow, including friends, family, and even celebrities. In essence, Twitter is a cell phone texting-based social network.

Flickr is a photo and video sharing Web site that lets you organize and store your photos online. You can upload from your desktop, send by e-mail, or use your camera phone. It has features to get rid of red eye, crop a photo, or get creative with fonts and effects. Google Picasa™ is another great photo sharing and storing application.

Friendster® had 110 million members worldwide at the time of publication and is a place where you can set up dates and develop new friendships or business contacts. This site is a leading global online social network. Friendster is focused on helping people stay in touch with friends and discover new people and things that are important to them.

Other popular business networking sites

The following sites offer businesses opportunities to network with other business owners:

- **Bizfriendz** (**www.bizfriendz.com**): Make new contacts, promote your products and services, get viral exposure to your business, and earn commissions while you build your network.

- **Biznik™** (**www.biznik.com**): Their tag line: "Business networking that doesn't suck." Geared directly to entrepreneurs and business owners, with a number of different communities.

- **Cofoundr (www.cofoundr.com)**: A private community for entre-preneurs. Promises to help members build teams and network with other entrepreneurs.

- **Ecademy (www.ecademy.com)**: Provides extra tools to build your business, such as networking events, Webinars on online topics, and the ability to locate members with specific knowledge.

- **Fast Pitch (www.fastpitchnetworking.com)**: Reports it is grow-ing faster than any other social network for professionals. Set up your own profile page and network with other businesspeople.

- **Konnects (www.konnects.com)**: Gives each member a profile page. Join communities, meet other members, and network with professionals with similar interests.

- **LinkedIn**SM **(www.linkedin.com)**: Connect and network with oth-ers in your field or who can use your abilities and/or services.

- **StartupNation (www.startupnation.com)**: Active forums with a wide variety of subjects for businesses.

- **Stumble Upon (www.stumbleupon.com)**: Post any information of value and interest to others.

- **Upspring (www.upspring.com)**: Increase exposure and attract more customers. Sign up for free and get a profile page, find and join groups, and increase your networking activities.

- **Xing (www.xing.com)**: An active group of professionals looking for ways to network with people of interest.

Know Where You Are Going

The key to keeping your business successful is to always refer to your business plan — the road map that you created earlier in the book. If you know where you are going, you can see the steps you need to take to get there more clearly. It is much easier to stick to a plan that you have already put time and effort into making than it is to make things up as you go along. Therefore, it is essential to always think ahead, and to always think about what you want.

What do you want?

Take a moment and to ask yourself what you want out of your life within the realms of:

- Your financial goals
- Your professional goals
- Your personal/lifestyle goals

In preparation for competition and during events, athletes use creative visualization as part of their process to practice toward and achieve goals. It is a proven technique to making goals a reality because it keeps the brain focused on the destination as actions are taking place. Your life is like a competition, too. There are limited hours in the day to accomplish what you want to achieve. Visualize what you want.

What could keep you from getting it?

There are many things you could do to keep from achieving your goals. Laziness, failing to plan, and fear of failure — or fear of the responsibilities of success — are just a few examples of how you might be the one getting in your way of success.

Poor planning, a stale product and lack of innovation are also things that can stand in the way of your business succeeding. Feel your fears, acknowledge they are real, and do the work. Only doing the work and following the examples that others have set forth will help you overcome apparent obstacles.

What do you need to do today?

No matter what yesterday looked like, you have today. Commit, or recommit, to your goals and to your vision. Make a plan, and then put your plan in action.

For example, say a successful couple in business has a daily ritual. They spend 15 minutes every morning dedicating their day to prioritizing the tasks at hand. At the end of the 15 minutes, which is commonly a review of their project and to-do lists, they connect their tasks with the grand goals they have for their life and their business. Their office is filled with whiteboards that detail their checklists, goal statements, and pictures of what their business will look like one day. Not only does it keep them organized, but it keeps them motivated during challenging times.

How can you plan for six years from today?

Having a long-term business plan in place will help keep you from veering in the wrong direction. If you think long-term when making any decisions regarding your business, the small setbacks will not set you off track. Just remember to follow your business plan, and adapt to the changes of society as you build your business.

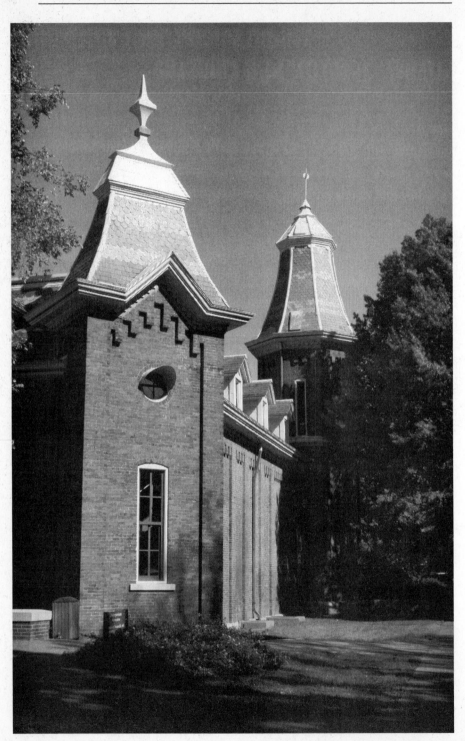

Photo provided by Mindy Schwartz

Chapter | 14

Photography and the Law

Much of photography involves people, whether it is photographing them or working with them to have your work publicly displayed. In both cases, legal issues can arise, and they can be tricky to deal with. You may run into someone who does not want their picture taken, or another publication or Web site has pirated your work. It is important to know the laws and your rights as a photographer so you can meet any challenges head-on.

Copyright Laws

Copyright laws affect all photographers. Because the photo is your product, you own the rights to your work, and understanding copyright laws can help you protect what is rightfully yours.

An overview of copyright law

You can, and should, visit the United States Copyright Office's Web site, **www.copyright.gov**, where you can find current copyright laws. You can also study copyright law for the United States. Under U.S. law, a work is

copyrighted when it exists in fixed form, or basically whenever you snap the picture. The moment you take a photo, it is copyrighted.

If you have any questions or doubts about copyrights, consult a lawyer.

Copyright registration

Copyright registration is not copyrighting something; the copyright already exists as soon as you take the picture. But, you should register your copyright with the United States Copyright Office so you can prove ownership of your intellectual property if a problem arises, like someone trying to steal your work for his or her own use. You cannot pursue a case against someone for copyright infringement until after you have registered the copyright. The earlier you register it, the better your chances of prevailing in a lawsuit becomes.

What can be copyrighted

1. Literary works
2. Musical works, including any accompanying words
3. Dramatic works, including any accompanying music
4. Pantomimes and choreographic works
5. Pictorial, graphic, and sculptural works
6. Photography
7. Motion pictures and other audiovisual works
8. Sound recordings
9. Architectural works

What cannot be copyrighted

Several categories of material are generally not eligible for federal copyright protection. These include (from **www.copyright.gov**):

- Works that have not been fixed in a tangible form of expression (for example, choreographic works that have not been notated or recorded, or improvisational speeches or performances that have not been written or recorded)

- Titles, names, short phrases, and slogans; familiar symbols or designs; mere variations of typographic ornamentation, lettering, or coloring; mere listings of ingredients or contents

- Ideas, procedures, methods, systems, processes, concepts, principles, discoveries, or devices, as distinguished from a description, explanation, or illustration

- Works consisting of information that contains no original authorship (for example: standard calendars, height and weight charts, tape measures and rulers, and lists or tables taken from public documents or other common sources)

How copyright protects you

The protections of copyright are fairly obvious. Your work belongs to you, and the copyright laws protect you against someone else stealing your work by duplicating it or trying to sell it as their own work. Your work remains your work because you own the copyright.

What you should be aware of

Of course, copyright protects everyone, so you need to be aware of other people's copyrights so you do not accidentally infringe on their property. Some people are not aware that Web site content, both images and words, are protected under copyright, as are many of the images in "free clip art" collections. Before you use something, make sure you know who owns it and whether or not you have permission to use it. Most Web sites will list

the photographer of the photos on the site, along with contact information. If you cannot get a hold of photographer to get their permission, do not use his or her photo. Some sites, though, will post a blanket statement saying photos are free for use for any reason. In that case, contacting the photographer is not be necessary.

What rights are you assigning?

As a professional photographer, you are not "selling" your photos. You always own the original, unless you assign all of the rights to your customers. What you are doing, however, is assigning rights for a certain purpose and a certain time, temporarily. When you do commercial work, you will need to specify clearly in what media the image may be used, for what purposes, and for what length of time. Most commercial clients are familiar with this process, and most are honest.

When you sell prints, you are selling that particular print, but not the right to reproduce the print without your permission.

You should have little trouble getting paid for your work, but you may need to enforce your agreement occasionally. Simply send a polite letter on your letterhead reminding the client of the agreement, and asking that they remit payment for the additional use at your regular rates. Never discount when someone is using your work without permission.

Work-for-hire and copyright

If you sign a work-for-hire agreement, where you are working for the company that hired you rather than for yourself, the other party owns all rights to your work, and the up-front payment you received from the company you worked for is all you will receive. For photographers, work-for-hire rarely makes sense because you do not control your photos and cannot make money off the photos in the future.

Model and Property Releases

When working with models and taking photos on location, you will need to get the permission of those you are working with to use their image or the images of their property. Knowing when you need someone to sign a release form will be important to keeping you from getting in trouble.

What is a model release?

A model release is a signed document stating that the subject of your image has given you permission to use the image. You cannot publish a photograph of a person without a signed model release by that person, or by their parent or guardian if the person is a minor.

You should send the person a copy of the photo or pay them a small sum in exchange for their permission to use the image. This is required by the language in the model release contract regarding some valuable consideration. You can buy sample model releases or pre-printed forms at many photography supply stores or online from sites, including the Digital Photo Corner, **http://dpcorner.com**, and Wikipedia.

When you do not need a model release

In general, if you are planning to use an image of a person or someone else's property in a fine-art print for a gallery, you may not need a release. Still, you may want to get a release just so you can be sure that you are protected. The only time it is clear that you do not need a release is when the person's face is not recognizable. If you have a recognizable face in an image, you should get a release while you have the opportunity.

Obtaining a signed release

If you ask someone to sign your release, explain that you are hoping to sell the image to a magazine and offer a copy of the photo in exchange for the signature; they will likely be glad to sign your release. If they will not sign it, thank them anyway and understand that you cannot publish the image.

There are times when a person may not give you their permission to use the photo. This could be if they are a high profile individual or were caught someplace they should not have been. Also, some people are just sensitive about having their picture taken. Whatever the circumstances, at that time, just cut your losses and agree not to use the photo.

When do you need a property release?

You may need a release if you are photographing private property, such as a building, an animal, or an automobile. The laws on this are fairly complex, and you should consult an attorney or a guide written by an attorney. Obtaining a property release is not much different from obtaining a model release; you need the signature of someone with the authority to sign a release.

Who Owns Your Photographs?

You own your photographs, unless you sell all the rights to those photographs to someone else. That is the bottom line: You own the images. Companies and individuals can buy prints from you, and they can buy the right to use images in certain ways, but the images still belong to you.

Editions

Some artists, particularly print makers (photographers who make their own prints), will create a certain print and sell a certain amount of copies, maybe 100 or 500, of that edition or special version of the print. Some photographers also do this, stating that they will only sell 100 of a particular print, signing and numbering the mats. Most photographers do not do this because it limits income and use of a particular image, and also because they do not see a point to doing it. Since all photos are identical, the thinking is that there is no point in limiting your ability to sell a photo over and over through creating editions.

Multiple prints

Most photographers who sell prints, particularly fine-art prints at galleries and art shows, sell the same photo many times in different sizes, with different mats and frames. This allows them to make the maximum income from one photograph.

Privacy, Security, and Cameras

As a photographer, much of your work may involve taking pictures of people in public places and events. The problem is, those people may not want their photos taken. Legally, their right to privacy usually triumphs in court. Because of this, you are probably going to do everything you can to prevent actually having to go to court, and the easiest way to do this is to respect the right to privacy. If you are a journalist, you have more latitude and can take photos in situations in which people might not want their photo taken. The press is more protected to tell a news story than someone who is taking photos to sell as art. For the photojournalists, they can run a picture of anyone if that person's photo was taken at a time and place that anyone could have seen them without extraordinary effort.

For example, if a photojournalist takes a picture of a councilman littering while driving his car down the road, the newspaper does not need the councilman's permission to run the photo. Anyone could have seen him litter without going through extraordinary effort. On the other hand, if a photographer climbs a tree to snap photos of the councilman doing something unsavory at home, that could be grounds for a lawsuit, since the average person would not have seen that happening without going through considerable effort.

If you are taking photos for advertising, you should never take a picture that you do not have permission to take. In between those two extremes are some gray areas, and many times you will have to use your own judgment as to what you should do. A good rule of thumb is that if anyone has a good reason to object, proceed carefully, and do not take their picture.

When this might become an issue

One of the most common times this might become an issue is if the people you are photographing are doing something they would not want published in a magazine. Illegal behavior falls into this category, of course, but so do arguments, people crying (except at some sort of ceremony where crying is natural), and a wide range of other behaviors from an embarrassing pose to a less-than-flattering look on their face.

Again, the best thing you can do is not take a photo if you have a feeling the subjects do not want to be captured in that particular moment. It will save you time and create less ill will in the community where you are building your business. It could also lead to people trusting that you will not embarrass them when you are taking pictures, which could lead to overall trust of the community, and, in the end more business.

Some things to avoid

Do not take photos of people when you would not want a similar picture taken of yourself. Put yourself in the other person's shoes before capturing their image. And, always ask before taking photos of children. Parents have a right to limit the use of their child's image in a publication until the age of 18. For example, if you are in a public place taking photographs of children playing and are approached by one of the children's foster parents. You learn that one of the children who was in the group photos you were taking was being hidden from her birth father due to an abusive situation. This instance presents a privacy issue and a potentially harmful situation that you would never have known about had the foster parent not informed you. But, if you would have asked for consent, you would have known about the child's situation before you even had a chance to snap the button.

What to say if you are challenged

If you do take a photo and someone objects, you should politely explain that you did not think there would be a problem, show them the photo, and explain that you are a photographer. Tell the person what the photo was taken for, and then ask whether they would like you to delete the photo or not. If they want you to delete it, delete it. A single photograph is not worth going to court over.

Liability Issues and Insurance for Photographers

Legally, liability refers to fault. This type of fault results from either the guilty person's actions or lack of actions. In most situations, the conditions of liability may be determined by a court of law. That is what you will want

to avoid. Being careful and using good sense in your business can keep you out of serious trouble.

Are you liable or libel?

Liable denotes that you have some sort of legal responsibility in what you are doing. For example, if you take a picture of someone, you have a responsibility to make sure you have all the release forms and use that picture in an appropriate manner.

Liability can also refer to people coming into your studio. Is your studio safe? Have you followed all regulatory guidelines? If someone gets hurt in your studio because of your negligence, you could be sued.

Preventing defamation

Libel, on the other hand, is more direct. Libel means that you have published something unfairly that was meant to harm the other person, or his or her reputation. Photojournalists run into this situation the most, especially when they are dealing with highly emotional situations, like a murder trial or car accident.

To protect yourself from being sued for libel, always make sure you get a signed release form if you are a commercial photographer.

For photojournalists, ask yourself, "Is this photo important to the story? Does the photo add anything to the telling of the story? Are the people and places in the photo important to the story?" In order to prove libel, those suing you have to prove that you intended to harm them — in other words, that you published the material with malicious intentions. But, if you can show that the photo was important to report the story, they will not have much of a case.

What can you be liable for?

Clearly defined, legal liability occurs when a person is liable, such as in situations of tort — a legally determined civil wrong or breach of duty. In situations concerning property or reputation, a judgment may be made requiring the individual responsible for the damages to provide compensation for any damage incurred — whether it be civil or criminal. Payment of damages will usually resolve the liability issue, but sometimes state or local agencies may get involved and apply additional fines, or even jail time, if the damage is serious enough. Those instances where a state or local agency will get involved usually are the ones where someone is severely injured or killed, or where there was a great loss of property.

You can be liable to a person if you take or publish a photograph without permission, or if you use it in a commercial endeavor without having the authority to do so, or without compensating the person for the right to publish it.

For instance, if you are attending a photography workshop and are taking pictures of figure models, and then sell the images of the models, you are probably licensed to do so because the models would have given permission for this to take place through participation in the workshop. In this situation, permission or consent forms have already been signed, as the models have given their consent to a work-for-hire arrangement, giving up their rights, or agreeing to be compensated in mutually beneficial manner.

As you can tell, the list of what you can be liable for is almost limitless and ever-changing. It is based on legal precedent and depends upon your specialty as a photographer. Think of liability like insurance: You would not drive a new car without the right coverage for it. Likewise, you would not hire a contractor without the right licensing and liability insurance to put a new roof on your house. Therefore, just like with other things in life, it is important that you have the proper insurance coverage to protect yourself

from liability issues that could arise. The type of insurance you have will impact your opportunities.

However, if you were to take a photograph of a person on the street and use the image in the same fashion, you would be opening yourself up to the likelihood of being sued. Group photographs from a distance, where individual faces cannot be made out, tend not to be an issue. But again, it is better to be safe and get permission in writing from all people in the shot. For instance, as part of some licensing agreements with professional organizations, such as sports teams, photographers are required to have a minimum dollar amount in liability insurance coverage to cover issues related to trademarks and intellectual property, should they arise.

Not all situations for photographers are this extreme, and as you develop and grow your business, your needs for liability coverage will also grow and change. As you expand, add additional photographers, or break into new areas of photography, schedule a check-up with your insurance agent once or twice a year to ensure you have what you need. It is best to discuss your specific needs with a qualified professional anyway, so scheduling biyearly or yearly meetings will force you to do this. There are, however, some basic generalities of liability insurance.

In forming a new business, many people choose to incorporate because the legal entity of incorporation acts as a barrier between your personal responsibilities and business responsibilities, and protects your personal finances from being taken from you in a lawsuit. A sole proprietor is personally liable for all the debts of the business, even if the debts exceed their investments. In a sole proprietorship, all of the owner's assets, which include both those used in the business and personal property, can be attached to creditors and sold to pay business debts, which is not true for an incorporated business.

There are many other issues of liability worth thinking about that have nothing to do with the actual pictures you are taking, but rather with the legal form of business you are operating. These include property loss, personal injury, or product liability. For instance, you are at a client's business photographing something for them and you put a soft drink down, accidentally spilling onto a piece of electronic equipment. The equipment is destroyed and the situation was disastrous, but if you have the appropriate insurance, it will take care of replacing the gear.

There are also instances where you may be taking photographs from a potentially dangerous locale, such as a ladder or scaffolding, and your own physical liability issues are at an increased risk. In extreme situations, there may even be an instance where you take a photograph of a product that is used in marketing in a fraudulent way and where you are named as one of many parties in a lawsuit.

Planning to Protect Your Business

You can see from the previous examples that there are many potential dangers to not having adequate, well-thought-out insurance. While your likelihood of being sued may be small, there is no way to determine all possibilities and variables that may cause someone to file a lawsuit against you.

If you have planned your business well, have budgeted properly, paid all your debts on time, satisfied your clients 100 percent of the time, and prevented accidents, you have less to worry about than someone else who does not strive to do those things. However, no one is perfect. Accidents happen. Clients may start out happy and later become disgruntled. And financial roller coasters are a part of life and business. *For a checklist to help you decide what types of insurance you should have for your business, see the Appendix.*

What kind of liability insurance should you have?

Unlike other forms of insurance, such as theft, fire, or replacement insurance where you are paid or reimbursed for damages done to you, liability insurance protects third parties from any damage you may be responsible for in the normal course of your business. Liability insurance is designed to offer specific protection, and the payment is made directly to the third party whose name is not on the insurance contract.

The type of liability policy that best suits your needs is best determined by an insurance professional. If you work out of your home, the policy you need would be quite different from a liability policy written for someone who works on location.

You will want to learn about the different types of insurance policies for property loss, personal injury, and product liability. If you interact face-to-face with clients on their property, you will want to ensure that you are covered, just in case something happens on their site as a result of your activity. In certain situations, you also will need to ensure that you are covered for models, or that you ask models to sign your own release liability form, which would absolve you of responsibility for their actions or any potential injuries.

As a rule, damage caused intentionally and contractual liability issues are not covered under liability insurance policies. When a claim is made, the insurance carrier has the right to defend you as the insured policyholder. In cases of defense, the legal costs are rarely affected by policy limits. This is useful because costs can be significant in cases where long trials are held to determine either fault or the amount of damages.

Do you need liability insurance?

Only a qualified insurance professional will be able to determine how much and what type of insurance you need. Although you can ask your colleagues, other photographers may not have the same situation you have for your business. Ask an insurance professional. You would not want to be caught without coverage and wind up losing everything you have worked so hard to attain.

If you plan to run your business out of your home, your insurance requirements, particularly those dealing with liability related to visitors and clients, will need to be altered. While some types of coverage can seem expensive, remember that insurance is protection against events that are beyond your control. Ideally, you will never have to make a claim, but in the event of a disaster, such as a fire or accident happening to a customer while on your premises, the right policy will protect you from extreme financial loss.

There are many different types of liability insurance — those dealing with casualty, which covers you against claims made by others — that includes liability claims that might be for property damage, personal injury, or product-related injury. Umbrella liability policies add additional coverage against catastrophic losses or claims industry specific insurance, commonly available through trade associations, and business interruption insurance.

Other sources for legal advice

Some professional photography organizations offer discounted legal services as part of their benefits packages. Non-profit lawyers for the arts organizations are also scattered throughout the country, providing advocacy and services for people and businesses in the arts fields that meet certain criteria based on specialty and income. Your state bar association can also make a referral to you for a qualified, competent attorney.

Aside from preventing a lawsuit, here are some other matters where you may benefit from legal counsel:

- Copyright issues
- Contract drafting, review, and negotiation
- Landlord/tenant issues for your business space
- Organizational taxes
- Employee/independent contractor issues, including labor laws
- Mediation and arbitration for debt collection
- Collections
- Tax law

Contracts

In its simplest terms, a contract is a legal agreement between two or more parties. When you sign a contract with a client, you are laying out what you will do, when it will be done, and other details of the agreement. There may also be a separate project outline or description explaining the details of the work to be done.

Contracts are legally binding and are designed to protect both parties. Of course, you want to make sure that any contract you sign is fair and reasonable, and you want to understand what you are signing or asking a client to sign.

Who you should sign a contract with

Commercial photographers are likely to sign contracts with clients, including ad agencies and corporate clients. Journalists and publication photographers are less likely to sign contracts, at least for individual photos, but there will be some sort of agreement, sometimes in the form of a letter, regarding the rights the publication is purchasing.

With portrait clients, you will probably use something less formal than a contract, but there may be an agreement regarding what you are providing and what they are receiving.

Many photographers use standard contract templates as a starting point, and then customize them with detailed information about the project or service being offered. This way, you can ensure that everyone is on the same page with regard to expectations and responsibilities.

Karen Bridges (Chapter 4) advises photographers to never take on a photography project, even for friends, without a signed contract. "A contract provides protection for all parties and you," she said. "If something goes wrong, it lays out the responsibilities." She also recommends making a short shot list to ensure clients' needs are covered and understood in advance.

Sales Tax Surprises

Liabilities and defamation are not the only legal concerns of running a business, however. Any business that sells a product is subject to tax on that product. In certain states, businesses that make taxable retail sales or provide taxable services must obtain a sales tax identification number. The number registers your business as authorized to collect and remit sales tax. It must be done before making any taxable sales to keep from incurring any possible penalties, and any sale you make can be taxed.

In addition to penalties, not registering could hurt you in other ways. You might wind up accidentally paying tax when you are not required to do so. Certain types of companies, like non-profits, are exempt from collecting and remitting sales taxes. Not having a full grasp of the possibilities could cost you time and money.

Payment of sales tax is also not required for certain types of purchases. Other types of sales tax may not be due on purchase, but if you sell an

item, you might be required to charge sales tax. If you plan on selling prints or enlargements, most states will require that you charge a sales tax. Some states also require that sales tax be paid on services rendered. Purchases made over the Internet are also exempt from state sales tax in some locales. It can be quite confusing, so make sure you are clear on the laws for your state. Remember, this is different from the taxes you must pay as an employer, which were described in Chapter 12.

Sales tax regulations for your state

Sales tax is considered a tax on consumption. It is a calculated by charging a certain percentage of the total item or service cost and then adding it to the total purchase price. For instance, a $400 purchase with an 8 percent tax rate (8 percent of 400 equals $32) would mean that you charge a customer $432 total.

After collecting the tax, you are then responsible for turning over the appropriate amount of collected monies to the proper tax regulation agency. Depending on where you operate your business, this can be done on a monthly or quarterly basis.

You will not know what the sales tax regulations are in your area unless you ask someone who handles taxes as a regular part of their day-to-day activities. Check your local library for books pertaining to state tax law, but often, the laws change faster than publishers can keep up with them.

Bear in mind that you might find another business that is set up similar to yours — use this business as an example to estimate how your sales tax structure will be. Your best bet, however, is to contact the Department of Revenue in your state as a starting place for your research. To find the Web site for your state's Department of Revenue, conduct a Web search that includes the name of your state and the words "Department of Revenue."

You can also visit the Federation of Tax Administrators Web site, at **www. taxadmin.org**. That agency, based out of Washington, D.C., provides information and links to state tax agency home pages, state tax forms and electronic filing sites, and general information on state tax structure. The organization also hosts and provides information about meetings and workshops where people may learn more about state tax laws and administration. Ensure that the information you are receiving comes directly from your State Department of Revenue or State Department of Taxation.

What you might not know about sales tax

Not knowing proper sales tax law for your business, specific to your area, could keep you from filing the appropriate paperwork with the right agency at the right time. Some states, counties, and cities require filing of a sales tax return even if you do not collect any sales tax at all. Other areas only require the filing of paperwork on a quarterly or annual basis, depending on location and revenue. These are factors that can also change from year to year in running a business.

What to do if you have problems with your taxes

If you have problems wading through the potential mire of red tape, legal terms, and accountant speak that you may run across when dealing with government agencies at the state or local level, hire an accountant to help you get things set up right. Do not try to cut corners to save money when setting up this part of your business. Make sure you have the information you need to run your business correctly, and you will not be hit with fines, penalties, or other surprises later.

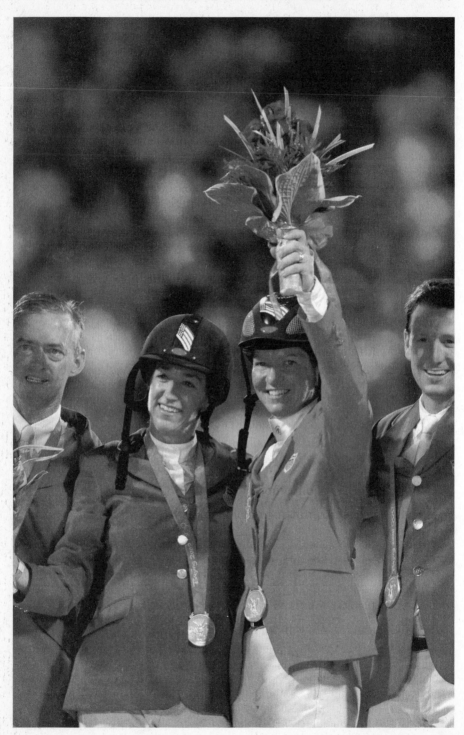

Photo provided by Diana De Rosa

Your Photography Business

Photography is a wonderful field that is continually changing and evolving. The rise of the Internet and other alternative media sources has created new and exciting ways for photographers to share their work with the public.

The main principles of photography, however, have remained the same. Framing the photo correctly and capturing the right lighting and moment are still the hallmarks of good photography.

Everything You Need to Know for a Successful Business

After reading this book, you are now armed with the knowledge you need to start and run your own photography business.

You know how to create a workable business plan and secure financing if needed to start your business. You can create a marketing plan that will get your business' name in front of your customers and you have learned the benefits of word of mouth advertising and social media marketing.

By reading this book, you can see the ways your business can grow and how it is important to stay diversified and current on the latest technologies. You have also seen the dangers, like libel, that your business can run into.

Now it is time to put what you have learned into action. You will make mistakes as you go, but it is important to learn from those mistakes. As long as you have planned correctly as discussed in this book, your business can continue to move forward, and you can go out and touch people's lives the way you have always wanted to.

Of course, there is an important administrative side to running your photography business, but always remember to be a photographer first and have fun with what you are doing. Be the artist that you want to be, and do not lose that vision as you run your day-to-day business. If you keep that in mind and make sound business decisions like the ones described in this book, you should find yourself with a successful photography business that you can enjoy for years to come.

CASE STUDY: ONCE YOU GO
PRO, YOU DO NOT GO BACK

Kerri Smith, Singer/Song writer
www.nittanyweddings.com
kerri@nittanyweddings.com
www.kerrileesmith.com
events@kerrileesmith.com
(814) 571-2984
381 W. Clearview Ave.
State College, PA 16803

It was a sight that had never been seen before — 100 brides tailgating alongside college football enthusiasts for the Penn State/Michigan game in 2005. Why the bridal wear? It was a promotional event called Bride Blitz put on by Kerri Smith, and she was not going to settle for any documentation that was less than fabulous. So, Smith hired two professional

photographers (J and A Photography, **www.jandaphoto.com**) for this photo scavenger hunt, where the brides had to complete silly tasks like getting their pictures taken while kissing a Michigan fan on the cheek.

"This was the first time I used a professional photographer, and it ruined me for anything else," Smith said. Since, Smith has turned to professionals when it comes to important events, both in her business and personal life, which is why she hired a photographer for first CD release party.

With more than 50 people at the event, which was held in the living room of her friend's farmhouse at the base of Mt. Nittany, the namesake town mountain, Smith wanted to make sure she walked away with quality photos she could use again on her Web site and promotional materials. Smith's photographer (Jan Thiessen, **www.photosbyjan.com**) worked with her — and around her — to produce the prints Smith wanted.

"I hardly knew he was there until I saw the pictures a few days later — that's a good photographer," Smith said.

In addition to looking for people who are outgoing and who mesh well with the assignment, Smith looks for photographers who are willing to give her a little something extra. Her photographer from her CD release party included a written copyright release of the photos on the spot. Although Smith paid for the copyright, she said it was a helpful necessity because she needed the photographs right away for marketing. The photographers of her Bride Blitz event also went the extra mile and posted the photos to the Web (**www.brideblitz.com**) that night so Smith could have her photos ready for the press to view right away.

"I've turned into a 'professionals only girl' when it comes to shooting important events," Smith said. "It's not worth the risk of getting a lot of lousy photographs back."

Conclusion

The world of photography can be a rewarding one. From the high-paced action of covering breaking news events to the leisurely pace of capturing stock photos of snowy mountain tops to the satisfaction of preserving a

family memory for posterity, photography offers something for everyone who participates. With a camera in your hands, you can help capture the moments of people's lives that will make them laugh, cry and reminisce for years to come.

Starting your own photography business can enhance the reward you get from your photography by leaving you in charge of your destiny and the way you create those memories. While the road to owning your own business is never easy, following the steps outlined in this book can make your dream come true, hopefully with a little less stress and a little more knowledge of what lies ahead.

In this book, you looked at the different types of photography and which one may be right for you. Finding your niche is one of the most important things to being a photographer, as being well-suited for the type of photography that will reflect in your work.

This book discussed the people you work with and how to determine who your base clientele will be. It also looked at how to determine what your strengths are and where you may need help down the road.

This book lead you through writing a business plan and discussed how this document will help you through your journey of starting your own business. It is the road map on which you rely and is needed to secure outside financing, what your business' focus should be, and narrows down your clientele. It also helps you determine the right type of business structure that will suit your needs including sole proprietorship, partnership, a limited liability company (LLC), or a corporation.

You were walked through what you need to start your company, from equipment costs to renting a building. With that in mind, this book looked at the difference between digital and film photography and what the pros and

cons of both are. Buying the right equipment for your business is essential to keep costs low and let you have the technology and resources available to do the job correctly.

After establishing your business plan, this book looked at creating your vision, or what you want your business to be and grow into someday. To that end, you saw how you run your business effectively and how to put the health of your business to the front of your priorities.

This book looked at how important environment is in the life of a photographer. For those working at home, it is essential to create an area away from your normal routine where you can go to do your work or meet with clients. For those working out of a studio, having a neat and organized work area will be key to showing customers that you are professional and trustworthy.

You then dove into the world of marketing, the lifeblood of any business. The book talked about the pitfalls of marketing, including marketing to the wrong people, not marketing enough, and not asking for referrals. The most important early marketing strategy for a new business is word of mouth, and your number-one job should be asking for referrals to grow your business.

This book helped you develop a marketing plan, so you can see where your marketing dollars should go and you can create the right "marketing mix" for your business. The marketing mix is putting dollars where they will do the most good, whether that is into a Web site, print ads, radio spots, or whatever marketing tools are available to you. You learned how to test your marketing plan, and how marketing is never set in stone — you should constantly be evaluating and reevaluating your marketing strategy as your business grows.

In this book, you read about the best ways to run your business, how to set up accounting systems, and how to make sure you take care of yourself financially while growing your business. You also learned that it is okay to admit that you may never understand accounting or tax laws, and that it is okay to go out and get help. Sometimes a good accountant is the best investment you will make in your company.

You also looked at sales, and how to evaluate your product and you customer's response to them. It is important to be tweaking your product as market changes and customer feedback dictate, so remember to be fluid with your business while staying true to your creative vision.

With a more serious tone, this book delved into the aspects of copyright law, tax laws and liable laws. Knowing what each of these is and how each affects you will give you peace of mind to know that you will not be sued or run afoul of the government.

Most importantly, this book taught you about having fun with your business and enjoying being a photographer. It can be a great experience, and by running your own business, you can meet lots of new and exciting people, go to new and exciting places, and have the freedom to be the photographer you want to be.

Glossary of Terms

Accounts payable: a file or account that contains money that a person or company owes to suppliers, but has not yet been paid (a form of debt)

Aperture: the opening that determines the cone angle of a bundle of rays that come to a focus in the image plane

Backdrop: backgrounds used for portrait photography

Balance sheet: summary of a person's or organization's balances; has three parts: assets, liabilities, and ownership equity

Billable hours: hours that can be billed to a client; number of hours per period (such as a year or month) that a company expects to be working at the client's expense

Business credit: a bank loan to a company

Business license: a legal document that grants you the right to operate a business in your city

Business Manager: a person who manages the work of others in order to run a business efficiently

Business needs: requirements that a private or public organization must follow, such as proper recording of its activities and transactions

Business plan: document that summarizes the operational and financial objectives of a business, and contains the detailed plans and budgets showing how the objectives are to be realized

Business structure: organization framework legally recognized in a particular jurisdiction for conducting commercial activities, such as sole-proprietorship, partnership, and corporation

Capital: cash or goods used to generate income, either by investing in a business or a different income property

Cash flow projection: study of the cycle of your business' cash inflows and outflows, with the purpose of maintaining an adequate cash flow for your business, and to provide the basis for cash flow management

Clientele: the clients of a professional person or practice considered as a group

Cold calling: the process of approaching prospective customers or clients, typically via telephone, who were not expecting such an interaction

Collateral: assets pledged by a borrower to secure a loan or other credit, and are subject to seizure in the event of default

Commercial photography: any photography in which money exchanges hands

Corporate records: records a corporation needs to keep to show that it is functioning in the manner required by the Internal Revenue Service, shows that the corporation is a separate entity, and maintains the corporate shield from liability

Corporation: a legal entity or structure created under the authority of the laws of a state, consisting of a person or group of persons who become shareholders

CRT monitor: an electrical device for displaying images by exciting phosphor dots with a scanned electron beam

Darkroom: a room in which photographs are developed

Day rate: the amount of money you will earn for a full day of work; the amount will depend on a number of factors, including your experience, popularity, and the caliber of the client

DBA: "Doing Business As;" a formal notice that an individual, company, or organization is conducting business under a different name

Demographic profile: the characteristics of human populations and population segments; used to identify consumer markets

Digital darkroom: the hardware, software, and techniques used in digital photography that replace the darkroom equivalents, such as enlarging, cropping, dodging and burning, as well as processes that don't have a film equivalent

Digital photography: photography using a camera that uses an electronic sensor to record the image as a piece of electronic data, rather than as chemical changes on a photographic film

Equity: the difference between the market value of a property and the claims held against it

FICA: a tax on employees and employers that is used to fund the Social Security system

Film photography: the art or process of producing images of objects on photosensitive material

Fixed costs estimate: attempt by a company to calculate the price of producing a product before making it

Freelancer: a writer or artist who sells services to different employers without a long-term contract with any of them

Image processing software: software used to analyze or manipulate images

Income projection: estimates of the future financial performance of a business

Incorporated: formed into, or organized and maintained, as a legal corporation

Incubator: an organization designed to accelerate the growth and success of entrepreneurial companies through an array of business support resources and services that could include physical space, capital, coaching, common services, and networking connections

Invoice: a detailed list of goods shipped or services rendered, with an account of all costs; an itemized bill

LCD panel: a thin, flat panel used for electronically displaying information such as text, images, and moving pictures

Lease: a contract by which one party (landlord, or lessor) gives to another (tenant, or lessee) the use and possession of lands, buildings, property, etc. for a specified time and for fixed payments

Liability: any legal responsibility, duty, or obligation

Limited liability company: a type or form of for-profit incorporated company where ownership is divided into shares, and where the governing rules are set forth in a contract entered into by all of the initial shareholders

Litigation: a legal proceeding in a court; a judicial contest to determine and enforce legal rights

Loan: the temporary provision of money (usually at interest)

Marketing expenses: cost incurred to sell or distribute merchandise; one of the types of operating expenses and is a period cost

Net 30: form of trade credit, which specifies that the net amount (the total outstanding on the invoice) is expected to be payment received in full 30 days after the goods are dispatched by the seller, or 30 days after the service is completed

Non-billable hours: hours that cannot be billed to the client

Partnership: a type of unincorporated business organization in which multiple individuals, called general partners, manage the business and are equally liable for its debts

Paypal: an e-commerce business allowing payments and money transfers to be made through the Internet

Photo printer: a printer (usually an inkjet printer) that is specifically designed to print high quality digital photos on photo paper

Photojournalism: journalism that presents a story primarily through the use of pictures

Pricing structure worksheet: sheets used by a business to determine the costs per day and what fees beyond fixed expenses need to be added to make a profit

Profit and loss statement: income statement; a financial statement that gives operating results for a specific period

Profit sharing: a system in which employees receive a share of the net profits of the business

RAM: "Random Access Memory;" place in a computer where the operating system, application programs, and data in current use are kept so that they can be quickly reached by the computer's processor

S corporation: a corporation that does not generally pay income taxes; instead, the corporation's income or losses are divided among and passed through to its shareholders

Scanner: a device that captures images from photographic prints, posters, magazine pages, and similar sources for computer editing and display

Shutter speed: the unit of measurement that determines how long the shutter remains open as the picture is taken

Simple partnership: partnership in which each partner makes an equal contribution of time and effort, each partner makes an equal contribution of capital, shares equally in the losses and the profits, and shares equally in decision-making

SLR camera: camera that uses a semi-automatic moving mirror system that permits the photographer to sometimes see exactly what will be captured by the film or digital imaging system

Sole proprietorship: type of business entity that legally has no separate existence from its owner; hence, the limitations of liability enjoyed by a corporation and limited liability partnerships do not apply to sole proprietors

Stock photography: consists of existing photographs that can be licensed for specific uses

Stockholder meeting: a meeting at which the management reports to the stockholders of a company

Targeted marketing: type of advertising whereby advertisements are placed so as to reach consumers based on various traits, such as demographics, purchase history, or observed behavior

Thumbnail image: a miniature representation of a page or image that is used to identify a file by its contents

Tripod: an adjustable three-legged stand, as for supporting a transit or camera

Tungsten light: term applied to photoflood bulbs, which are brighter and give more consistent light

Variable costs estimate: looks at the fluctuating costs of doing business on a month-by-month basis

Venture capital: wealth available for investment in new or speculative enterprises

Work-for-hire agreement: an exception to the general rule that the person who actually creates a work is the legally-recognized author of that work; the employer — not the employee — is considered the legal author

Photo provided by Mindy Schwartz

Bibliography

Crawford, Ted, *Business and Legal Forms for Photographers*, New York, Allworth Press, 2007.

Heron, Michal and David MacTavish, *Pricing Photography: The Complete Guide to Assignment and Stock Prices: An essential reference for Photographers, Art Directors and Graphic Designers*, Third Edition, 2002.

Lilley, Edward R., *The Business of Studio Photography; How to Start and Run a Successful Photography Studio*, New York, Allworth Press, 2002.

Michaels, Nancy and Debbi J. Karpowicz, *Off the Wall Marketing Ideas: Jumpstart Your Sales Without Busting Your Budget*, Adams Media, 1999.

Oberrecht, Kenn, *How to Start a Home Based Photography Business* Fifth edition, The Globe Pequot Press, Guilford, Connecticut, 2006.

Orenstein, Vic, *Photographer's Market Guide to Building Your Photography Business: Everything you Need to Know to Run a Successful Photography Business.* Cincinnati, OH, Writer's Digest Books, 2004.

White, Sarah, *The Complete Idiot's Guide to Marketing*, Alpha Media, Indianapolis, IN, 2003.

Williams, James, *How to Create a High Profit Photography Business in any Market*, Amherst Media Inc., Buffalo, NY, 2006.

Zuckerman, Jim, *Shooting and Selling your Photos*, Writer's Digest Books, 2003.

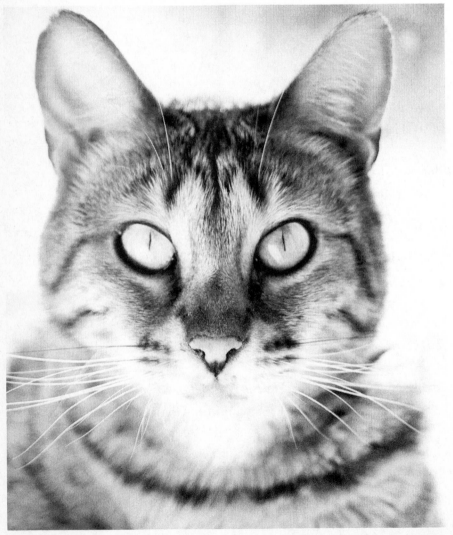

Photo provided by Sara Kirk

Biographies

Bryan Rose

Bryan Rose is a freelance writer and photographer specializing in athletic and outdoor events, and lives in Fond du Lac, Wisconsin. He spent five years working as a writer and photojournalist covering athletic events for the *Ripon Commonwealth Press* in nearby Ripon, Wisconsin. After leaving the newspaper to pursue writing interests, he continues to shoot photographs as an occasional freelancer and for recreation.

Joni Strandquest

Joni Strandquest is a publicist, journalist, and photographer specializing in lifestyle, travel, arts/entertainment, and small business themes. A native of Atlanta, Georgia, she recently relocated to Minneapolis, Minnesota, where she operates the d/b/a Quest Media and Public Relations and is partnered in another company, EaglesQuest Media, Inc.

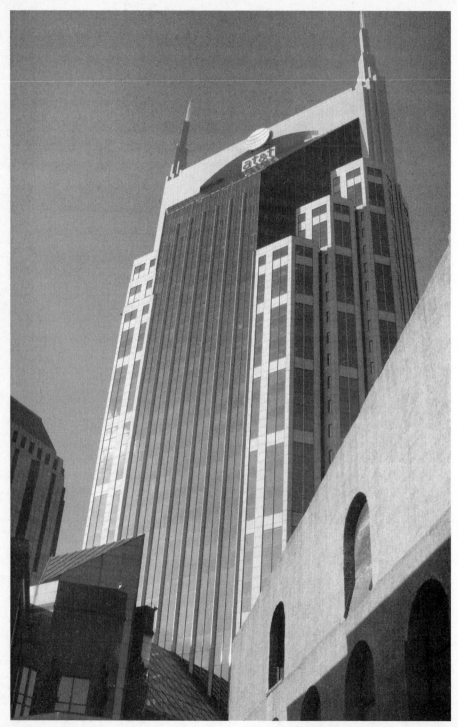

Photo provided by Mindy Schwartz

Index